2000 **WORLD PRESS PHOTO**

Thames & Hudson

It took the jury of the 43rd World Press Photo Contest two weeks of intensive deliberation to arrive at the results published in this book. They had to judge 42,215 entries submitted by 3,981 photographers from 122 countries.

World Press Photo

World Press Photo is an independent nonprofit organization, founded in the Netherlands in 1955. Its main aim is to support and promote internationally the work of professional press photographers. Over the years, World Press Photo has evolved into an independent platform for photojournalism and the free exchange of information. The organization operates under the patronage of H.R.H. Prince Bernhard of the Netherlands.

In order to realize its objectives, World Press Photo organizes the world's largest and most prestigious annual press photography contest. The prizewinning photographs are assembled into a traveling exhibition, which is visited by over a million people in 35 countries every year. This yearbook presenting all prizewinning entries is published annually in six languages. Reflecting the best in the photojournalism of a particular year, the book is both a catalogue for the exhibition and an interesting document in its own right. A six-monthly World Press Photo newsletter deals with current issues in the field.

Besides managing the extensive exhibition program, the organization closely monitors developments in photojournalism. Educational projects play an increasing role in World Press Photo's annual calendar. Several times a year seminars open to individual photographers, photo agencies and picture editors are organized in developing countries. The annual Joop Swart Masterclass, held in the Netherlands, is aimed at talented photographers at the start of their careers. They receive practical instruction and are shown how they can enhance their professionalism by some of the most accomplished people in photojournalism.

World Press Photo is sponsored worldwide by Canon, KLM Royal Dutch Airlines and Kodak Professional, a division of Eastman Kodak Company.

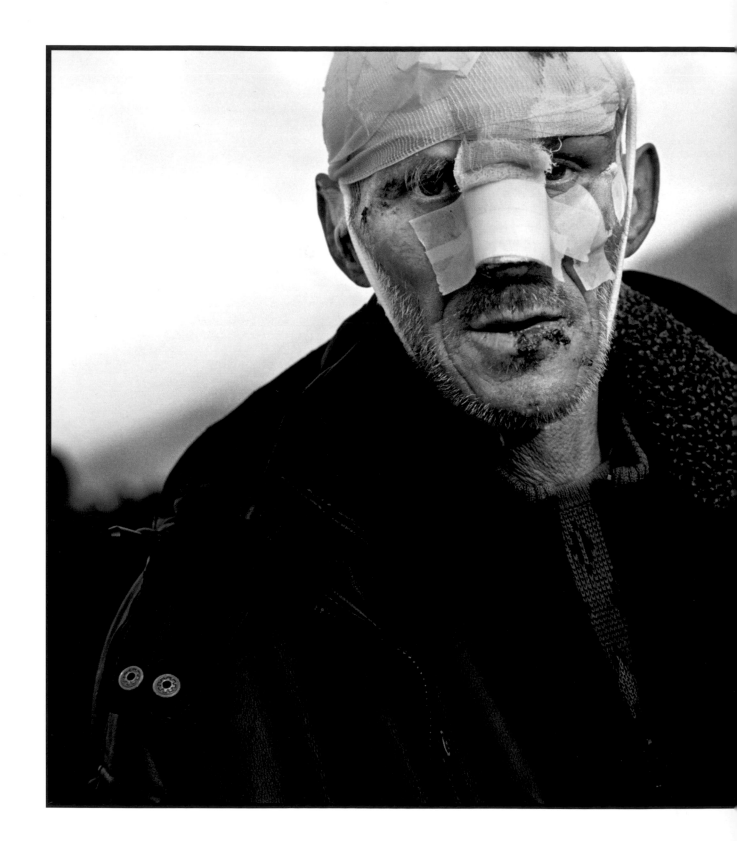

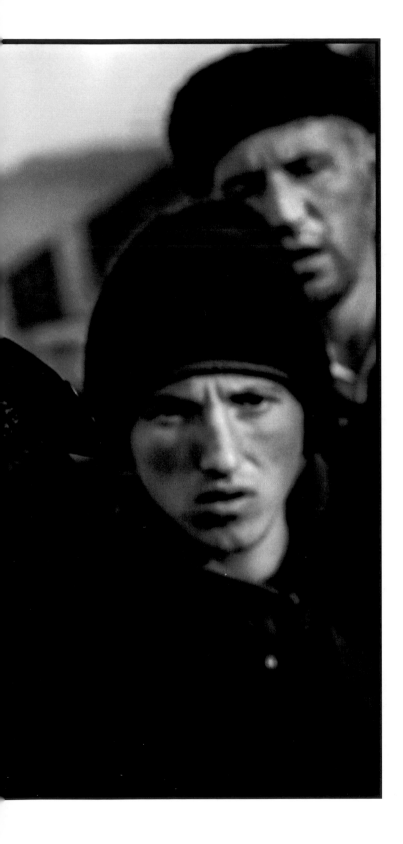

World Press Photo of the Year

· Claus Bjørn Larsen
Denmark, Berlingske Tidende

A man walks the streets of Kukës in Albania, one of the largest gathering points for ethnic Albanian refugees fleeing violence in Kosovo. The photographer's interpreter couldn't establish where he came from or what had happened to him. Nobody around him knew who he was.

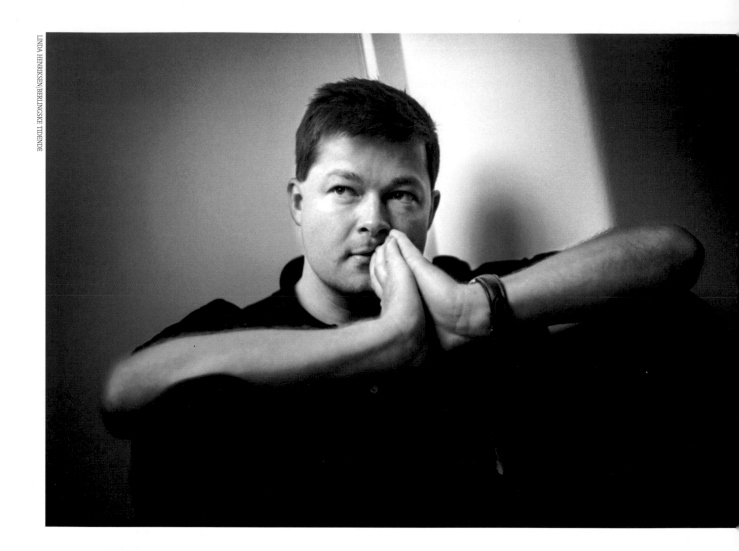

LINDA HENRIKSEN/BERLINGSKE TIDENDE

Claus Bjørn Larsen was born in Holbæk, Denmark, in 1963. After graduating from high school, he started working as a freelance photographer and darkroom runner. In 1986 he was hired as a student press photographer at the Copenhagen newspaper *B.T.*, and graduated from the Danish journalism high school as press photographer three years later. In his final year he won the Danish Photographer of the Year award. Later, he worked at the *Ekstra-Bladet* newspaper, covering such foreign assignments as the Gulf war, the intifada in Israel and the war in Bosnia. During this time he picked up two more national photography awards. Since 1996 he has worked with the Danish paper *Berlingske Tidende*, where he is now deputy picture chief. He is married to a nurse, Merete Lind, and their daughter Frederikke is nearly 5.

Claus Bjørn Larsen

Claus Bjørn Larsen, the author of the World Press Photo of the Year 1999, answered some questions about his work.

How did you first become involved in photography and how did you make the transition into becoming a professional?

It all started during my last few years at high school. I borrowed a friend's camera, started to take pictures and quickly found I could make good money selling photos of parties and trips with schoolmates. That meant I could finance my own photography. After school I worked as a runner for a newspaper, and had an agreement with the photographers that I would stay and clean up the darkroom after they were finished. So I got film and paper for free, and I could use my own money on camera equipment.

Going out as a runner with photographers every night was a good way of getting into the job. I could see how they worked, and some of my own pictures got into the paper. I suppose you could say I learned the old way, because next I joined a tabloid for three years, slotting in about 30 weeks study at the Danish journalism college. Nowadays people do more time at college and not so much out on a paper.

What are your special strengths as a photographer?

I'm good at catching the right moment to be somewhere, at finding the hotspot. But for me taking good pictures is hard work. Some people have the luck of just walking up and shooting a tremendous picture. In Kosovo I had to work at it. It was down to getting up early to catch the morning light, then developing and transmitting, then back to work in the evening light — and returning to places again and again to see if anything was happening.

How did you feel about working in Kosovo?

At times it was like experiencing something from the Second World War. There were so many people, not saying anything, just walking. I noticed their eyes especially. It made a very deep impression on me. When I returned home it took me quite a while to get back to normal. I was in Kosovo and Macedonia for about two and a half months in all. When you are there such a long time the story gets inside you. Back in Denmark it was so hard to explain exactly what was happening. They are two different worlds, even though Kosovo is only three hours flight away. My small mission in this was that people would see my pictures and get involved.

Did your experiences in Kosovo affect your work in any other way?

So many photographers were there that I very soon realized for my pictures to have impact I would have to work in some other way. So I switched to black-and-white, put away all my high-tech cameras and worked with simple, basic equipment. That forced me to get very close to people, to talk to them, to look them in the eyes. I think this one of the reasons that the pictures were so noticeable. If I hadn't have reassessed things, my pictures wouldn't have stood out.

How did the winning photo come about?

I'd been there for two weeks, up every morning at six, because in the mornings people were packing up to go further into Albania. I was walking along with my interpreter, and suddenly I noticed this man. Perhaps he stood out because not many people had been beaten like that, but he also had such incredibly strong eyes. My interpreter tried to find out what had happened to him, but nobody knew — which was strange, because usually there's a family or at least neighbors about. But nobody knew him. He couldn't say anything, he just stood looking at me. Then he walked off into the crowd, and we never saw him again. I don't know his name or where he came from.

What is it that's happening in Denmark at the moment? It seems that there's a sudden blossoming of Danish photography.

There are a number of reasons for that, I think. One is that about ten years ago the photographers union started holding an annual conference. Henrik Saxgren, who is a mentor to many of us, started to get top photographers along. For the first time we not only saw the pictures, but got to speak with the photographers about how they were made. I think before that a lot of us knew how to do it, but we didn't have the self-confidence to take things further. Then three years ago a really young Danish guy, Joachim Ladefoged, won a first prize in the World Press Photo contest, and people thought, if he can do it, so can I. And also, there's a lot of camaraderie in Danish photojournalism. We don't see ourselves as competitors, as photographers in many other countries seem to. Of course, we are competitors in a sense, but we also talk about our pictures a lot, learn from each other and gain inspiration from each other. I'm very proud of the award — and now I'm going to have to try to find a new story and make pictures like this again, and in turn I hope I can inspire someone else.

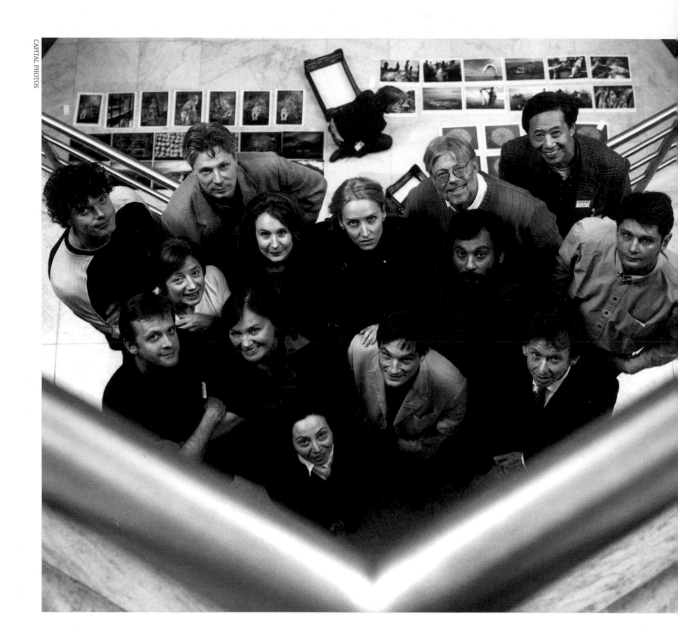

THIS YEAR'S JURY

IN FRONT:
Michele McNally, USA

FIRST ROW, LEFT TO RIGHT:
Roger Hutchings, United Kingdom
Grazia Neri, Italy
Mark Grosset, France (chair)
Adriaan Monshouwer (secretary)

SECOND ROW, LEFT TO RIGHT:
Margot Klingsporn, Germany
Sally Stapleton, USA
Robin Comley, South Africa
Pablo Bartholomew, India
Krzysztof Miller, Poland

BACK ROW, LEFT TO RIGHT:
Kadir van Lohuizen, The
Netherlands
Peter Dejong, The Netherlands
Don Rypka, Argentina
Xia Daoling, People's Republic
of China

Foreword

As ever, there were more entries to the World Press Photo contest this year than last: 42,215 photos (7,213 or 17.1 percent of which were digital) by 3,981 photographers from 122 countries. Impressive figures that make this competition unique in its international dimension. For the 13 jury members with their different cultural and geographical perspectives, it was an extraordinary opportunity to view a record of the year, both in the photographic sense, and of events that had taken place. This book enables you to discover, or re-discover, the pictures we selected.

Our discussions were intensive, often lasting late into the night. But the two weeks that it took to arrive at this selection were our way of giving recognition to the profession of photojournalism, which is often not accorded its true worth. The number of high-quality entries was so large that we could have made other choices, and it was often with sadness that we were forced to vote out pictures. I hope the photographers whose work was eliminated in this way will forgive us, but we did have to make decisions.

This year's World Press Photo contest was special because it was the last one of the century. An occasion to take stock. It would seem that the world is still dominated by atrocities, wars (whether anonymous or in the spotlight), famines and epidemics — to which we often pay too little attention. It seems we will never learn anything from history, and that increasingly we are getting into the habit of accepting these kinds of events as inevitable as earthquakes or hurricanes. Fortunately, photographers are here to set us right, most of the time with talent.

Last century was a one of contradictions. On the one hand it witnessed unprecedented technological advances, which although they were supposed to improve our daily life, benefited only 10 percent of the planet. On the other, the 20th century will go down in history as a period of barbarity and violence. And it is thanks to the work of photographers that today we have facts and evidence of this. We need to stand in solidarity and defend this work. The right to information is at stake. If the pictures are disturbing, it is because they show us events which many would like to keep concealed.

Photographers' work is made more difficult every day by leaders who seem to have learned the lessons of Vietnam, where the press could work without hindrance. Last year, it was practically impossible to work in Chechnya, in Sierra Leone and even inside Kosovo (during the exodus) — to mention but a few. Only a handful of photojournalists, taking considerable risks, were able to get information through to us. Paradoxically, it is this kind of censorship that points up the function of journalism, and the necessity of remaining vigilant in defense of freedom of the press.

After I returned from judging the contest in Amsterdam, many people asked me why we gave such importance to Kosovo, and why Claus Bjørn Larsen's picture was selected as World Press Photo of the Year 1999. Curiously, I don't think Kosovo is over-present in the results. On the contrary, we paid careful attention to keeping a balance. The number of photographs about this subject was so large that Kosovo could be found in almost all categories. In addition, the photographic quality of the subject was undeniably strong, so it is natural to find more items about Kosovo than any other event.

As for the World Press Photo of the Year 1999, there were strong arguments to support this decision, even if it wasn't unanimous. Whether you like it or not, events in Kosovo belong to the major moments of last year. It is not that often that NATO goes to war. As for the picture itself, we felt that it possessed very strong photographic qualities. The immobility, the static aspect of it, is re-enforced by the look in the men's eyes. It gives free rein to the viewer's imagination, which is one of the very points of photography. It is a still photograph and not a motion picture. We wanted to avoid the kind of tear-jerking images that television presented to us at the time, even though there were a great many heart-rending photographs of excellent quality in the contest. Finally, I recall a remark made by one of the jury members, pointing out that this picture had a timeless, non-localized aspect to it. It could just as easily have been made during the Second World War, or in Chechnya. In that sense it is truly representative of the past century.

MARK GROSSET
Chairman of the Jury
Paris, February 2000

P.S. According to the organization *Reporters Sans Frontières* (Reporters Without Borders), in 1999, 36 journalists were killed, 450 arrested, 84 imprisoned, and 357 media were banned across the world.

World Press Photo
Children's Award

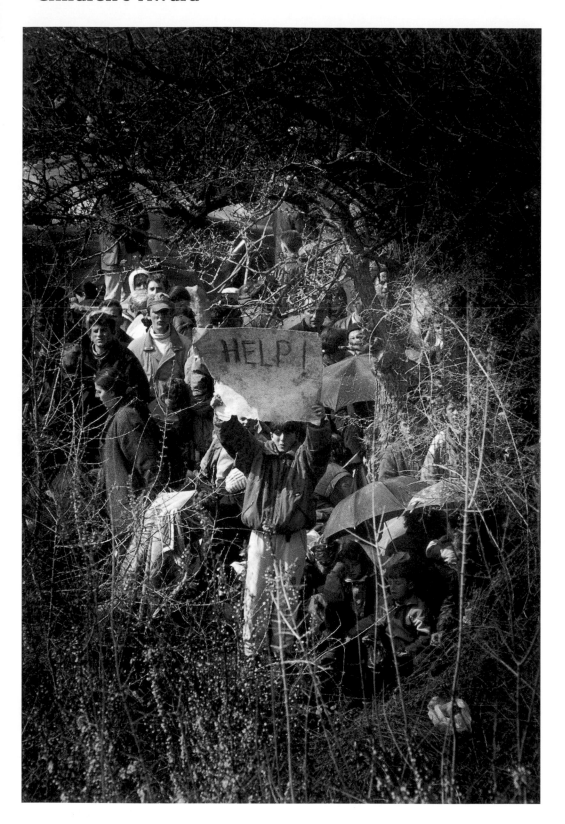

· Harald Henden
Norway, Verdens Gang/
Black Star, USA

Kosovo Albanians trapped in a no man's land at the Blace border crossing between Kosovo and Macedonia in April. As tens of thousands of ethnic Albanians fled their homes, Macedonian authorities closed the borders for fear of too great an influx. The Kosovars were caught between Serb paramilitary units on one side, and Macedonian forces on the other. International media were given severely restricted access, so it was difficult for the refugees to communicate their plight.

Spot News

· Cho Sung-Su
Republic of Korea, Corbis Sygma

1ST PRIZE SINGLES

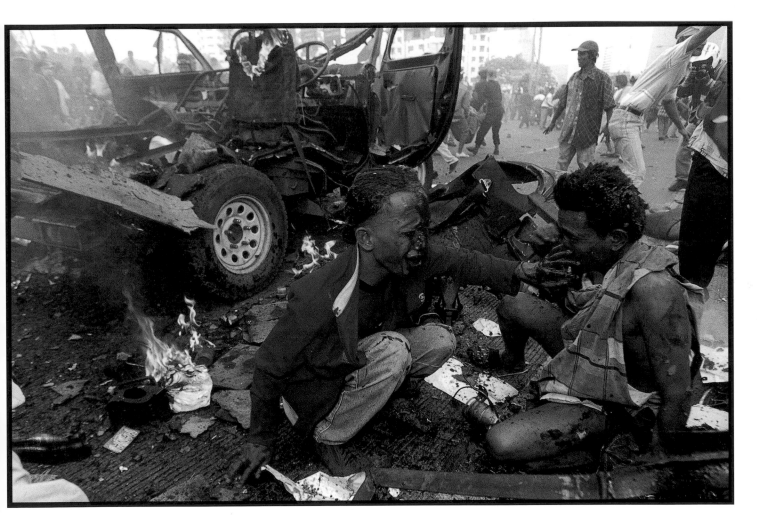

Survivors emerge from the wreckage caused
by a car bomb in Jakarta. In 1999 Indonesia
held its first ever democratic elections. In June
the PDI party headed by Megawati
Sukarnoputri won most seats in parliament,
but not enough to guarantee she would be
elected president. At subsequent presidential
elections in October the parliament voted in
PKB party head Abdurraham Wahid as leader.
Megawati lost by just 60 votes. As word of her
defeat spread, rioting broke out.

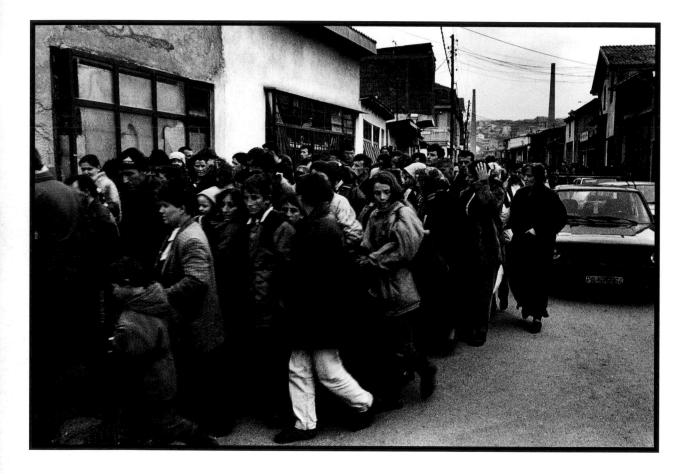

· Afrim Hajrullahu
Contact Press Images for
US News & World Report

2ND PRIZE SINGLES

Kosovar Albanians, forced from their homes in Priština, are marched to the train station by plainclothes Serbian police in unmarked cars. The photographer and his family were part of the evacuation, and were eventually taken to Macedonia. His photos form the only known record of the ethnic cleansing operation taken from inside Priština. The film was smuggled first out of Kosovo, and then out of the refugee camp.

· Aijaz Rahi
India, Associated Press

3RD PRIZE SINGLES

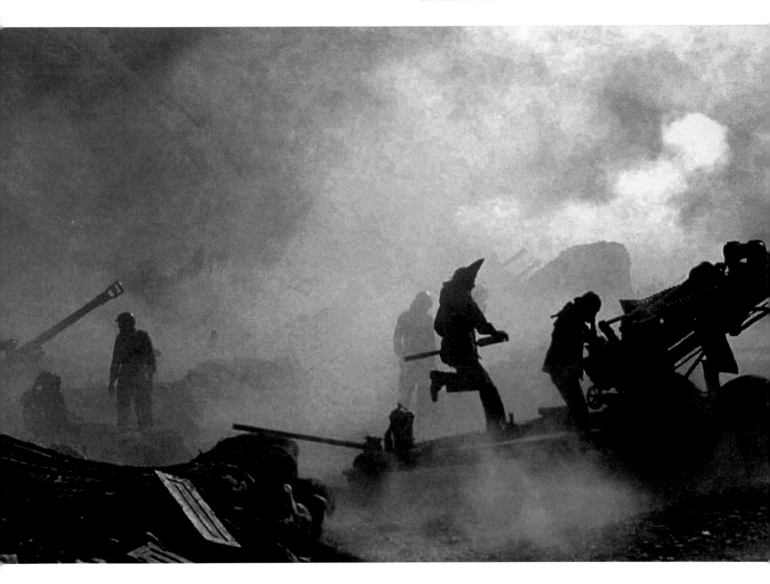

Indian artillery guns are engulfed in smoke in
Dras, one of four battle zones in the disputed
territory of Kashmir. Fighting had been raging
since May, bringing India and Pakistan to the
brink of war. On July 10 an operation by the
Indian army cleared most infiltrating troops
from Dras, and by July 16 fighting in Kashmir
had died down. The conflict over Kashmir
dates back more than 50 years, and has been
behind two of the three wars between India
and Pakistan.

· John Stanmeyer
USA, Saba Press Photos for Time

1ST PRIZE STORIES

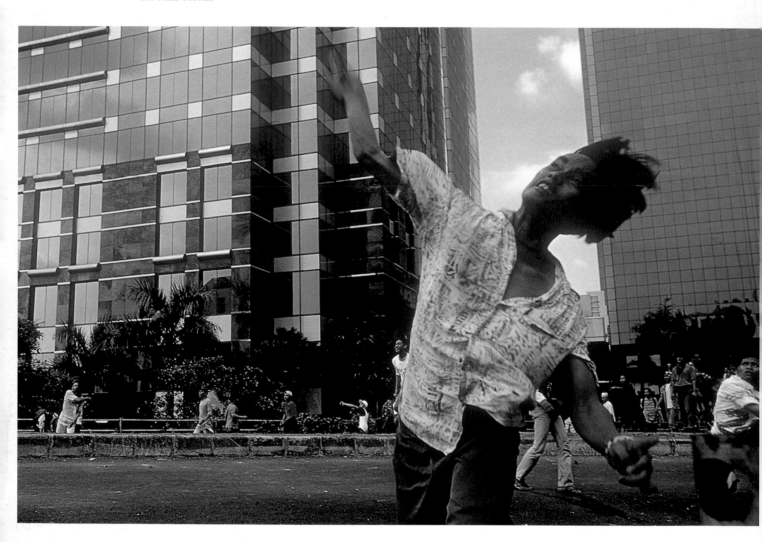

During Indonesian presidential elections in October, the first news to spread among crowds waiting for the result was that the popular Megawati Sukarnoputri had won. Supporters' jubilation turned sour when they learned the true result, that parliament had chosen Muslim leader Abdurraham Wahid as president. Above and top right: Students and riot police clash in the days prior to the election, as protestors demand that then President Habibie not be reselected. Below right: Megawati supporters react to initial news that she had won. (story continues)

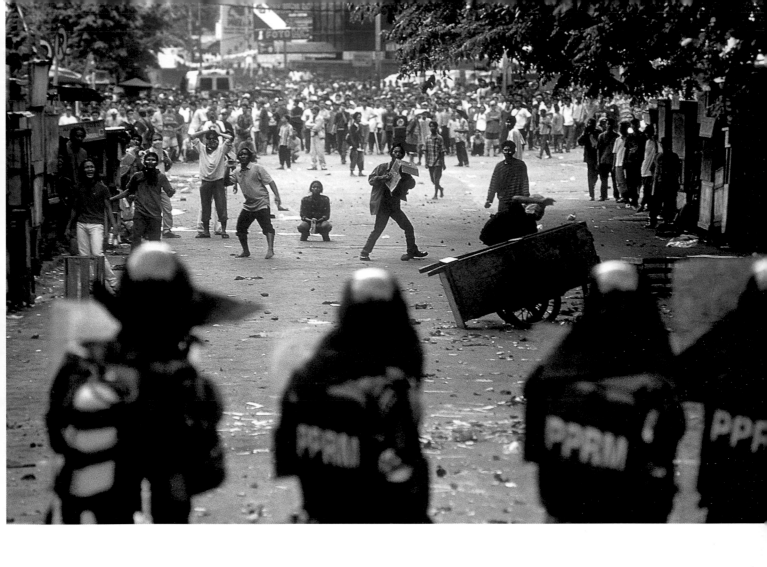
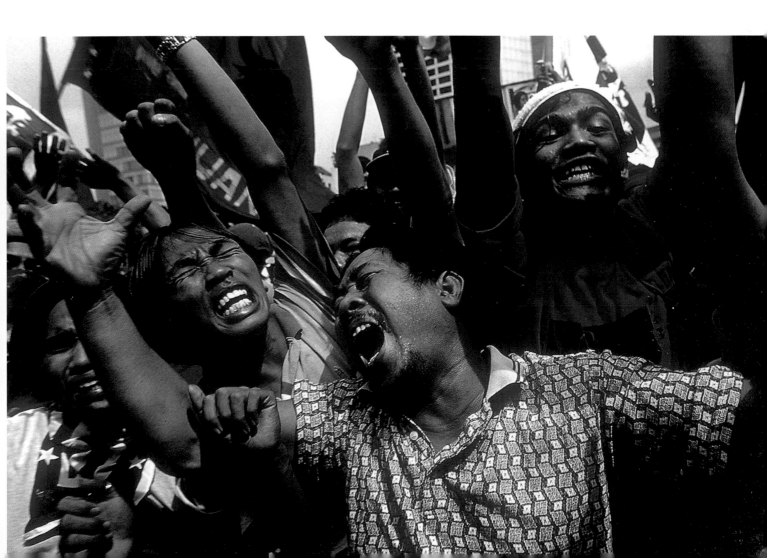

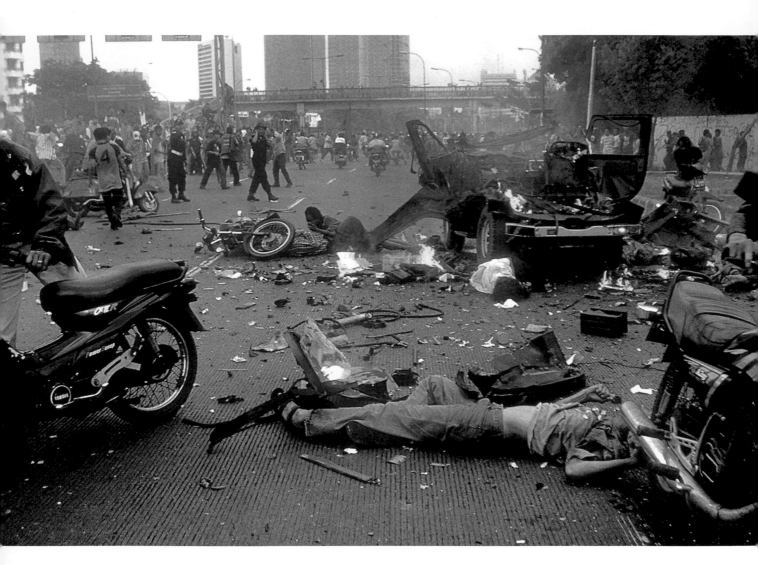

(continued) The street violence that broke out as the true election result became known died down only after Megawati herself appealed for calm, and when it was made known that she was to be vice-president. Above and top right: Megawati supporters lie dead and injured minutes after a car bomb explosion near the parliament building in Jakarta. Right: Police form a cordon to prevent protestors from marching on parliament.

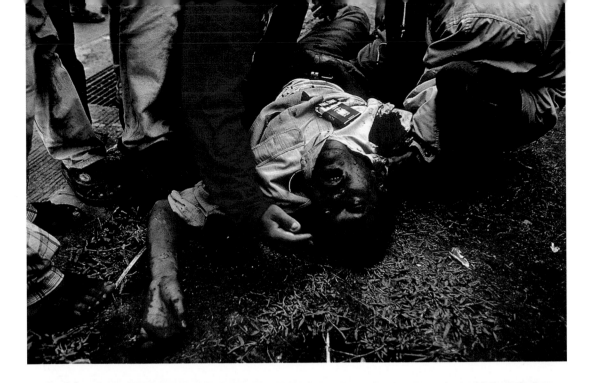

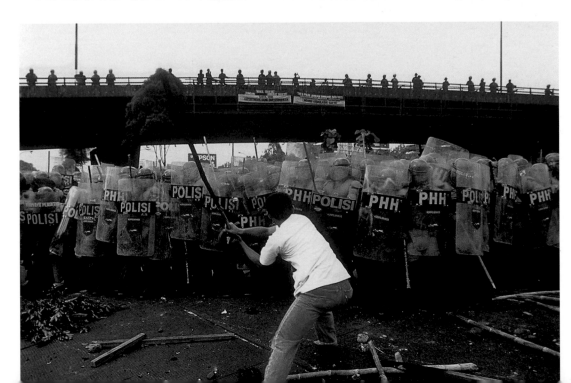

· Neil Libbert
UK, Network Photographers

2ND PRIZE STORIES

Early in the evening of April 30 a nail bomb exploded in The Admiral Duncan gay pub in Soho, London. Three people died and up to 70 were injured. It was the third such bombing in less than two weeks. Earlier bombs had gone off in predominantly black and Bengali areas of the city. Police arrested and charged a 22-year-old man early on May 1. They reported that the bomber had been acting alone, and was not affiliated to any of the extremist right-wing groups that had claimed responsibility for the bombings. Later, the man admitted causing the explosions.

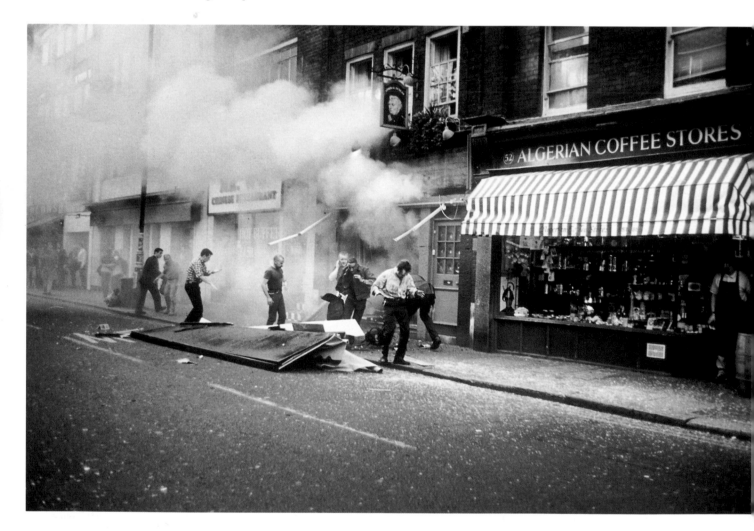

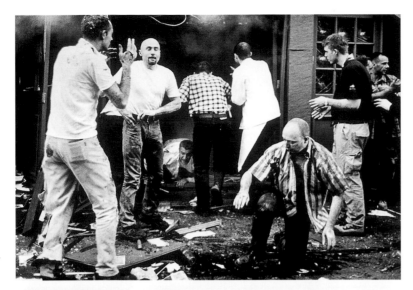

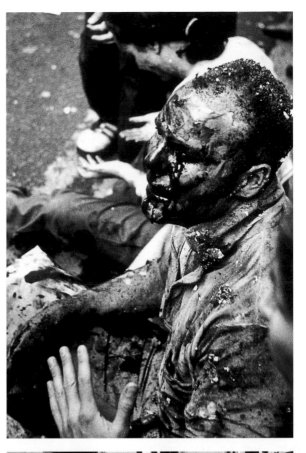

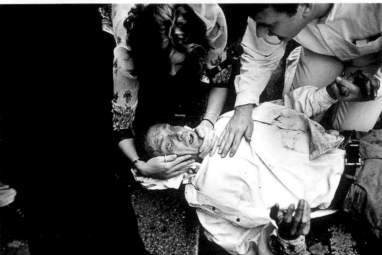

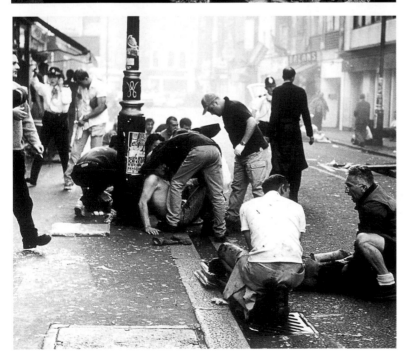

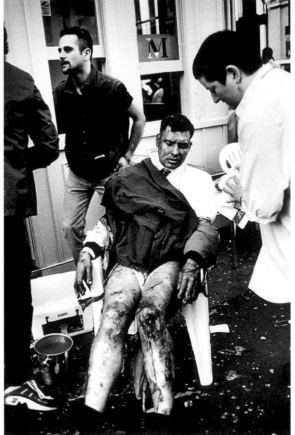

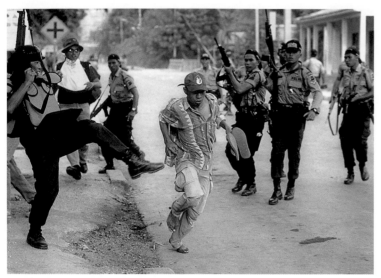

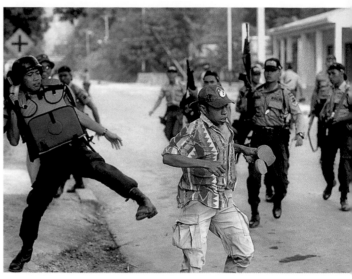

· John Stanmeyer
USA, Saba Press Photos for Time

3RD PRIZE STORIES

Bernardino Guterres is shot by Indonesian police in Dili, East Timor. In August, residents of East Timor voted to end Indonesian occupation of the island. Four days before the election, violence broke out between pro-independence supporters and the anti-independence militia. During one of the clashes, Guterres, wearing a badge of East Timorese leader Xanana Gusmao pinned to his cap, appealed to Indonesian police standing nearby to intervene. Instead, they turned on him. He was killed by a police bullet.

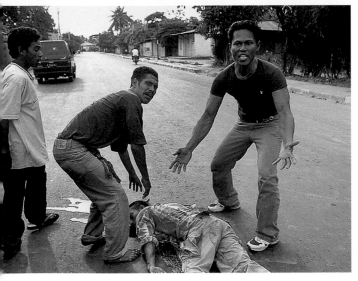

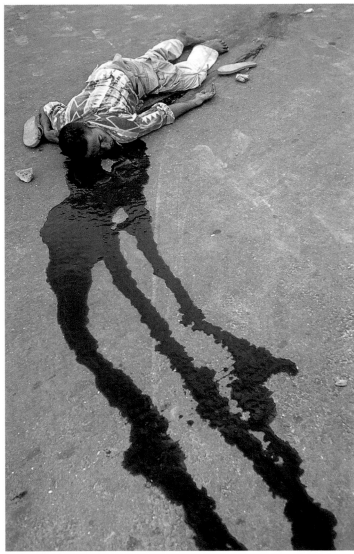

· Paolo Pellegrin
Italy, Agenzia Grazia Neri

1ST PRIZE SINGLES

Having just crossed the border into Albania, Kosovar Albanian refugees arrive at a camp on the road to Kukës in late April. By March 19 peace talks in Rambouillet, France, had broken down, with the Serbs refusing to agree to a NATO peace-keeping force in Kosovo. The failure of diplomacy opened the way for NATO airstrikes. After the first bombardment of Serbia on March 24, Serbian troops and paramilitaries intensified attacks on Kosovo villages, and the exodus to neighboring countries escalated.

· Robert Knoth
The Netherlands, Hollandse Hoogte for Metro

2ND PRIZE SINGLES

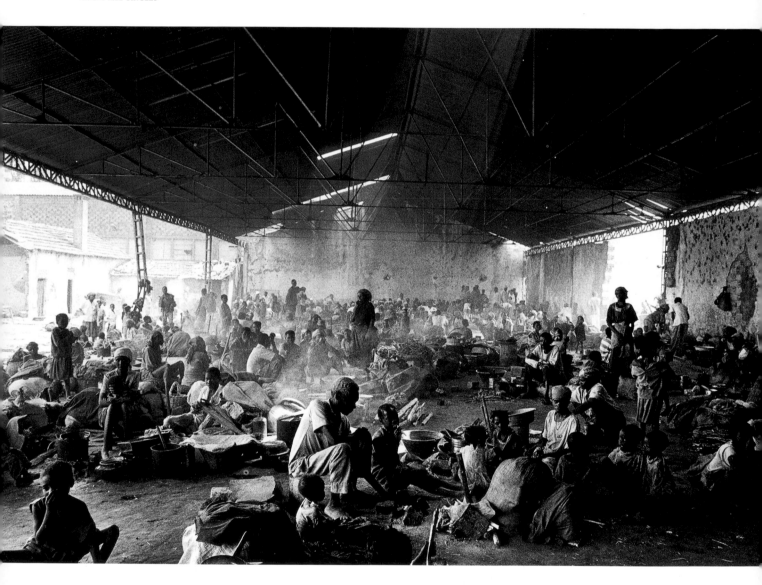

Refugees shelter at a camp in the town of Caála, near Huambo, following renewed hostilities in
Angola. The civil war between Unita resistance forces led by Jonas Savimbi, and the governing
MPLA under President Eduardo dos Santos has gone on almost continuously since indepen-
dence in 1975. Landmines make farming dangerous and villages have been burned. More than
a million Angolans have been made homeless since the collapse of peace agreements, and
renewed fighting at the end of 1998. Many live in abandoned factories, railway stations and
makeshift camps in the cities.

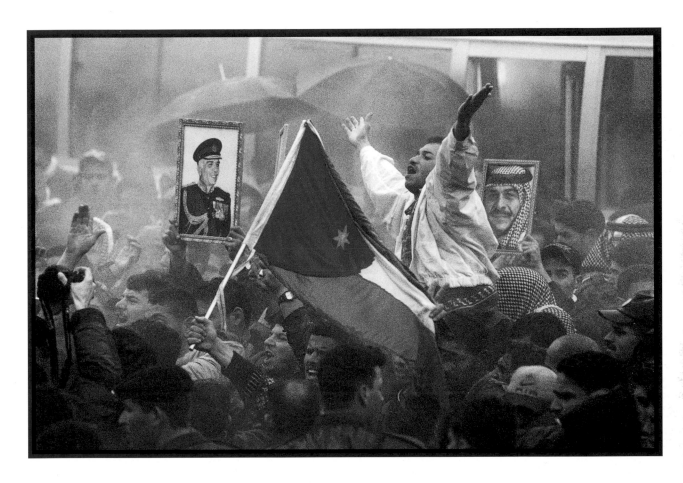

· Tim Zielenbach
USA, Contact Press Images for Stern,
Germany

3RD PRIZE SINGLES

Jordanians mourn the loss of their lead-
er King Hussein outside the King
Hussein Medical Center in Amman. The
king died from cancer in February at
the age of 63. He had been Jordan's
monarch for nearly 47 years and was a
strong advocate of peace in the Middle
East. Grieving Jordanians streamed to
the palace to pay their respects.
Thousands lined the route of the funer-
al procession, and representatives of
countries that traditionally were ene-
mies stood alongside each other at the
ceremony.

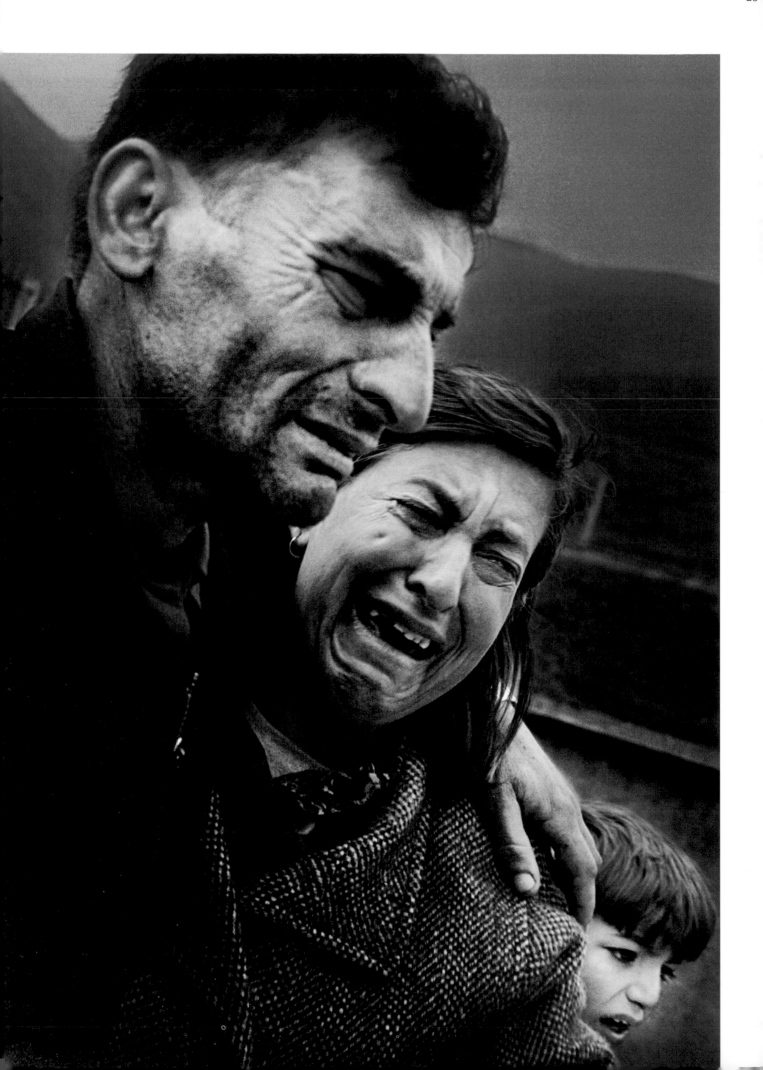

an Grarup
enmark, Ekstra-Bladet

st Prize Stories

om March through May,
thnic Albanians fled
erbian aggression in
osovo in their hundreds
f thousands. After a
ngthy hold-off in the
ce of NATO bombard-
ent, Serbian president
ilosevic finally accepted
peace plan for Kosovo
n June 3. By the end of
e month the refugees
egan to return. Facing
age: A family fleeing
osovo is reunited at the
lbanian border, after
other and child had
rossed alone. Top right:
efugees wait to leave
osovo at Morine on the
lbanian border. Below
ght: A Kosovar soldier,
ho had been a priest
efore he joined the con-
ict, prays on returning
his home country.
tory continues)

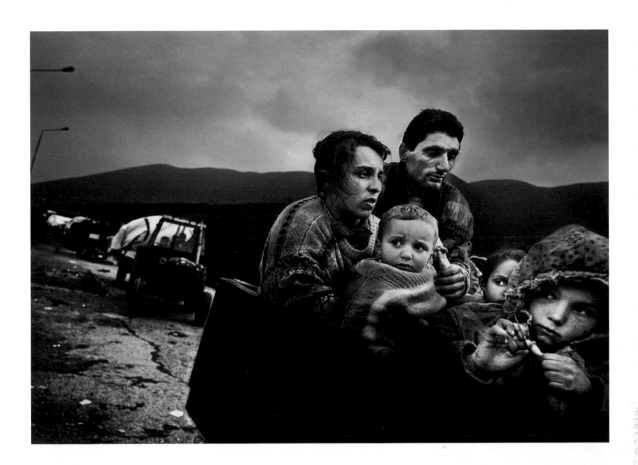

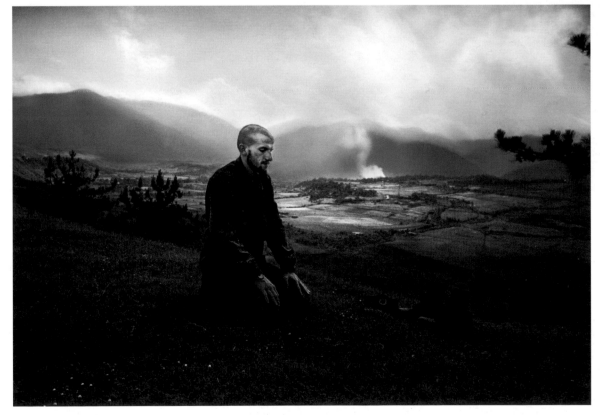

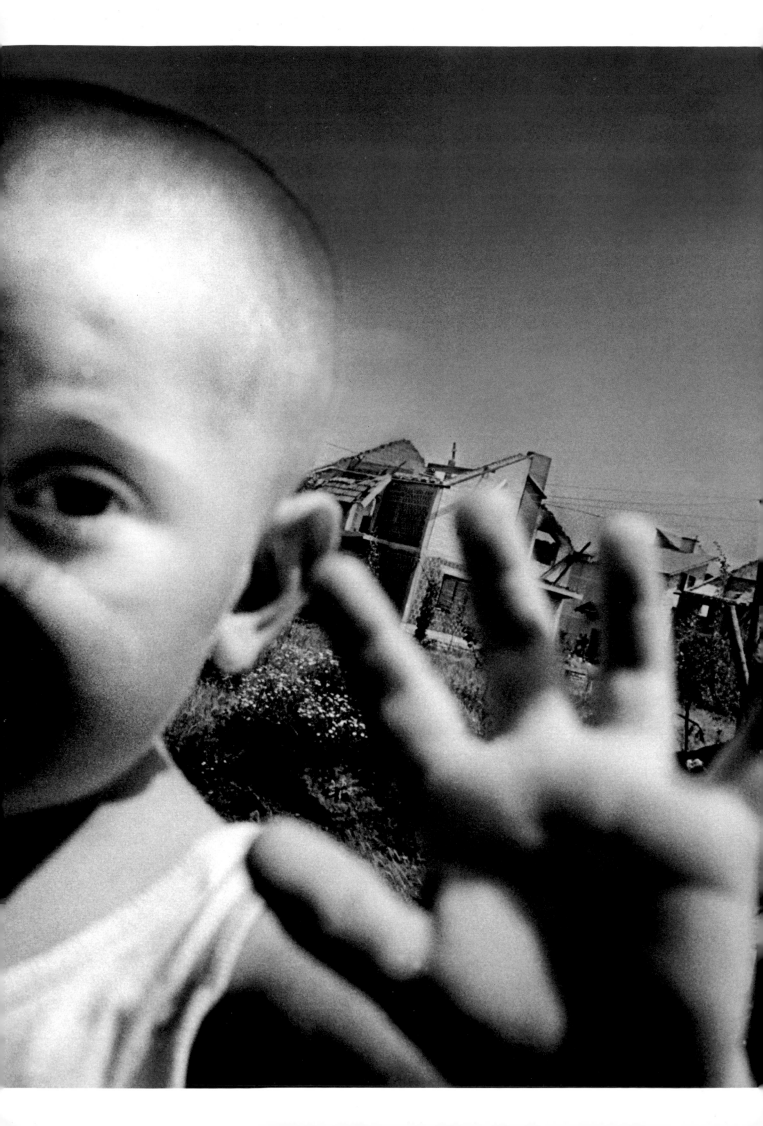

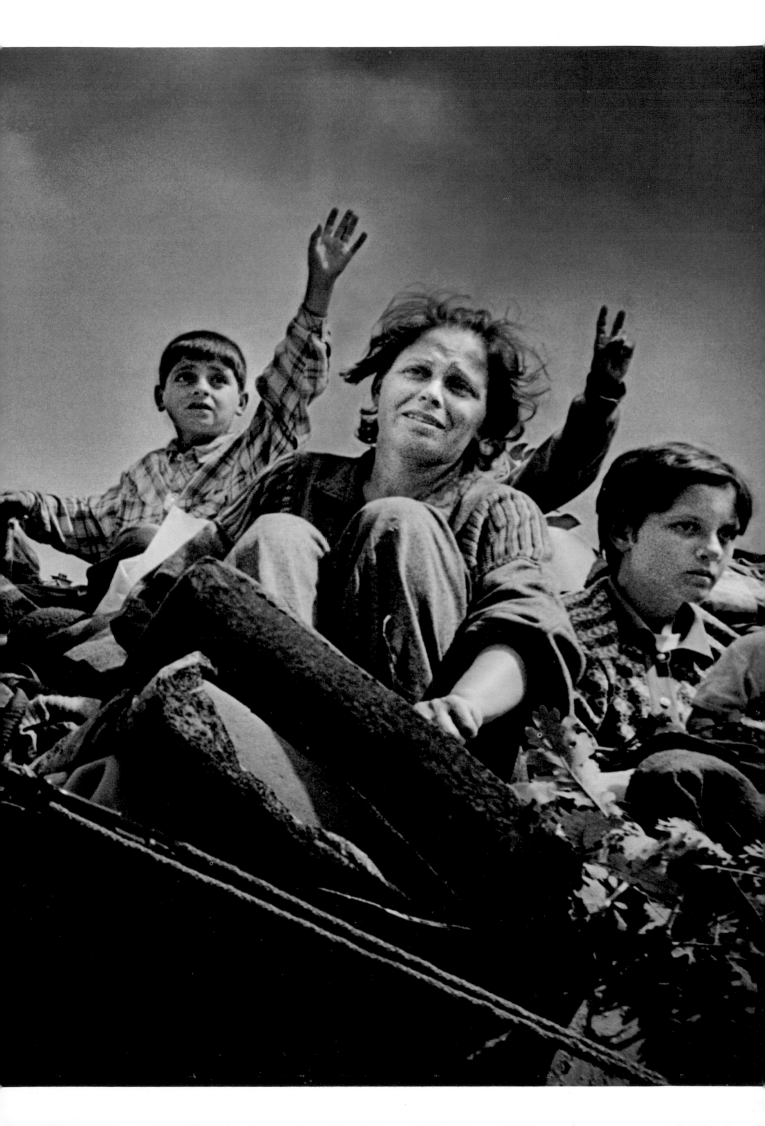

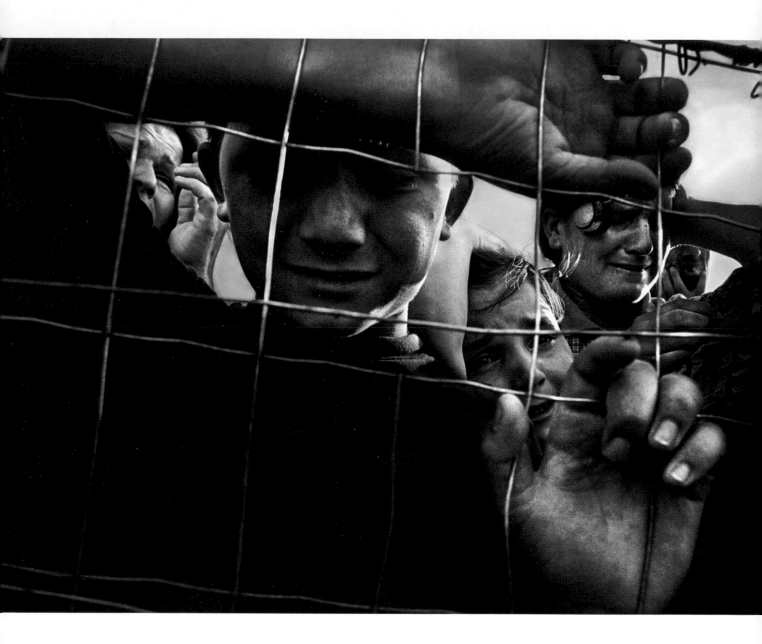

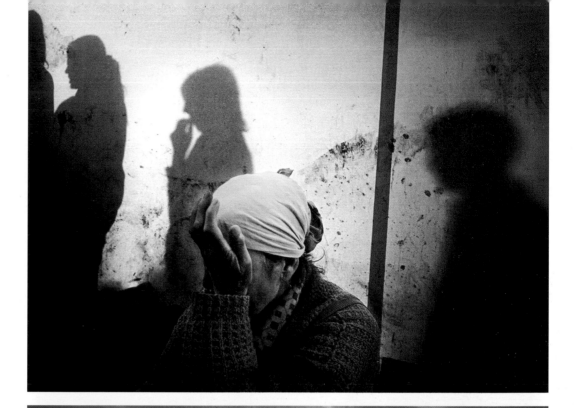

(continued) On June 12, NATO forces made their way into Kosovo from Albania and Macedonia. As Serbian civilians and the Yugoslavian military moved across the border to Serbia, Kosovars began to return, but many found their homes destroyed. Previous page: After hiding for six months in a forest in central Kosovo, this family begins its journey home. Facing page: Refugees at a camp in Kukës, Albania, hear from newcomers that their village has been burned. Middle right: People in an Albanian camp watch as helicopters airlift sick and injured relatives to Italy. Below right: Refugees cheer NATO forces as they arrive at the border between Macedonia and Kosovo.

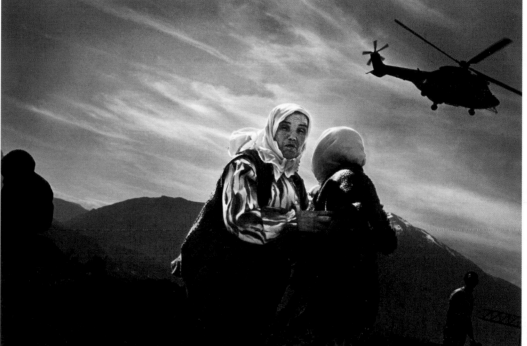

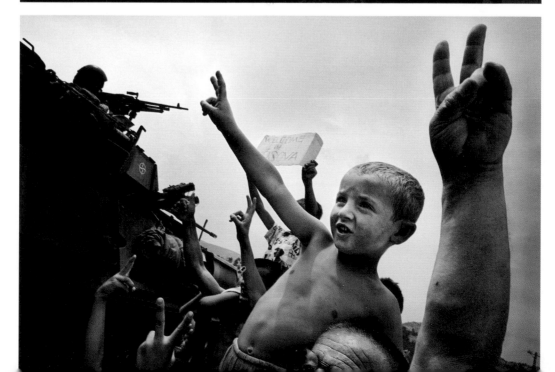

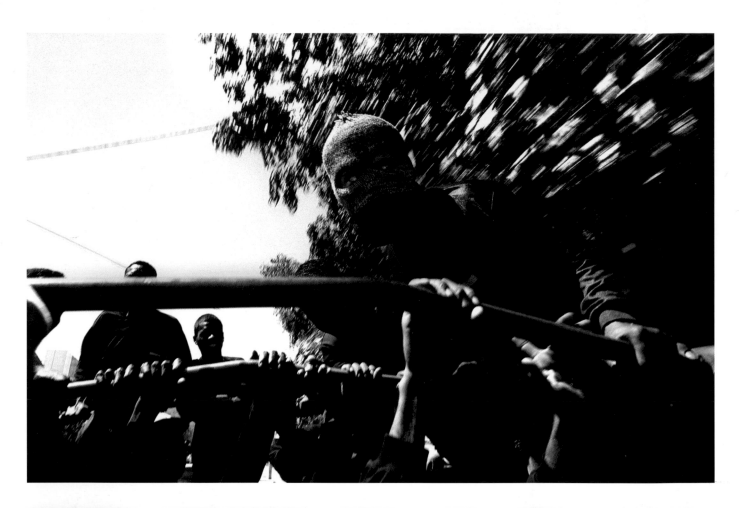

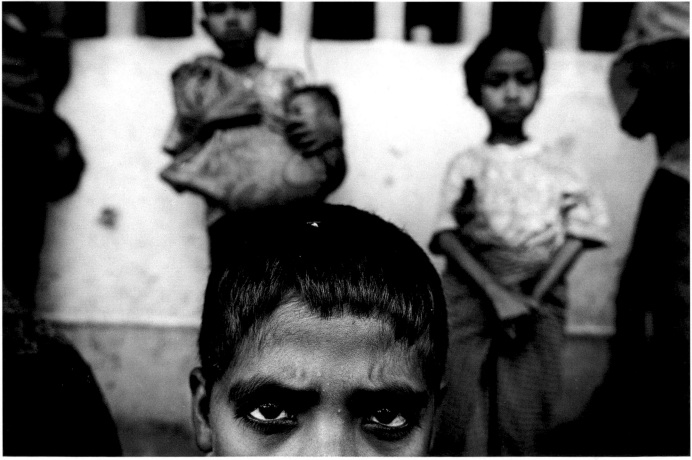

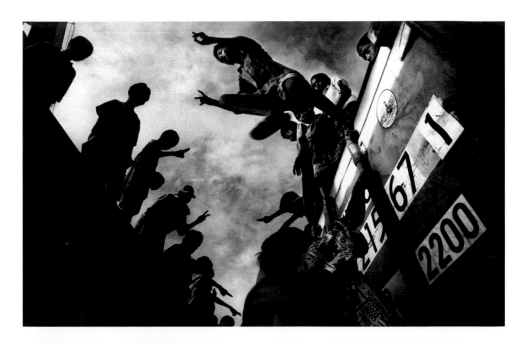

· Dean Sewell
Australia, The Bulletin

2ND PRIZE STORIES

Violence erupted in East Timor following the Indonesian president's announcement in April that a referendum would be held on the question of the island's independence. Pro-Indonesian militia groups clashed with supporters of independence in an attempt to force a 'No' vote. Facing page top: A masked member of the Aitarak militia looks down from the back of a lorry in Dili, the capital. Below: People displaced by the violence gather in a disused building in the hill town of Hatolia. Top right: Boys swarm a United Nations supply ship in Dili. Middle: An East Timorese man is detained after allegedly carrying a concealed weapon. Below: A mother mourns after the body of her son, killed by militia outside Dili, is brought home.

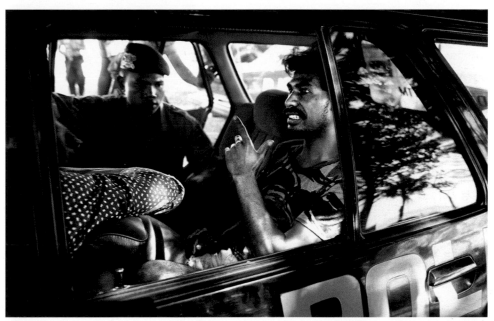

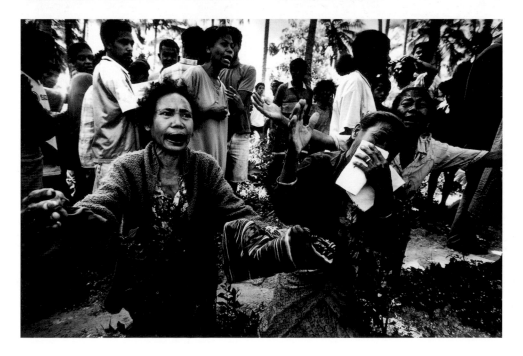

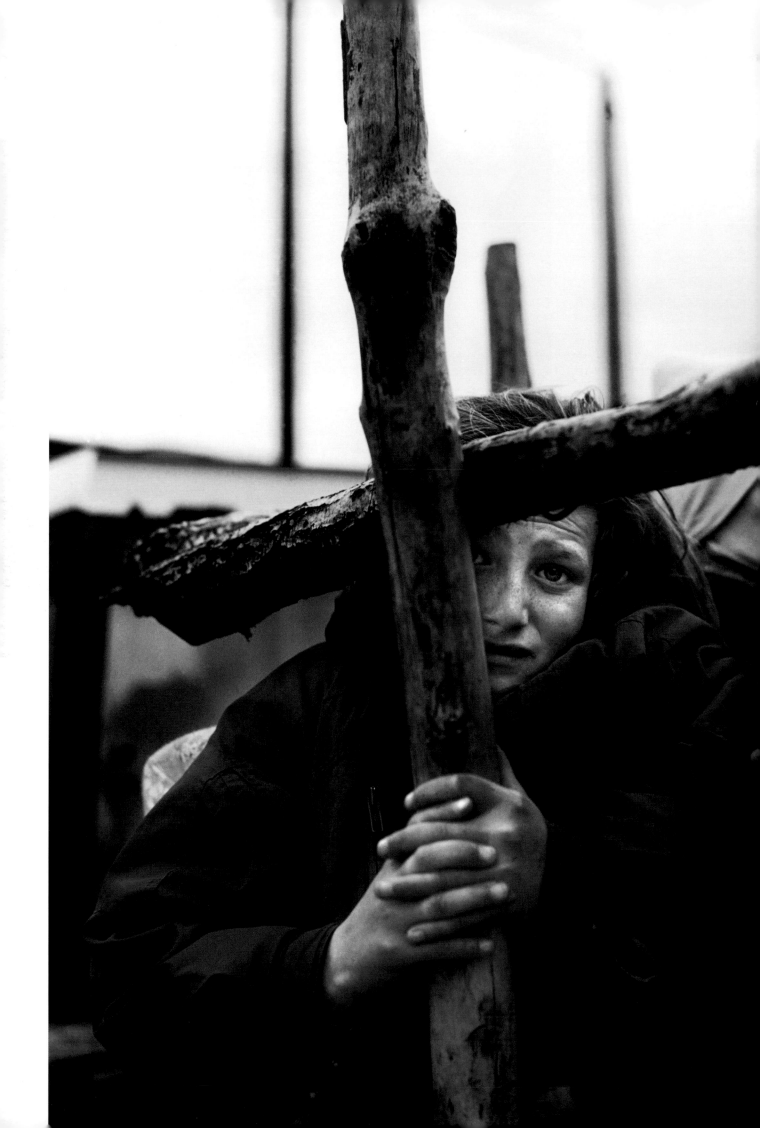

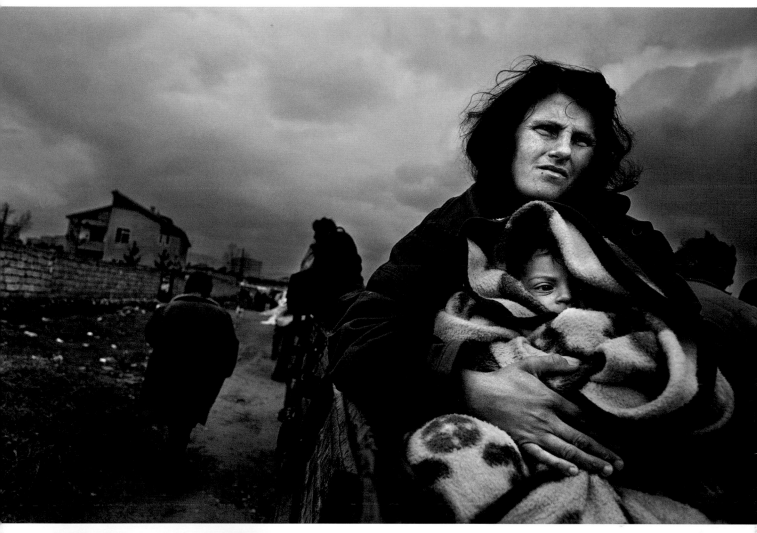

· Claus Bjørn Larsen
Denmark, Berlingske Tidende

3RD PRIZE STORIES

Kosovar refugees in the Kukës area of Albania.
In the first week after the onset of the NATO
offensive against Serbia, 118,000 ethnic
Albanians fled increased Serbian violence in
Kosovo. Governments and aid agencies were
taken by surprise at the volume of the exodus.
UN officials had expected a total of 100,000
people to leave Kosovo, but in the end some
900,000 ethnic Albanians fled the country.
Initially, many refugees headed to Macedonia,
but the authorities feared further ethnic ten-
sion as there was already a sizable Albanian
minority living there. Extra camps were set up
in Albania, where more than 50,000 people
ended up near the town of Kukës. Facing
page: A girl arrives in Kukës early in April,
soon after the beginning of the NATO bom-
bardment. This page: A mother and her child
move further into Albania after spending the
night outdoors. (story continues)

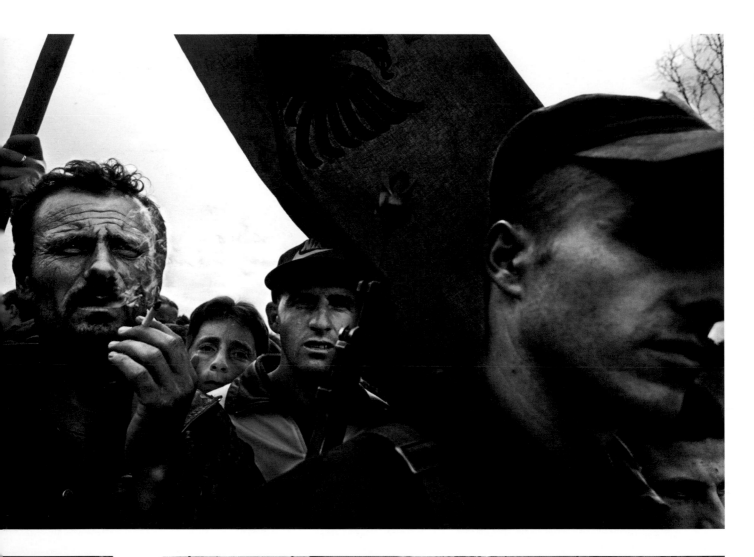

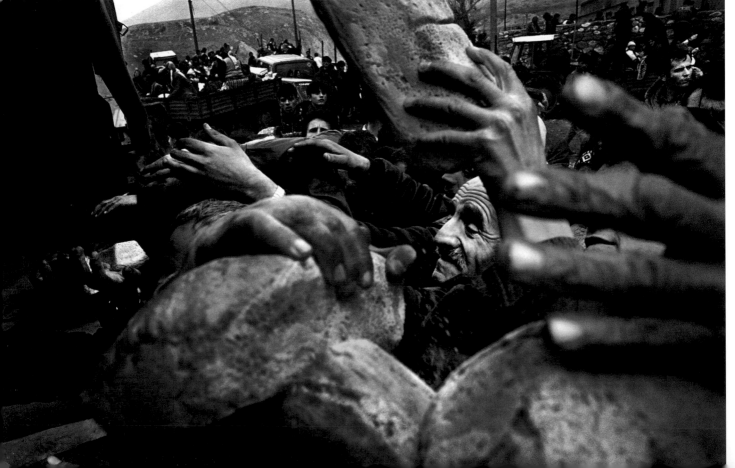

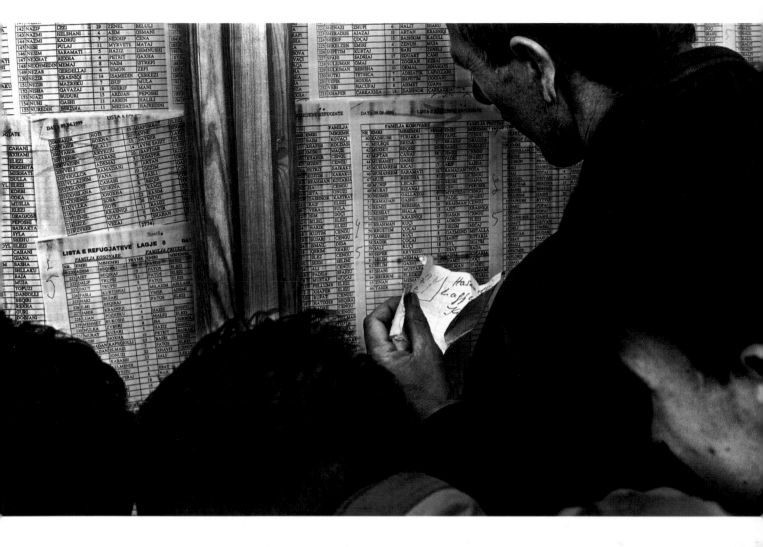

(continued) It is estimated that the vast majority of the 1.8 million people living in Kosovo had to leave their homes during the conflict. There is no way of knowing how many people were trapped inside the country itself, hiding out in forests and in the hills. Facing page top: In June, members of the Kosovo Liberation Army return from the hills, where they had been based during the conflict. Facing page below: Refugees scramble for limited bread rations. Above: People scan a Red Cross bulletin board posted outside a refugee camp in Kukës for the names of friends and relatives.

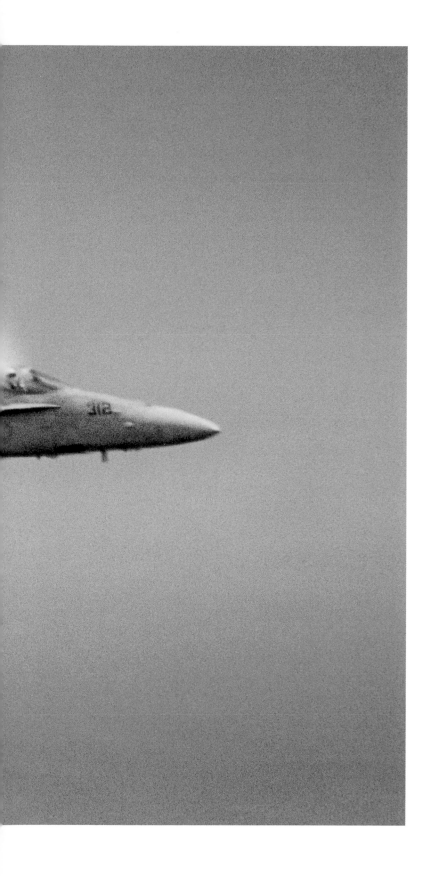

· John Gay
USA, US Navy/Sports Illustrated

1ST Prize Singles

A US Navy F/A-18 'Hornet' creates
a water vapor cloud during a
flight at the speed of sound over
the Pacific Ocean on July 7. The jet
was assigned to Strike Fighter
Squadron One Five One, at the
time deployed with the aircraft
carrier USS Constellation. The
shot was taken from the 0-10
level weather deck, the highest
vantage point on the ship.

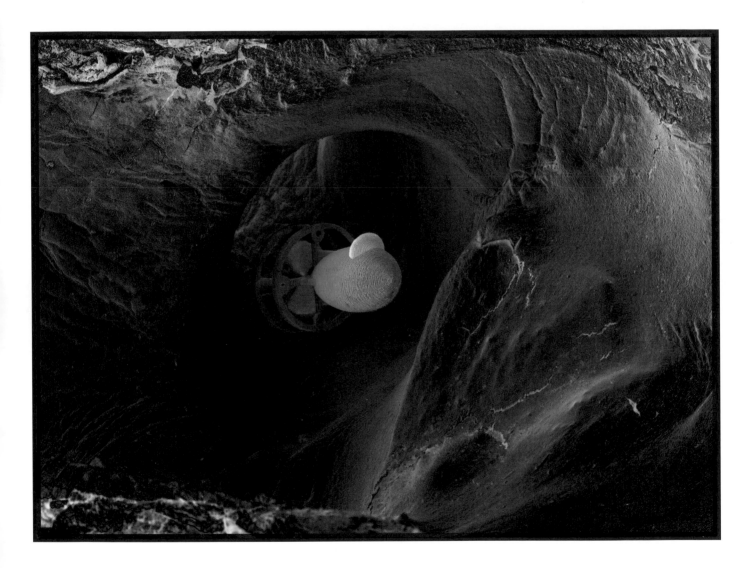

· **Oliver Meckes & Nicole Ottawa**
Germany, Eye of Science for Capital

2ND PRIZE SINGLES

A micro-submarine travels through a human artery. The submarine was made by a microtechnology firm in Duisburg, Germany, using a technique by which three-dimensional objects can be created directly from a computer program, by means of laser beams. Equipped with appropriate instruments, such submarines will in future be able to detect defects in internal organs.

· Michael Adaskaveg
USA, Boston Herald

3RD PRIZE SINGLES

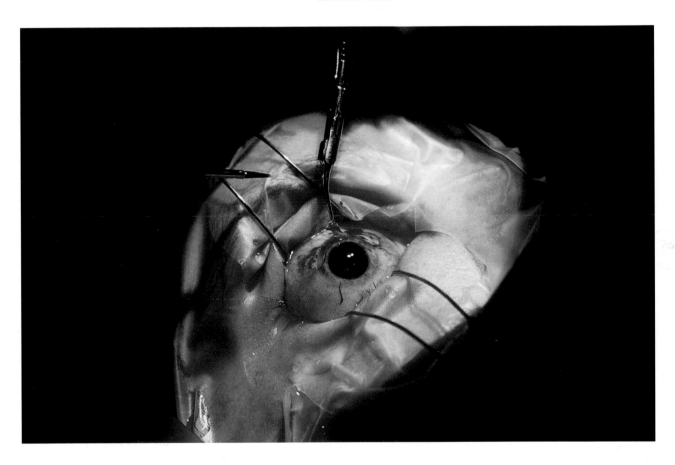

The sight in Michelle Pevarnik's right eye is saved by a tissue transplant from her sister Brenda. Dr Stephen Foster, a professor at Harvard Medical School in the USA, harvested stem cells — factories that produce various types of cells — from the surface of Brenda's eye under local anaesthetic. Normally, the body replaces these cells regularly, but in Michelle's case they were damaged and had to be replaced.

· Peter J. Menzel
USA, for Stern, Germany

1ST PRIZE STORIES

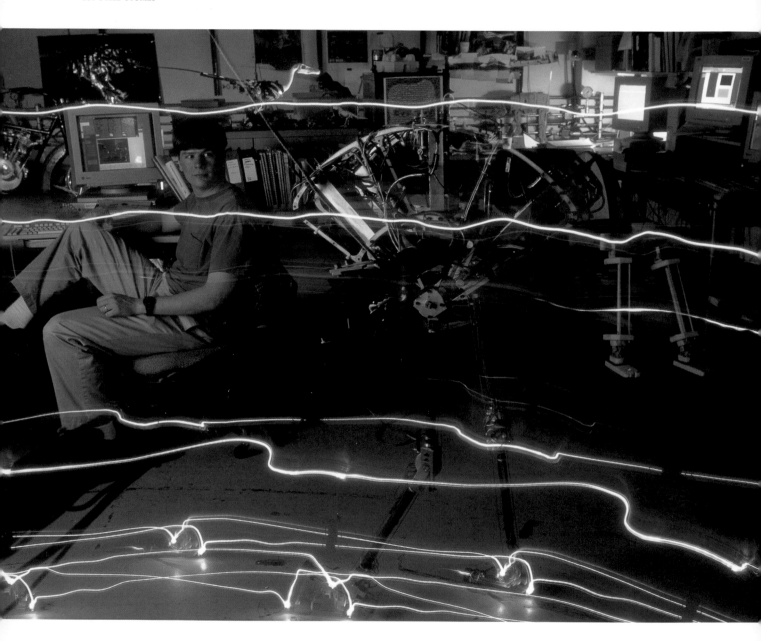

Robotics institutes around the world come up with inventions that have both practical application and popular appeal. Above: Graduate student Jerry Pratt at the MIT Leg Lab, Boston, controls Spring Flamingo, the first walking robot with fully jointed ankles. It can walk at human pace and manage slopes of 15 degrees. Top right: Professor Fumio Hara of the Science University of Tokyo poses with a face robot (stripped of its latex skin) which can recognize expressions and make faces of its own. Middle: The self-supporting Honda P-3 humanoid. Below: Robosaurus, an electro-hydromechanical monster, breathes fire and crushes cars in Las Vegas. Next page: This face robot from the Science University of Tokyo has electric actuators beneath its silicon skin that change facial expressions much as human muscles do.

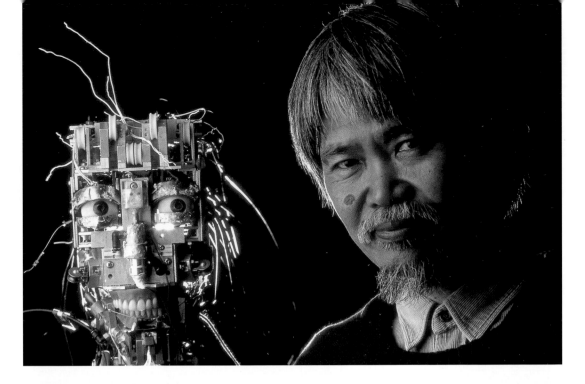

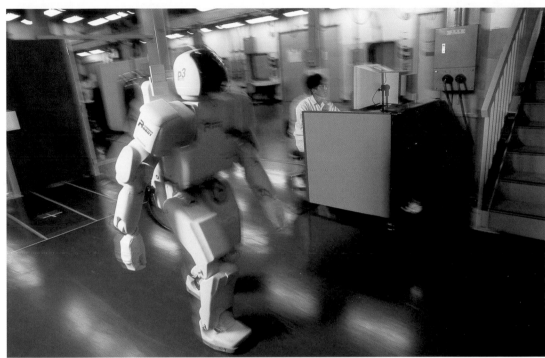

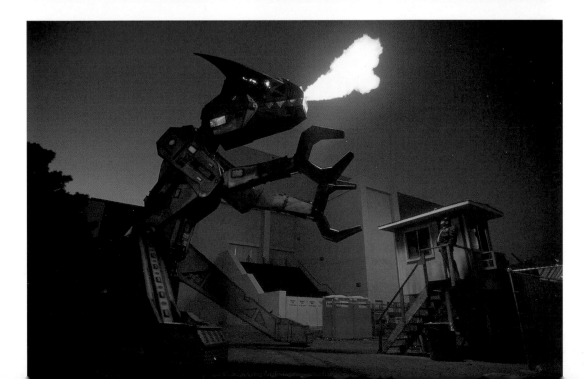

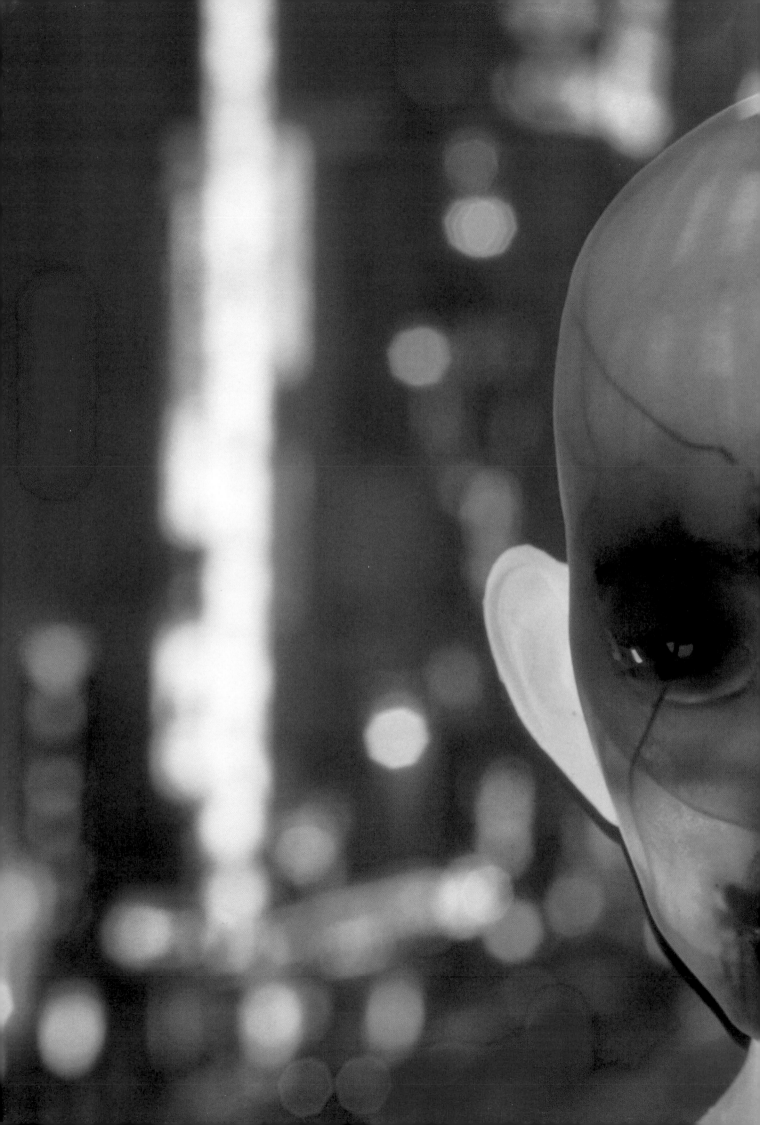

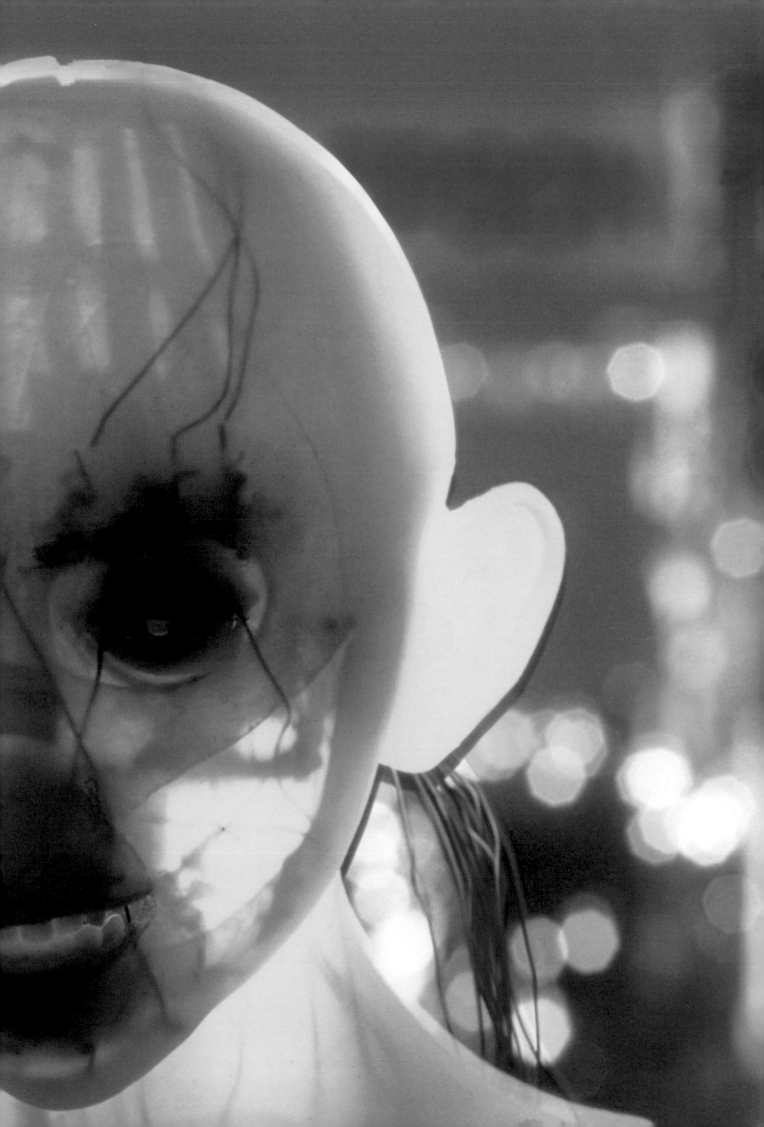

· Joe McNally
USA, for National Geographic Magazine

2ND PRIZE STORIES

Astronomers claim the universe itself is their laboratory. The link to that laboratory is made at observatories around the world. Below: An observer in New Mexico studies the Galaxy. Right, from top: The Very Large Array telescopes in New Mexico gather faint radio signals from the cosmos. The Keck Observatory on Mauna Kea, Hawaii. The Very Large Telescope (VLT) in Chile captures some of the best images of any telescope on earth.

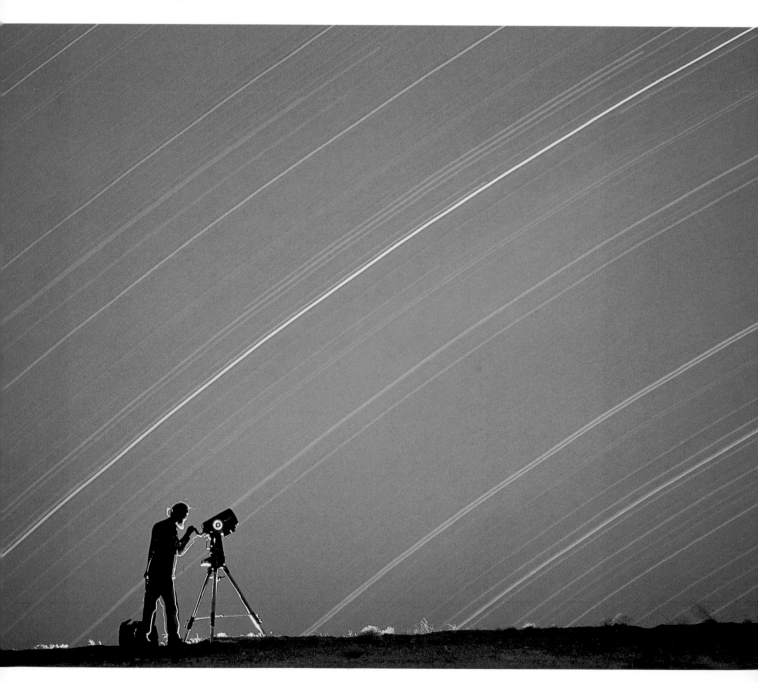

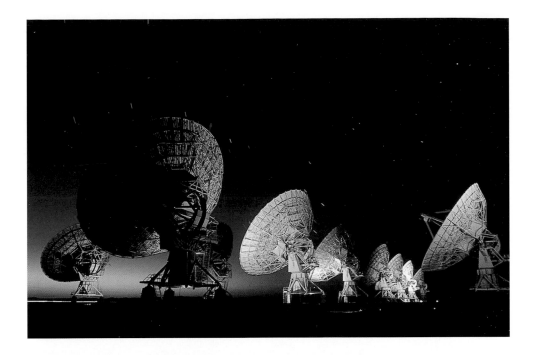

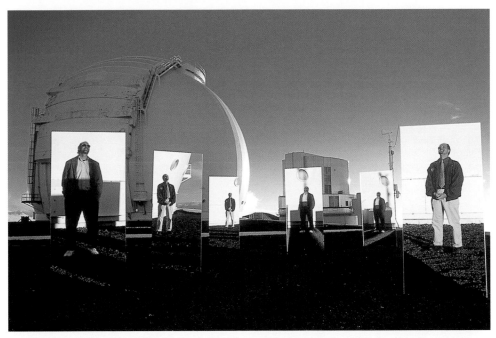

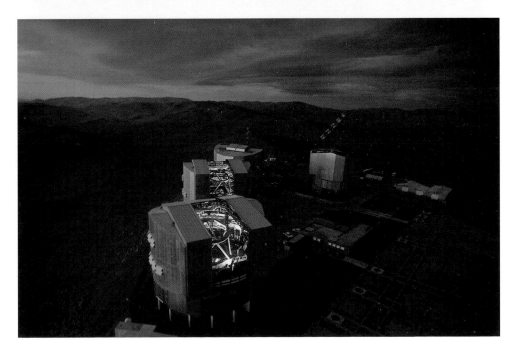

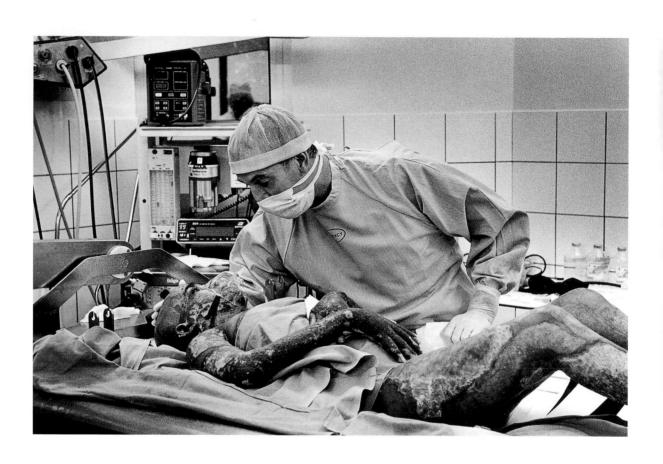

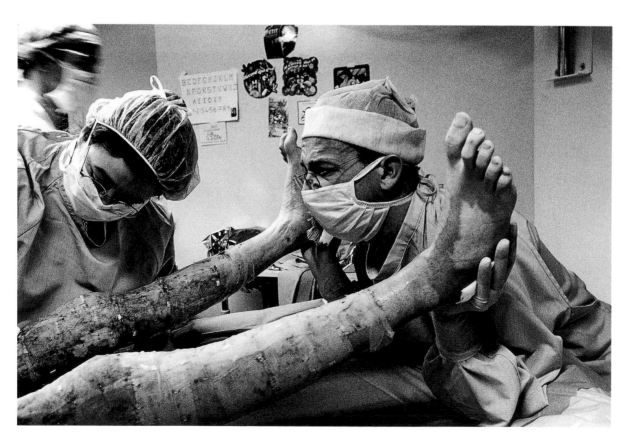

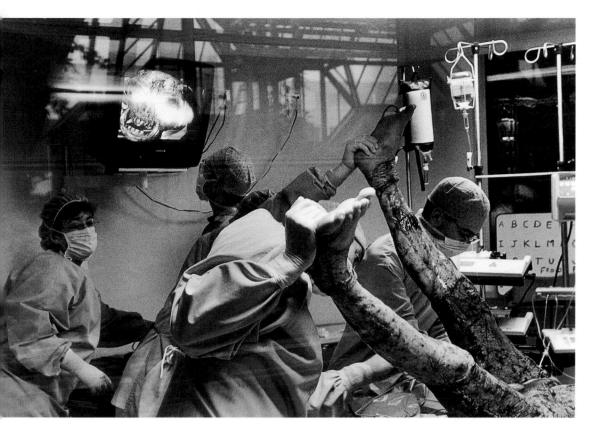

· Raphaël Gaillarde
France, Gamma

3RD PRIZE STORIES

Doctors in a highly specialized Emergency Burns Unit at a hospital in Clamart, France, carry out a new treatment for severe burns that involves grafting skin grown in a laboratory from the patient's own cells. Transplants of skin from another person result in rejection. Patients have to be kept in exceptionally sterile conditions, as the body has lost its protective layer. Clockwise from top left: The doctor assesses a patient's condition and tries to illicit response to voice and touch. A patient is made ready to receive a graft of cultivated skin. Following the transplant, it takes around five weeks before doctors know whether the tissue has attached itself properly. Bandages are removed for an initial assessment after nine days. (story continues)

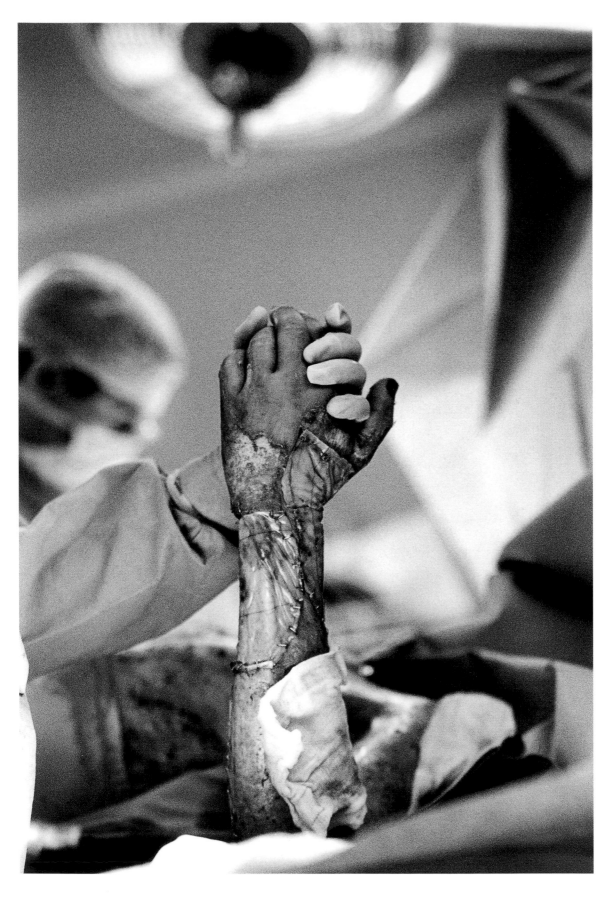

(continued) Even patients with 90 percent burns usually have small patches of healthy tissue, such as between the toes. This skin is sent to a laboratory in Boston, USA, where epidermal cells capable of quick reproduction are extracted and cultivated. In less than three weeks, a piece of skin 10,000 times the size of the original sample has grown. This can survive for only 24 hours outside the lab, so must be rushed to the hospital. Left: A temporary skin layer, usually obtained from a dead donor, must first be removed before patches of skin cultivated from the patient's own cells can be applied.

Sports

· Eric Larson
USA, Fort Lauderdale Sun-Sentinel

1ST PRIZE SINGLES

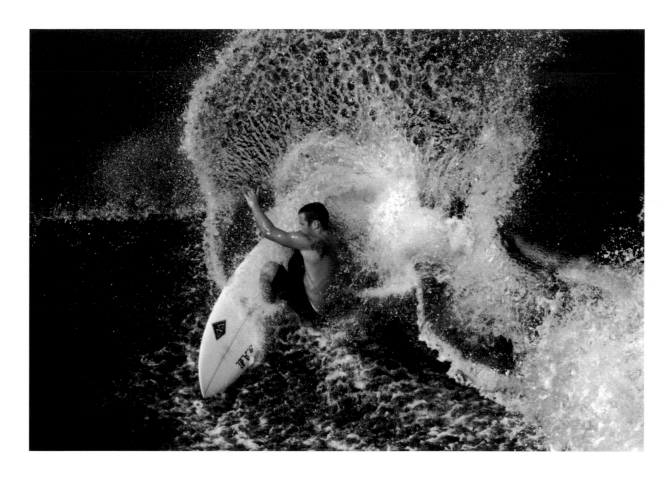

A surfer carves his way
through a breaking wave off
Playa de Hermosa in Costa
Rica. Large numbers of Florida
surfers travel to Costa Rica, as
the waves are good and life is
cheaper than the west coast
of the United States.

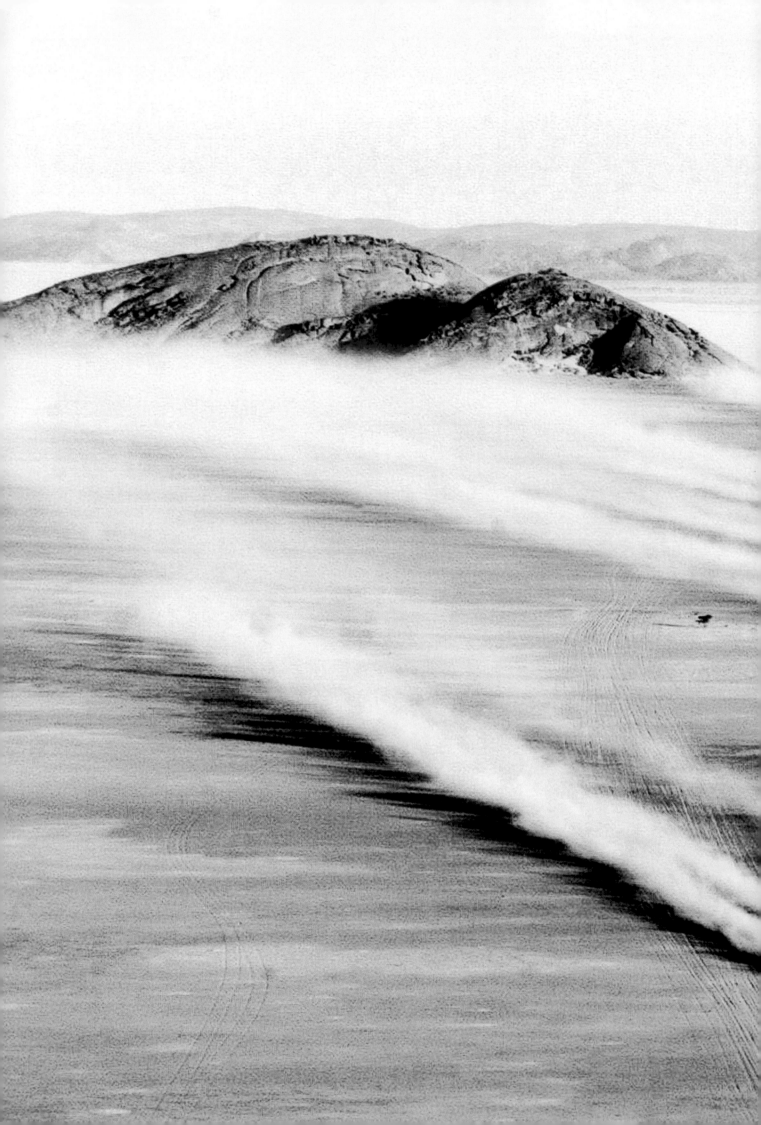

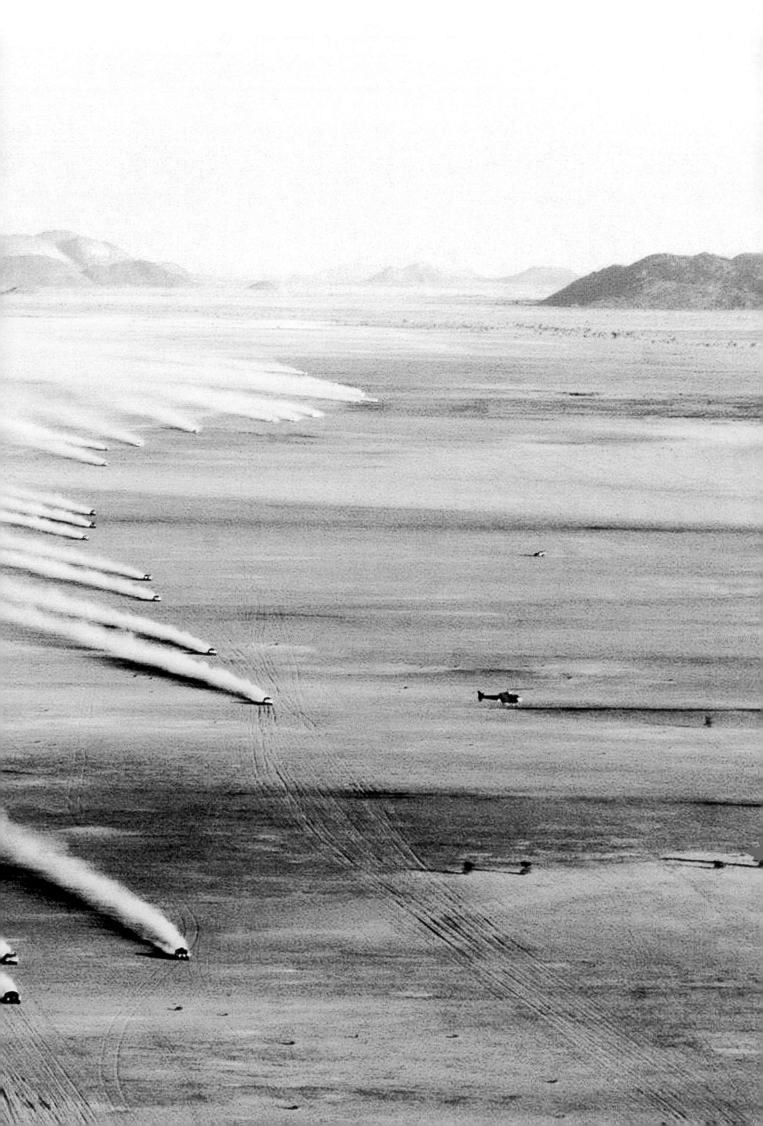

· **Bruno Fablet**
France, L'Equipe

2ND PRIZE SINGLES

Cars streak across the Mauritanian desert on the Bîr
Mogreïn/Atâr leg of the Paris-Dakar Rally, which this
year started from Granada. The fifth leg of the race
begins with a mass start on a wide piste, and covers
625 kilometers. The rally was won by the Frenchman
Jean Louis Schlesser with co-driver Philippe Monnet.

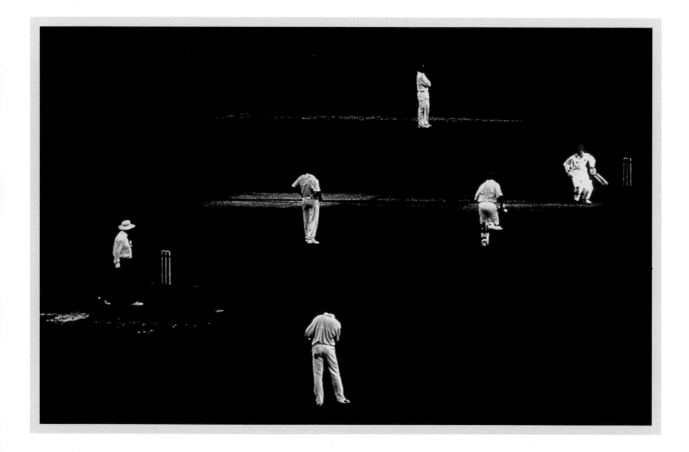

· **Scott Barbour**
New Zealand, Allsport

3RD PRIZE SINGLES

A South Australian batsman sets off for a run as light fades towards the end
of the second day's play during the Sheffield Shield cricket match in Sydney,
Australia. The Sheffield Shield is Australia's major domestic cricket competi-
tion. The strategic game of cricket is a slow-moving one. South Australia
eventually emerged victorious over opponents New South Wales on the
fourth day of play.

· Harald Schmitt
Germany, Stern

HONORABLE MENTION SINGLES

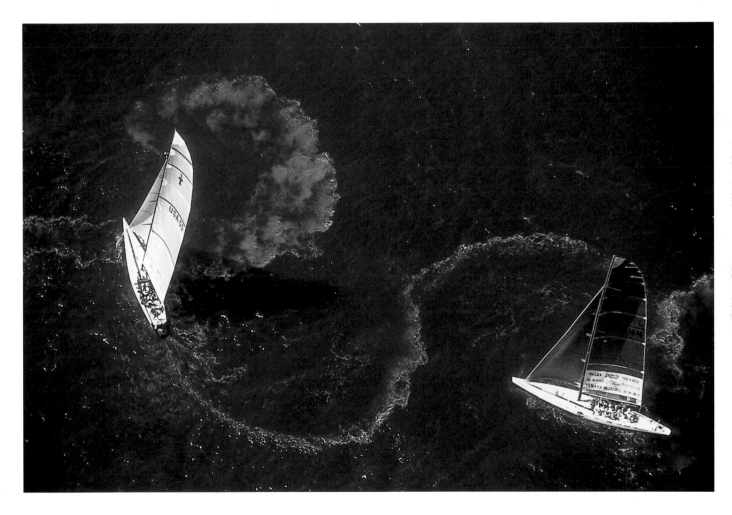

Crews of two yachts play tactical games to get into the best starting position during the America's Cup, one of the sailing world's most prestigious competitions. In the first rounds of the contest, yachts race against each other in twos. The winner is the first past the finishing line, so getting off to a good start is crucial.

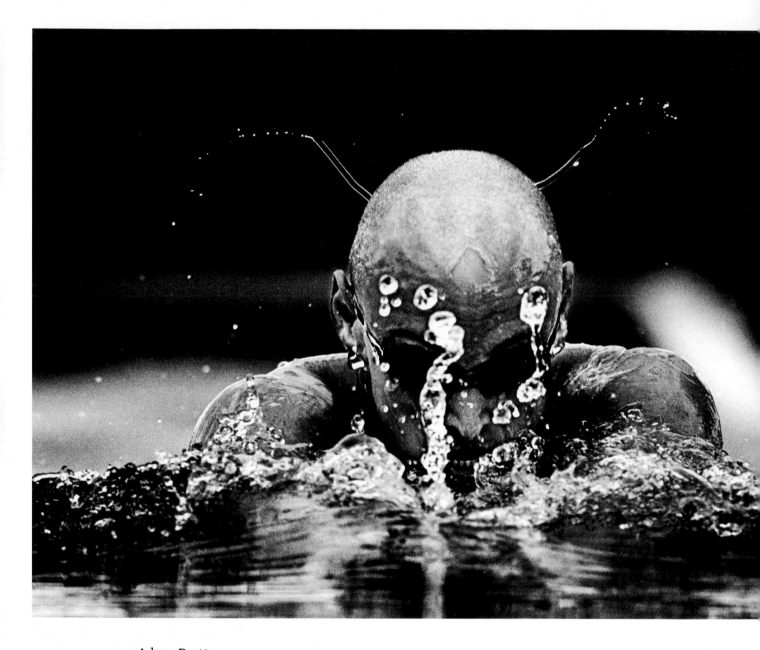

· Adam Pretty
Australia, Allsport

1ST PRIZE STORIES

A portfolio of sportsmen and sportswomen in action. Above: Phil Rogers races in the 50-meters breaststroke during the One Summer multi-sports event at Cronulla Beach, Sydney. Top right: A gymnast on the Uneven Bars at the Australian Gymnastics Championships in Sydney. Below right: New Zealand's Rip Curl Heli Challenge, an extreme skiing event, is accessible by helicopter only. (story continues)

(continued) Left: Xue Sang of China somersaults past a diving poster display during the final of a diving contest in Sydney. Right: A gymnast performs her routine with a ball at the Australian championships in Sydney.

· Tim Hetherington
UK, Panos Pictures

2ND PRIZE STORIES

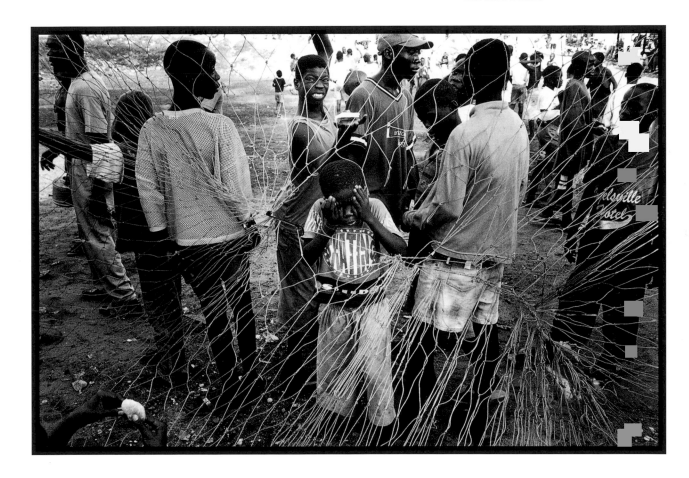

Football provides some relief to children traumatized by civil war in Liberia. The war went on for seven years in the 1990s, leaving a broken economy and continuing skirmishes in the north of the country. Thousands of children fought in the war. Football offers displaced children some focus and stability. Makeshift football stadiums have sprung up all over the capital Monrovia. Here street children play around in the nets before the start of a match. (story continues)

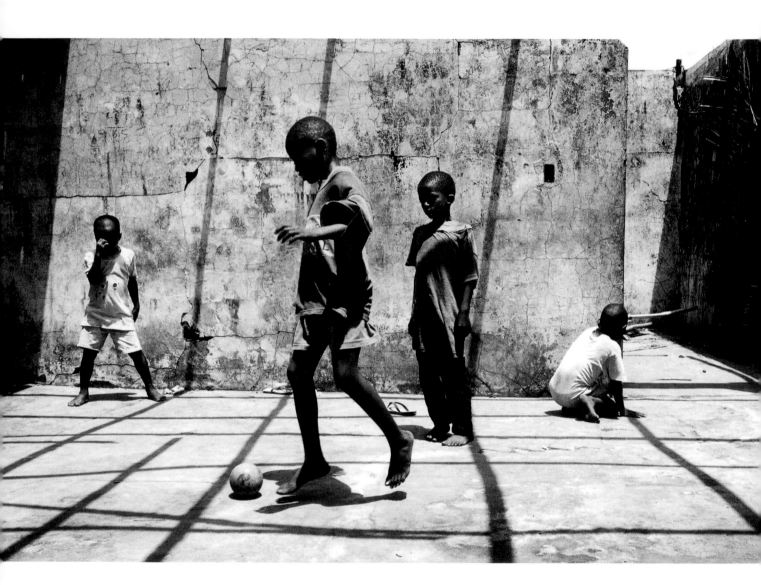

(continued) The Millennium Stars is a team made up of former child-combatants. It was formed two years ago with the idea that football helps develop an alternative sense of pride, in sports skill rather than in violence. Above: Children play in the bombed-out ruins of Monrovia. Top right: Members of The Millennium Stars say a prayer before training. Middle: Fokpa Sumo stretches during practice. Below: Crowds watch a knock-out match in Monrovia.

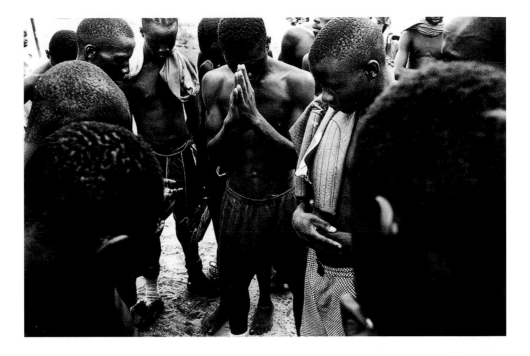

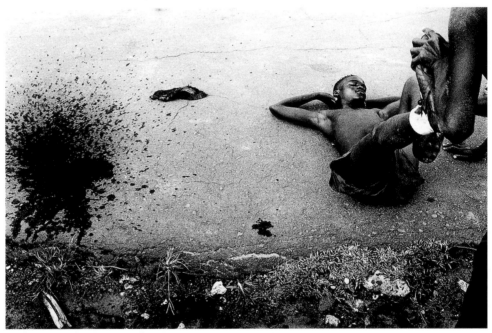

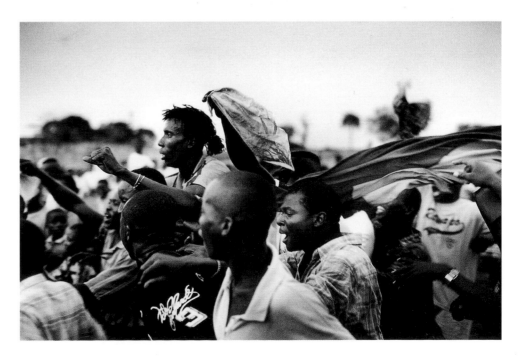

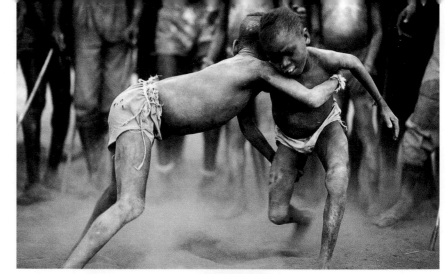

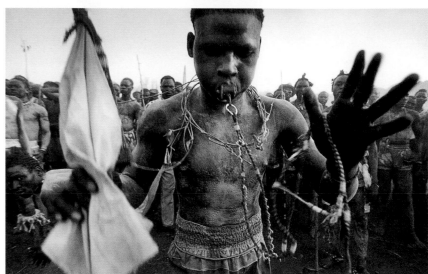

· David Stewart-Smith
UK, Katz Pictures

3RD PRIZE STORIES

Nuba wrestlers join in a three-day contest at Shatt Safiya village in the Nuba Mountains in southern Sudan. The festival was held to commemorate the great champion, Jumping Donkey, who had died six months earlier at the age of 95. The village is in the same region where, half a century ago, the photographer George Rodger took a classic photo of a Nuba wrestler carrying another on his shoulders. Today, the Nuba are struggling to preserve their culture from forced assimilation into the dominant Islamic culture of the north. Top: Children wrestle in their own competition before the adults. Second from top: Singing and dancing precedes the contest. Facing page: Champion Tutu Jok is carried shoulder high.

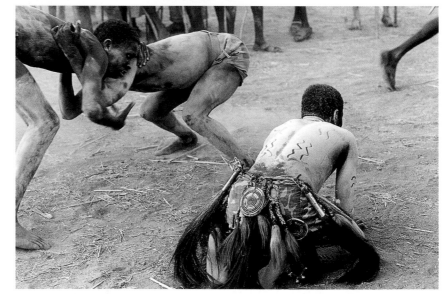

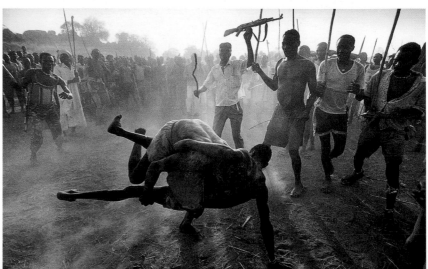

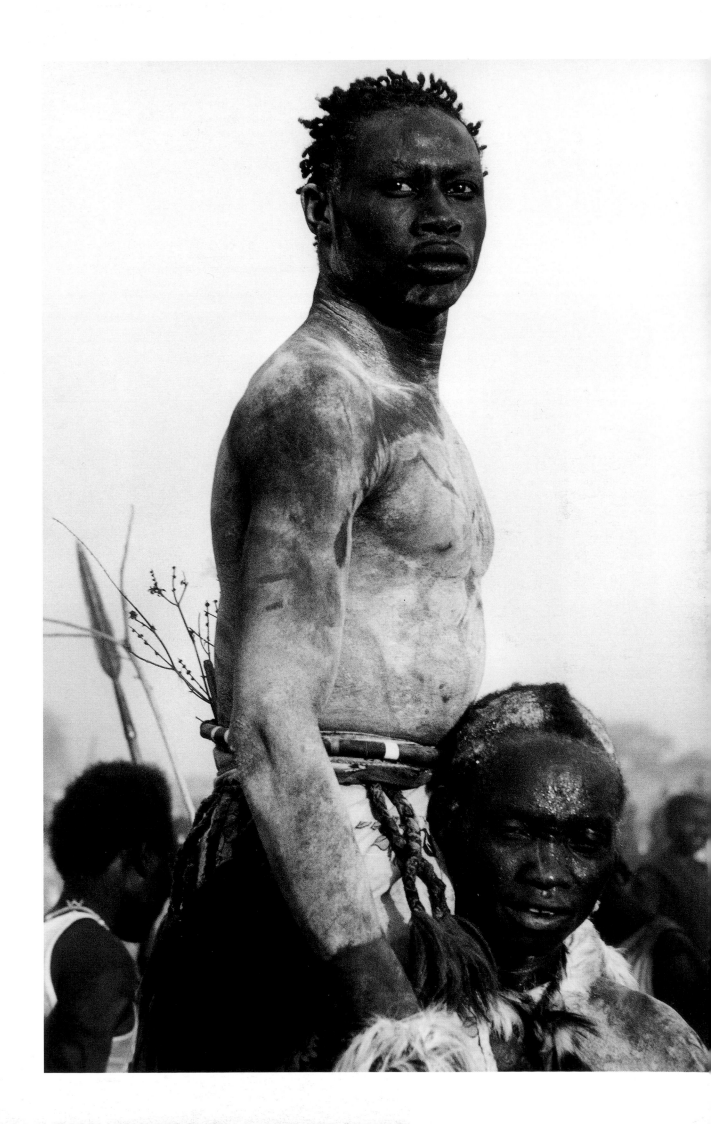

The Arts

· **Kalpesh Lathigra**
UK, for The Independent

1st Prize Singles

Kathakali actors prepare to go on stage at the Globe Theatre in London. The theater is a replica of the original Globe, where Shakespeare's plays were performed 400 years ago. The Annette Leday Dance Company, an Indo-French collaboration of dancers, perform a Kathakali version of Shakespeare's *King Lear*. Kathakali is a centuries-old South Indian dance form in which vivid use of make-up, costume, and delicate eye and hand movements play an integral part.

· **John Peter Hogg**
South Africa, The Sunday Independent

2nd Prize Singles

Nelisiswe Xaba marks her footsteps by sprinkling flour over her feet as she moves about the stage in a dance by Robyn Orlin at the Dance Umbrella festival in Johannesburg, South Africa. Dance Umbrella is a month-long annual event, now in its twelfth year, that showcases contemporary dance from the region, as well as from abroad.

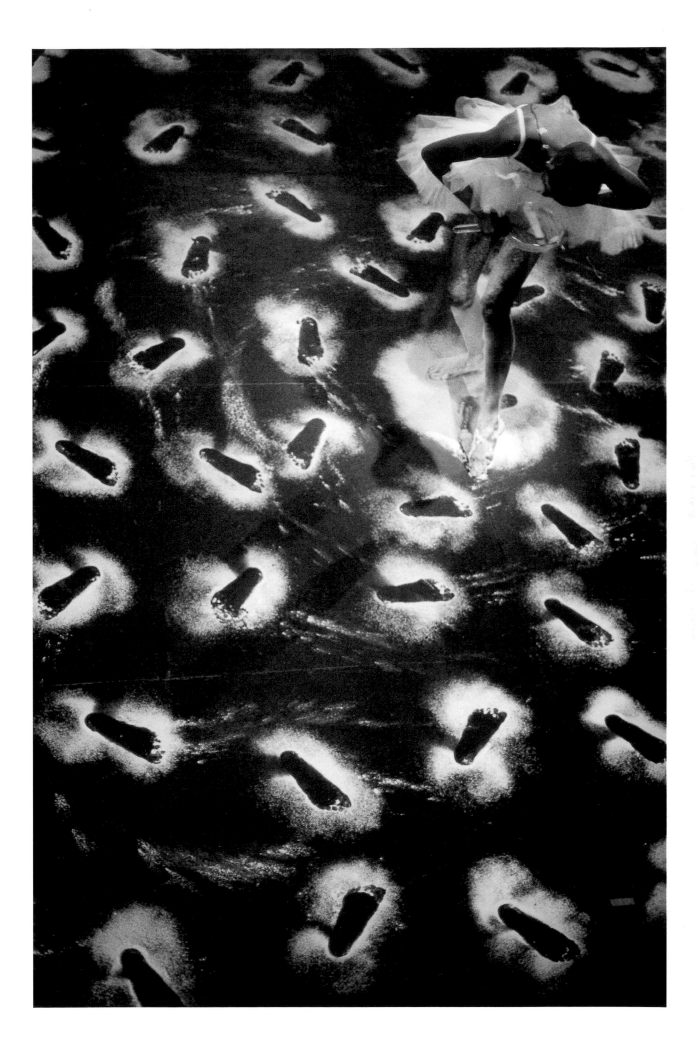

· Cecilia Larrabure Simpson
Peru, El Comercio

3RD PRIZE SINGLES

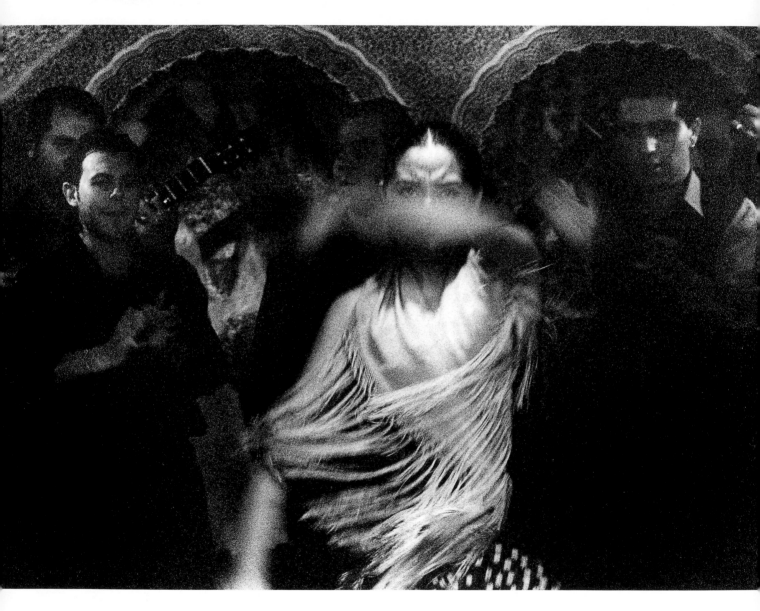

Flamenco dancer Silvia Chanivet performs
with her group in Barcelona, Spain. The
group comes from Cádiz, in Andalucía,
southern Spain, where flamenco has its
heart. But they spend eight months a year
performing in the north, primarily for
tourists.

· Wang Yao
People's Republic of China, China News Service

1ST PRIZE STORIES

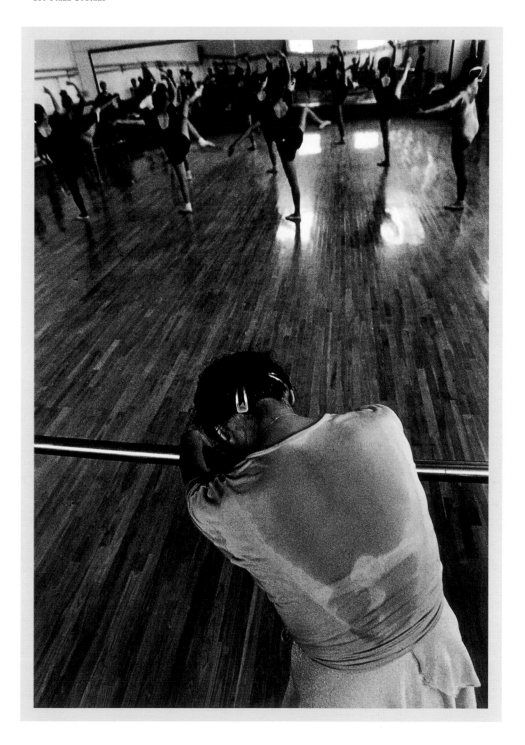

Dancer Chen Ailian, now 60, prepares for her comeback. In her youth Chen
was known as the 'Queen of Chinese Dance', and won four gold medals in an
international competition. But in 1966, during the Cultural Revolution, she
was forced to abandon her career and to go and live in the country. Returning
to the profession in the 1980s, she opened a private academy to promote
Chinese dance. In 1999 she made a stage comeback. (story continues)

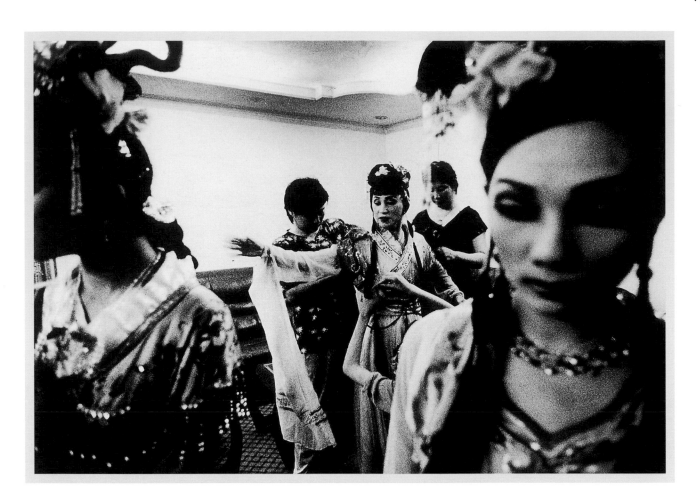

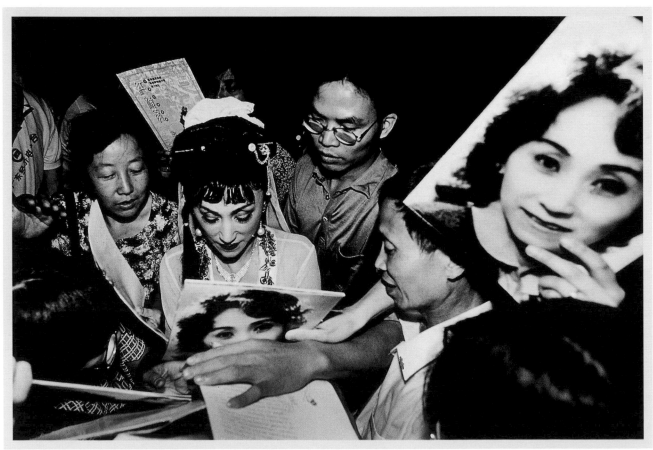

(continued) Chen took the leading role, of a 15-year-old girl, in the classical dance *Dreams of the Red Mansion*. Fans were enthusiastic, but the physical demands of the role, and a tour that covered a city a day, took their toll.

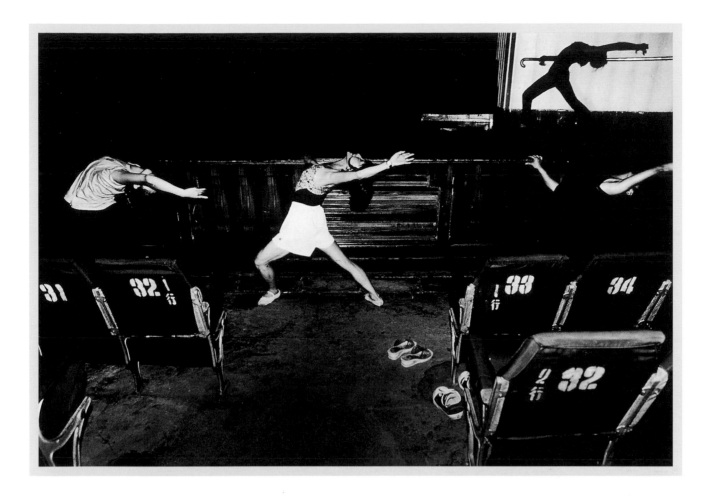

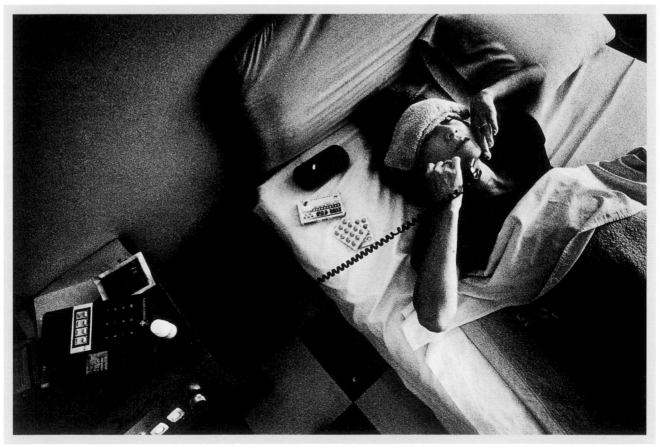

· Isabel Muñoz
Spain, Agence Vu, France

2ND PRIZE STORIES

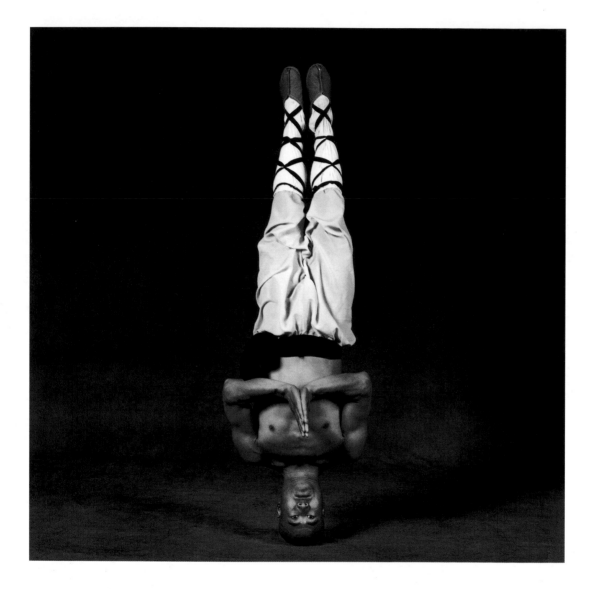

At the Shaolin temple in the Henan province of China, men practice a partic-
ular form of *wushu* ('war art'). The 18 basic positions of what some call
Shaolin Kung Fu are inspired by the movement and agility of animals.
Legend has it that over 1,500 years ago, the Buddhist monk Bodhidharma
introduced Indian principles of meditation and yogic calisthenics to the
Shaolin monks' own tradition, to help them endure the physical demands of
long periods of meditation. Over the centuries, the men of the Shaolin tem-
ple added skills from different martial arts to Bodhidharma's original system,
and became renowned as warrior-monks.

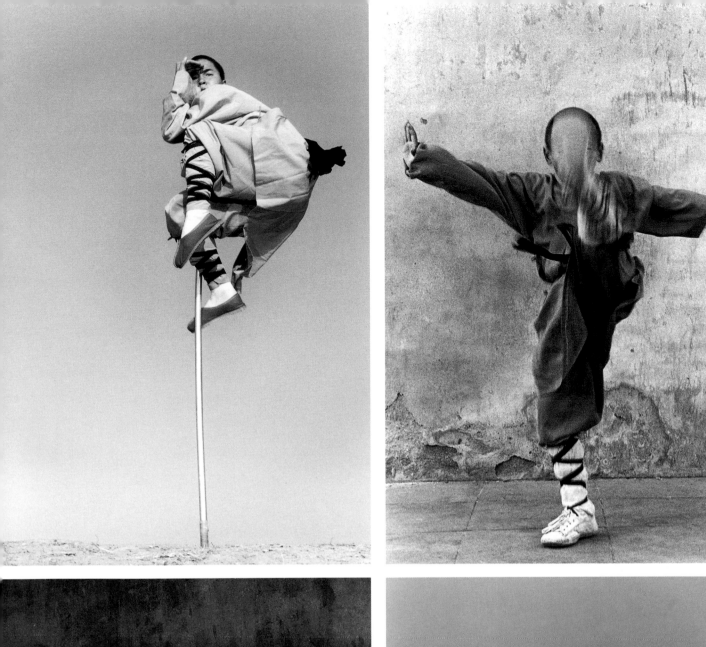
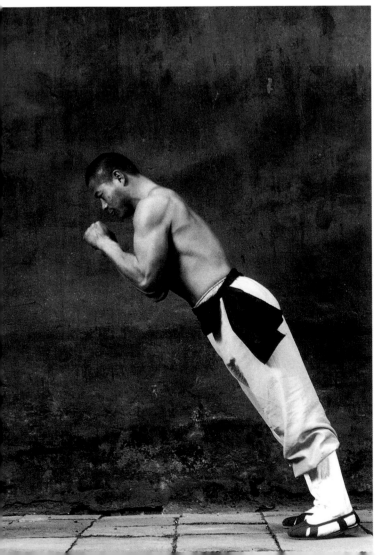
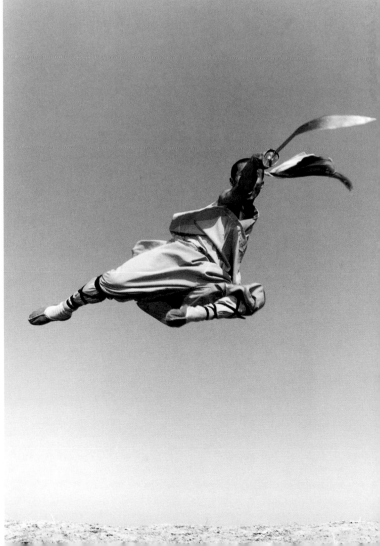

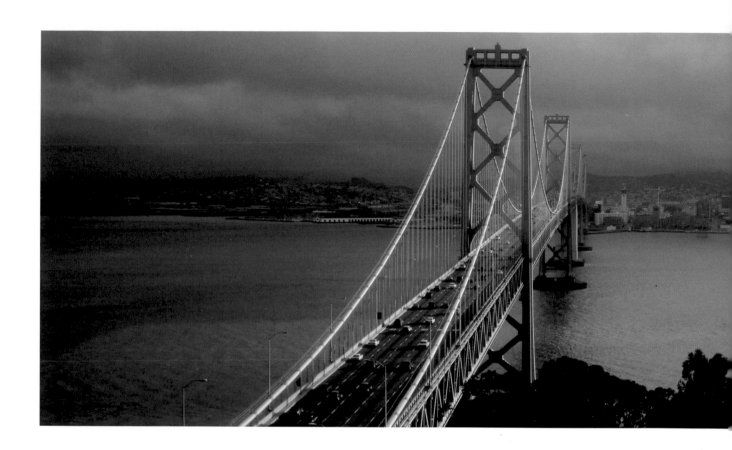

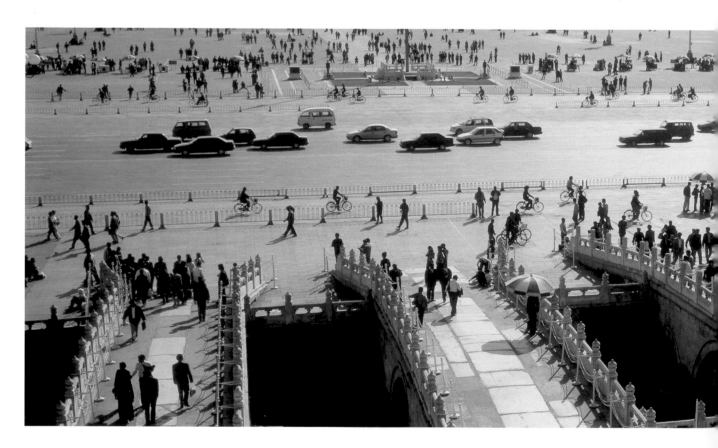

· Karl Lang
Germany

3RD PRIZE STORIES

Portraits of bridges show how they combine technological know-how with architectural impact. In medieval times, bridges often formed part of fortifications; by the 18th century they had become lighter and more elegant. In the 19th and 20th centuries new materials and techniques led to spectacular feats of engineering. Top: Opened in 1936, the San Francisco-Oakland Bay Bridge is the longest high-level steel bridge in the world, at 13.2 kilometers across. Below: Footbridges connect the Tiananmen Gate of the Forbidden City in Beijing to the street. (story continues)

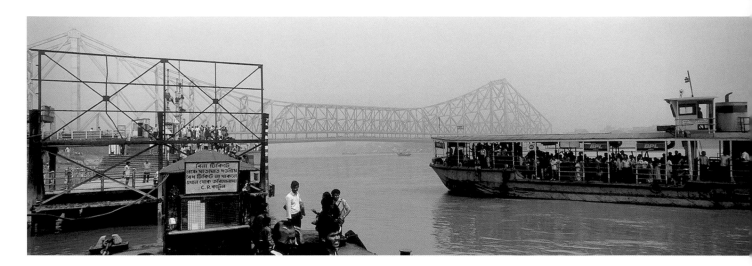

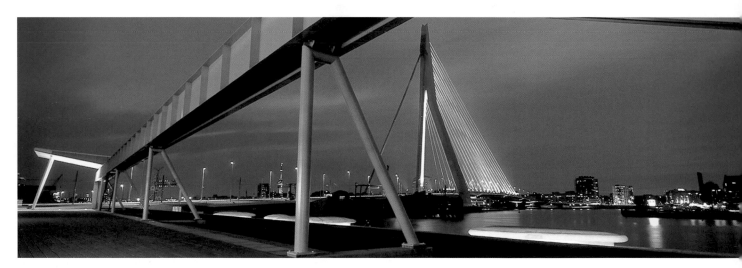

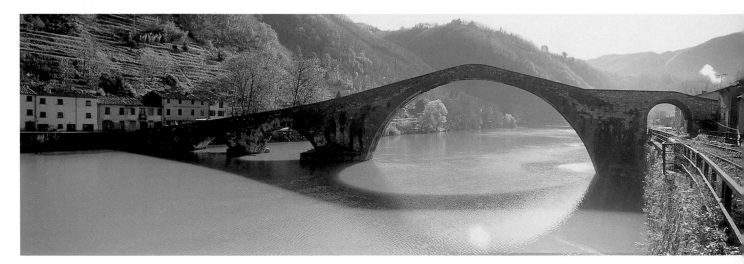

(continued) Bridges often represent technological highpoints of their time. Top: Calcutta's Howrah Bridge, built in 1943, stretches over the Hugli river in a 457-meter span, without a single pylon in the water. It is considered the world's busiest bridge, with a daily flow of some 60,000 vehicles and multitudes of pedestrians. Middle: Rotterdam's Erasmus Bridge, opened in 1996, has a 410-meter span suspended from a single arch. Below: Ponte della Maddalena, nicknamed 'The Devil's Bridge', was built at the beginning of the 12th century so that a local countess could reach the natural springs at Bagni di Lucca in Tuscany, Italy.

· Enric Marti
Spain, Associated Press

1ST PRIZE SINGLES

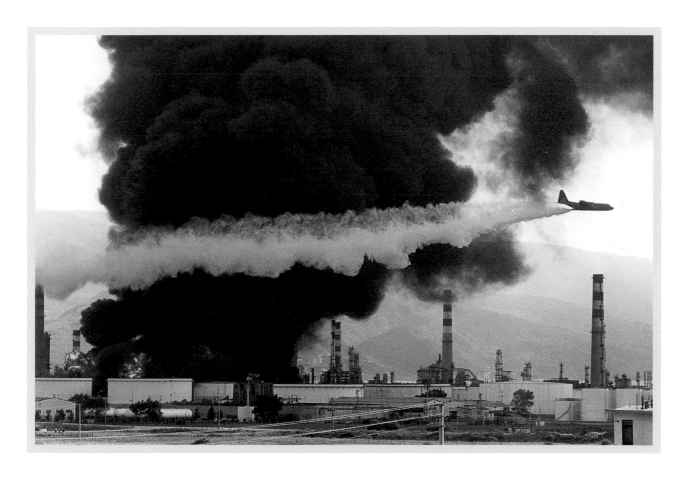

A firefighting plane sheds its load over the Tupras Oil refinery in Izmit, Turkey on August 18. The refinery had been on fire since an earthquake hit the area early the day before. Firefighters could not pump water to fight the blaze, because the quake had knocked out electricity to the region. The earthquake, which measured 7.4 on the Richter scale, claimed more than 17,000 lives and made hundreds of thousands homeless. It was not only a humanitarian disaster, but had a severe impact on the Turkish economy, as the affected area formed the industrial heart of the country.

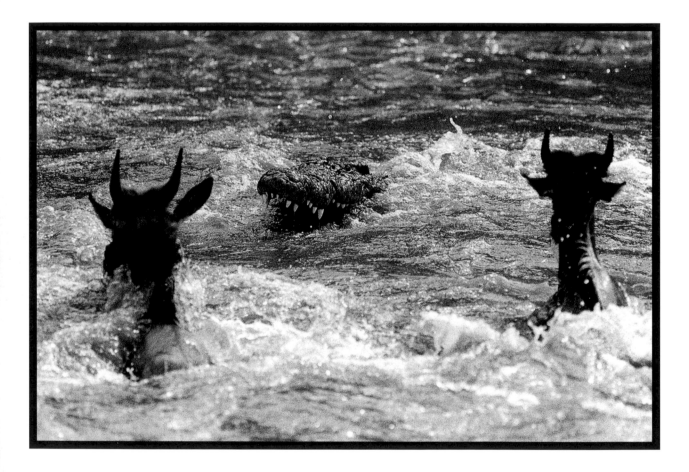

· Tomasz Gudzowaty
Poland, Wprost magazine

2ND PRIZE SINGLES

Wildebeest cross the Mara river in Kenya. Each
year, wildebeest migrate from the south Serengeti
in Tanzania to Masai Mara in Kenya, in search of
fresh grazing grounds. Along the way they are an
easy target for predators. Some 1.5 million beasts
made the journey in 1999, in the biggest migration
for 25 years, and around 10,000 lost their lives.

· Olivier Boëls
France, Contrast Photo Agency, Canada

3RD PRIZE SINGLES

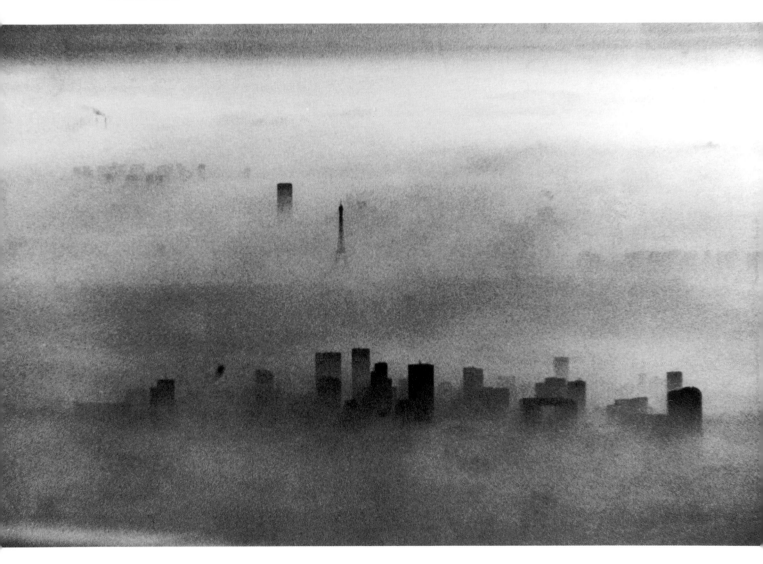

Paris, as seen from an airplane on a January morning. Over the past 40 years
air pollution from industry and domestic heating has been much reduced,
but emissions from automobiles have increased. Initiatives aimed at tackling
the problem range from campaigns to educate drivers about how to reduce
pollution from their car engines, to a club for owners of electric vehicles.
Four months before this photograph was taken, a 'reduced traffic day' imple-
mented in 35 towns countrywide, resulted in a 20 percent drop in the num-
ber of cars entering Paris.

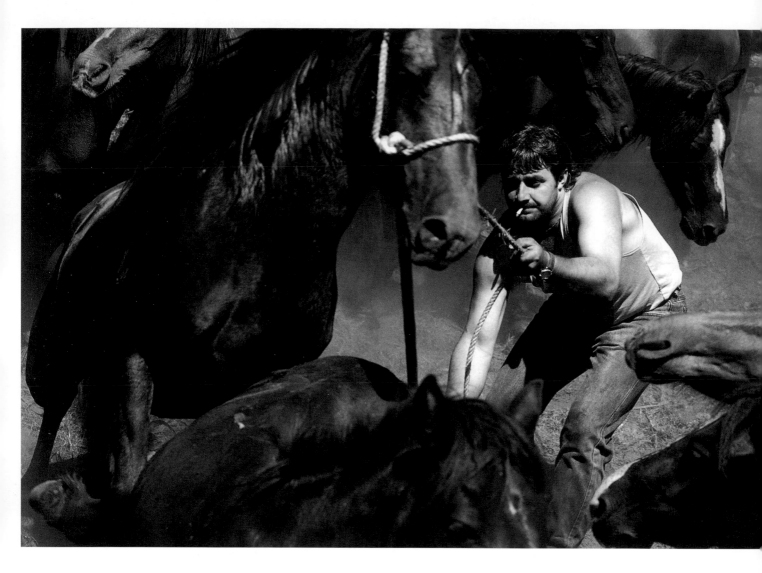

· Tine Harden
Denmark, Politiken

1ST PRIZE STORIES

Wild horses are captured and branded in Galicia, Spain. Every summer, hundreds of horses are rounded up in a tradition that was mentioned as long ago as Roman times. Then, the people used horses for food and in war. It is dangerous work, and skills are handed down from father to son. After being branded and having their manes clipped, the horses are set free again.

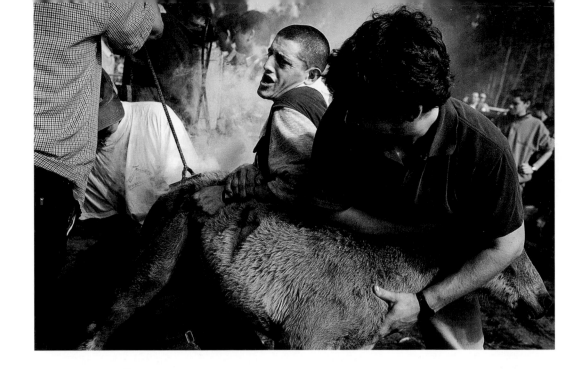

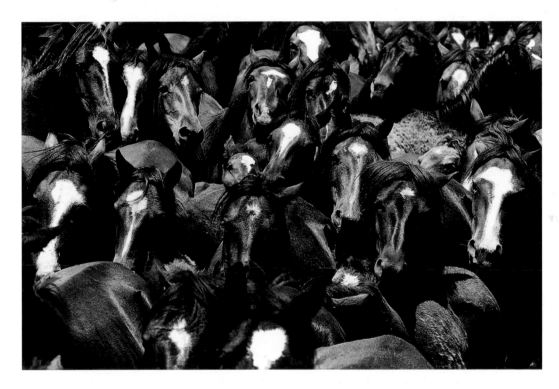

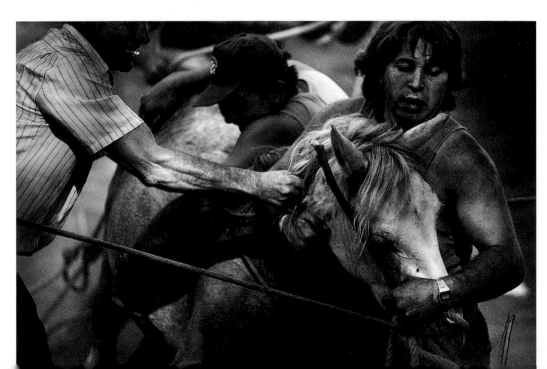

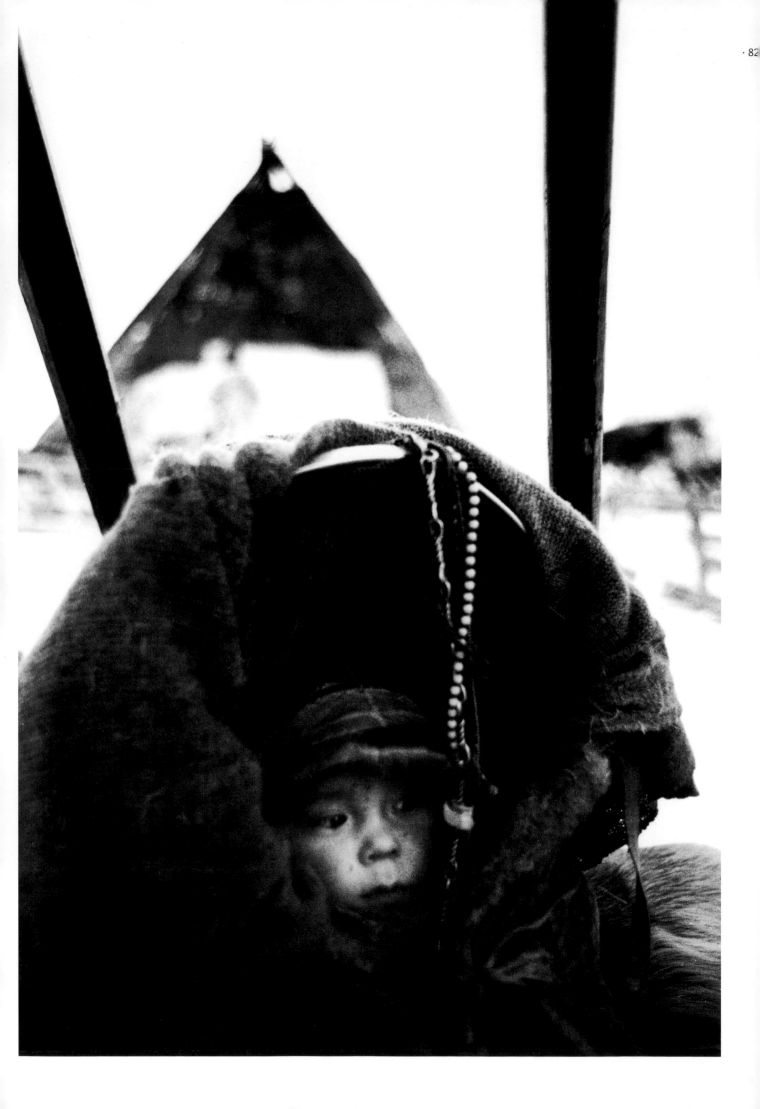

· Claudine Doury
France, Agence Vu

2ND PRIZE STORIES

Members of the 34,000-strong Nenets ethnic group lead a nomadic life on the Yamal Peninsula in northwest Siberia. They speak a Samoyedic language, have shamanist traditions, and live in tepee-like tents called *chum*, which dismantle and transport easily. (story continues)

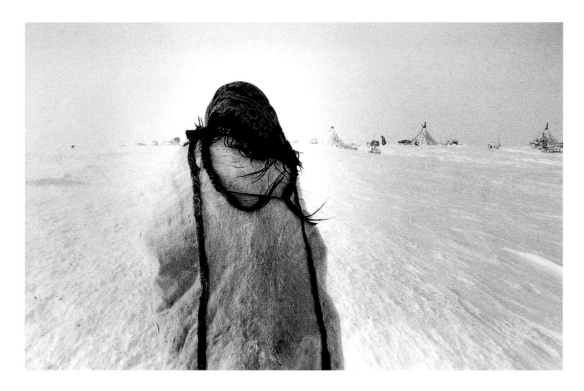

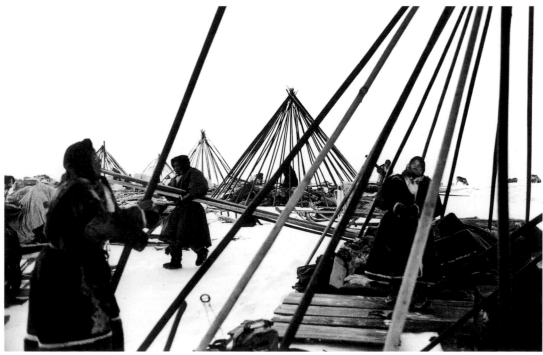

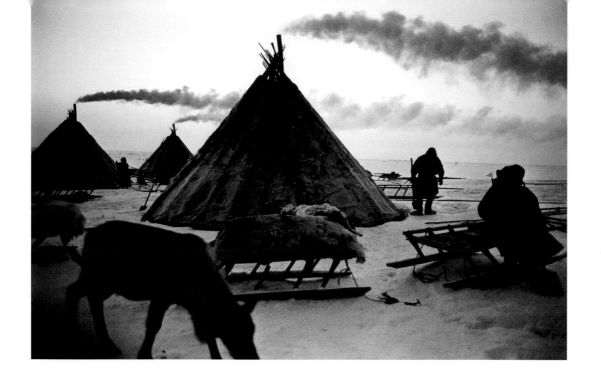

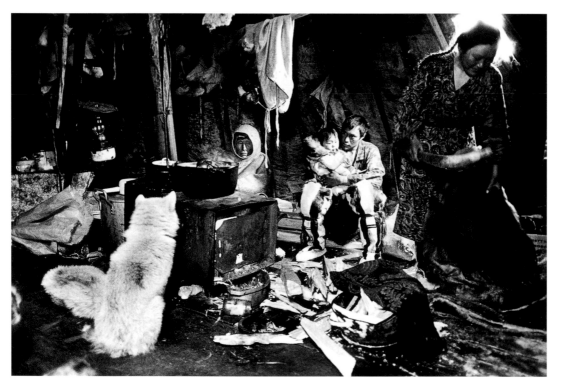

(continued) The Nenets' life revolves around raising reindeer. It takes 64 reindeer hides to make a *chum*, which becomes home to an extended family. Each year the children go away to boarding school, where they stay for eight months. Despite the modern comforts they find there, most children choose to come back to the traditional way of life after school. Below: A Nenets man lies in the snow after a drunken party.

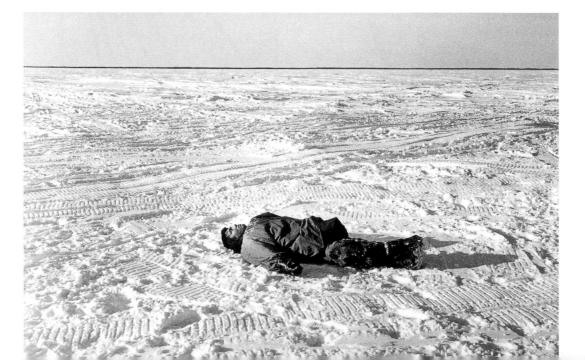

· Norbert Wu
USA

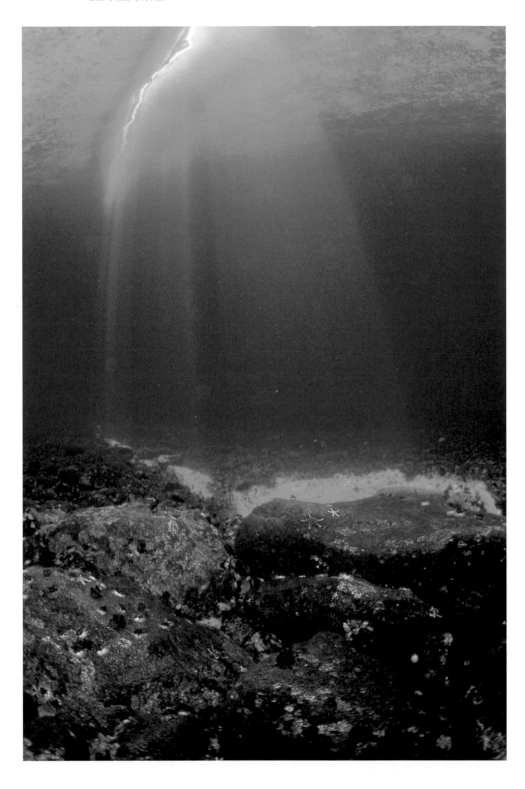

Sunlight shines through a crack in the sea ice in Antarctica, illuminating sea urchins and starfish. Sea urchins are common scavengers in shallow waters, where they feed on animals trapped in frozen icefall. The icefall is brown due to microscopic algae, which the urchins scrape off and eat. An underwater photography team worked from the US Antarctic Program's base on Ross Island during the late Antarctic spring, but even then the preparations demanded by freezing conditions meant that it took ten to twelve hours to support three dives. (story continues)

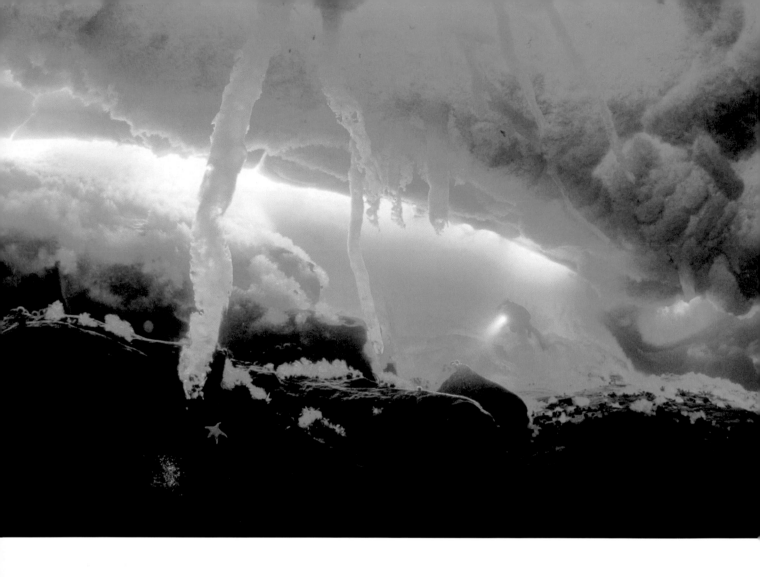
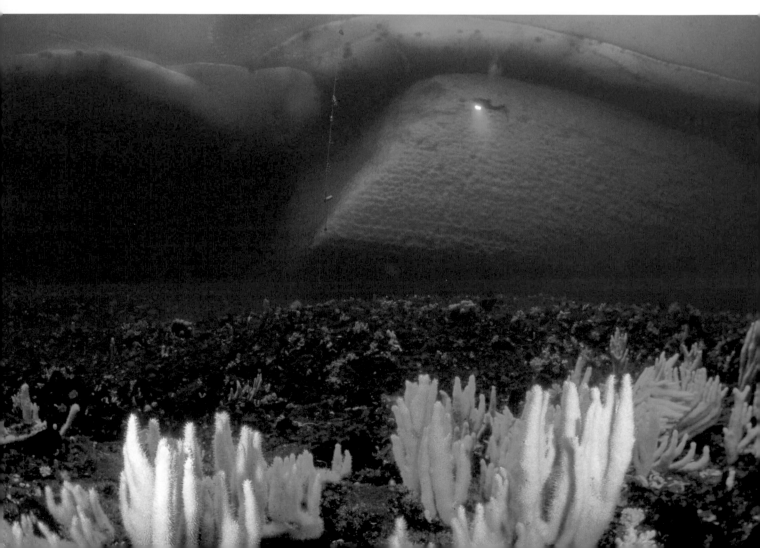

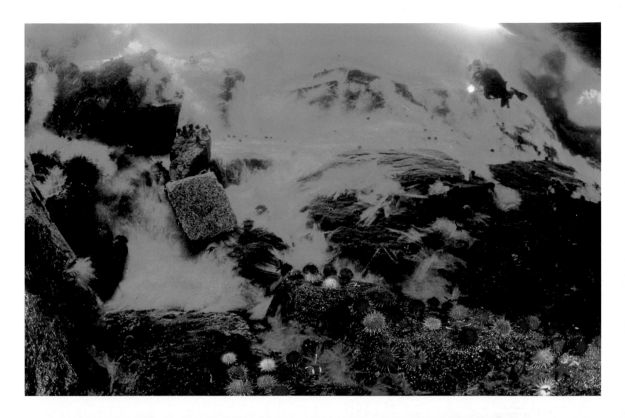

(continued) Grounded icebergs, frozen waterfalls and sea-ice stalactites form part of an underwater tableau. Top left: Sea ice stalactites are hollow, and grow as brine drains away from the surface ice. Top right: Meltwater drips from glaciers and freezes upon contact with sea, making frozen waterfalls. Below, left and right: Icebergs can become grounded in shallow coastal water. Sponges are the dominant animal life in these shallow zones.

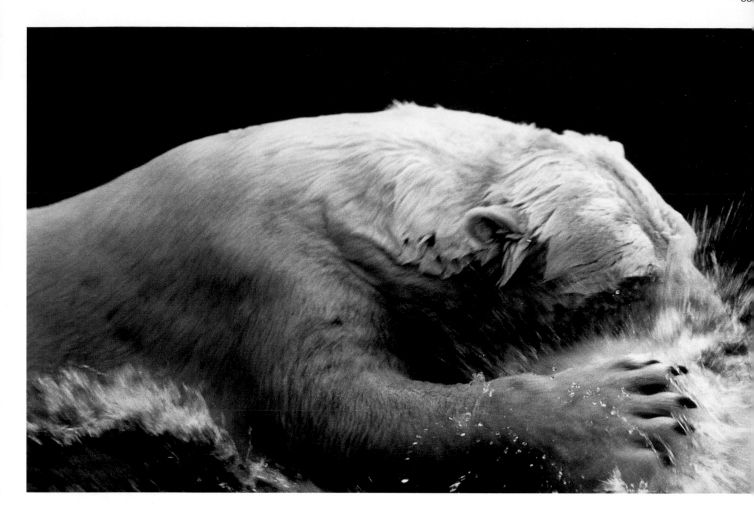

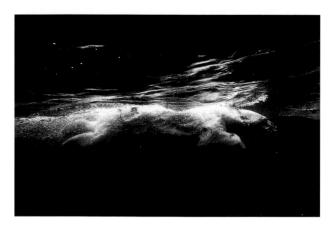

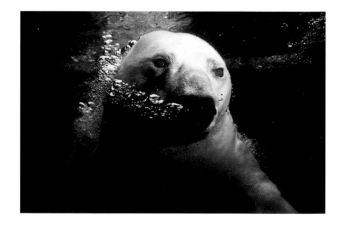

· Heidi & Hans-Jürgen Koch
Germany, for Mare magazine

HONORABLE MENTION STORIES

Polar bears in German and Swedish zoos. The photographers set out to demonstrate that natural animal behavior can be as authentically photographed in captivity as in the wild. Above: Polar bears usually swim below the surface. Their nostrils can shut off, but their eyes remain open for orientation and hunting prey. Top right: A polar bear's coat is excellent insulation against the cold. Water runs easily off the hair, which is hollow and transparent and directs sunlight onto black, heat-absorbent skin. Below right: When swimming, polar bears use their forepaws as paddles and their back paws as a rudder.

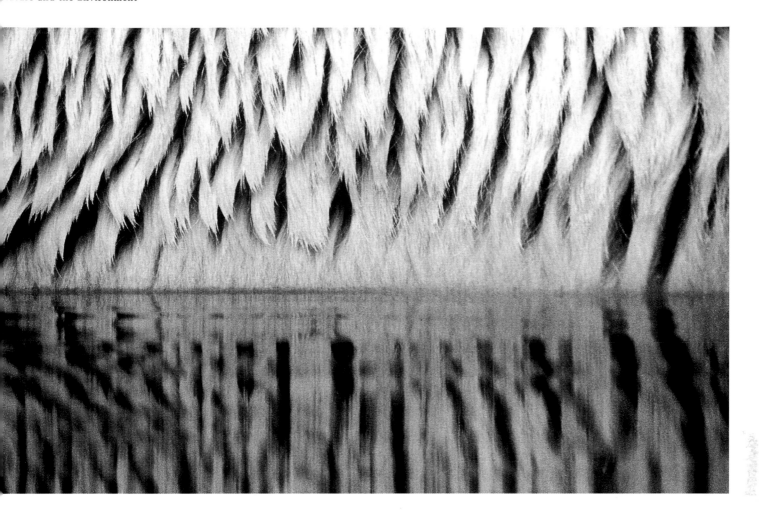

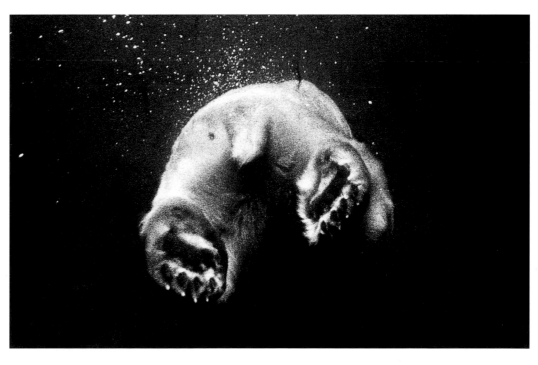

Portraits

· Lara Solt
USA, Sun Publications

1ST PRIZE SINGLES

Diane Carpenter bathes her
13-year-old daughter Beth,
who is autistic. Beth's lan-
guage development
stopped at the level of a
20-month old child, and
she has most of her basic
needs taken care of by her
mother. Diane helps her
daughter bathe, wash her
hair, clean her teeth, and
get dressed every day.

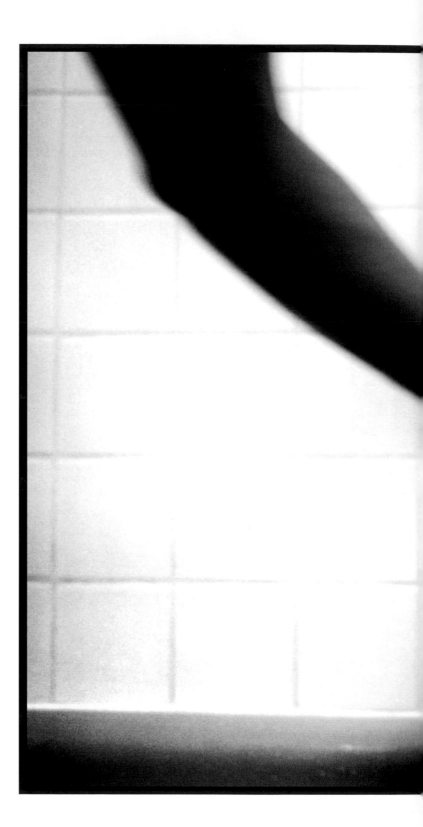

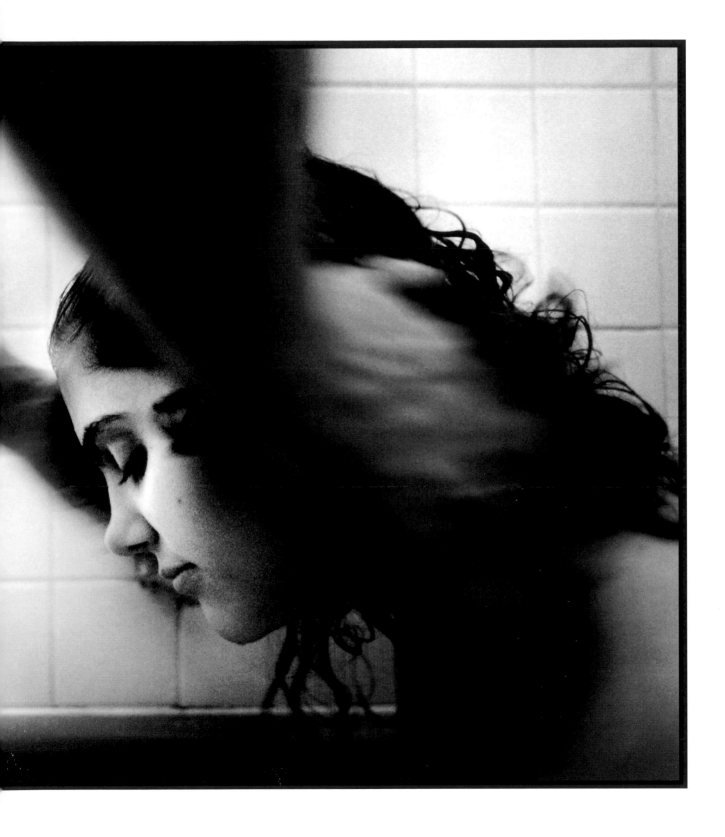

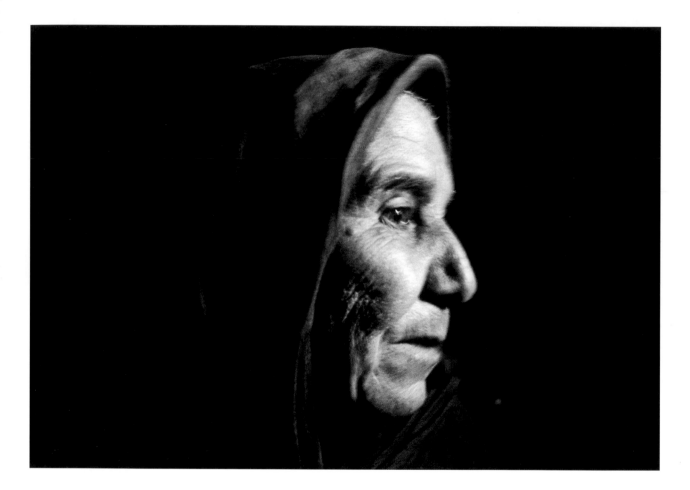

· Tim Georgeson

Australia, Propaganda Pictures for World Vision/Rolling Stone

2ND **P**RIZE **S**INGLES

Gulhar Hasanova has lived for the past seven years, together with 10,000 other Azerbaijanis, in a camp made up of old metal railway carriages in Imishli in south Azerbaijan. The war between Azerbaijan and Armenia, begun in 1993, has left thousands of people displaced. Gulhar's former home village is occupied by Armenian forces. Gulhar was born around 1917. Her first husband and her brother were killed in the Second World War. Her second husband and two of her three children have died in Imishli.

· Gabriel Bouys
France, Agence France Presse

3RD PRIZE SINGLES

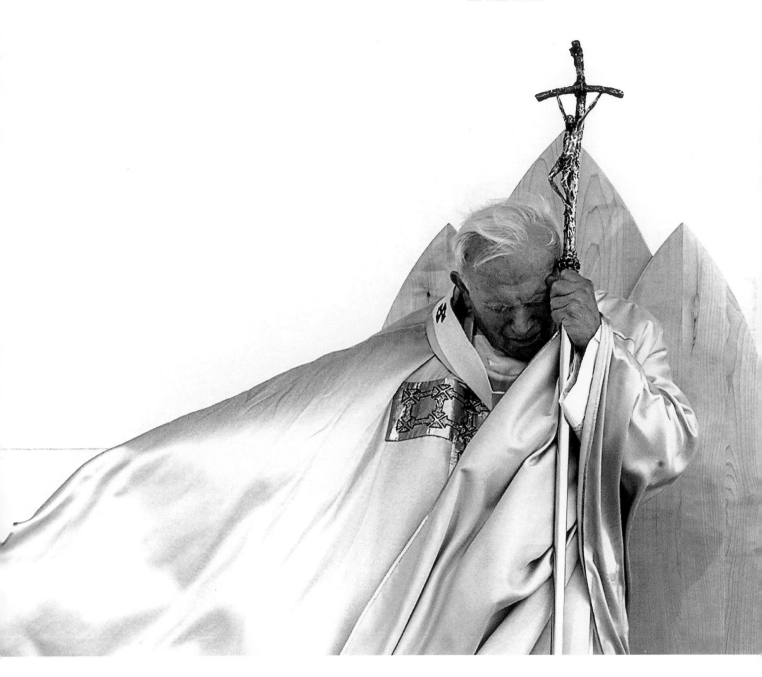

Pope John Paul II celebrates an outdoor mass for the beatification of Anton Martin Slomsek in Maribor, Slovenia. Anton Martin Slomsek (1800-1862) was the first bishop of Maribor. The aging pope uses his crosier for support at a rare moment in the mass when he is not attended.

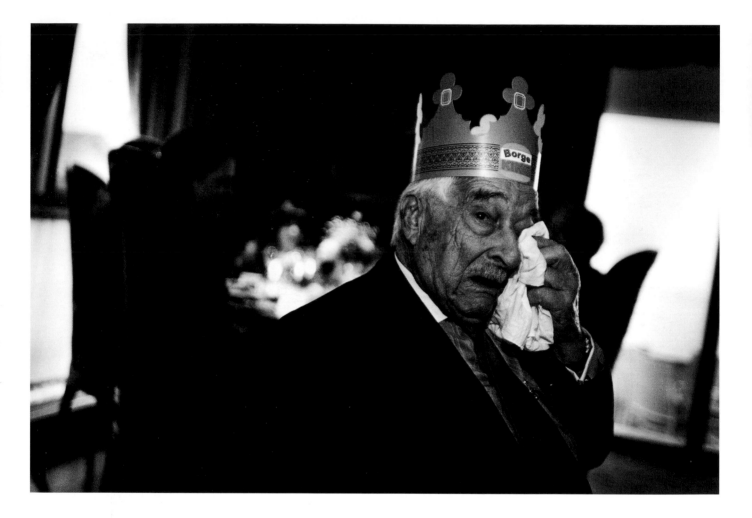

· Tine Harden
Denmark, Politiken

HONORABLE MENTION SINGLES

The musical comedian Victor Borge is now in his nineties. Born in Copenhagen, he trained as a classical pianist, but by the 1930s was already blending humor with his music. In the 1940s he left Denmark for the USA, becoming an American citizen in 1948. Though at first he could speak little English, he soon learned the language and adapted his unique comic routine for a wider audience. Worldwide popularity followed. Here Borge himself recovers from a fit of laughter at his home in Connecticut, USA.

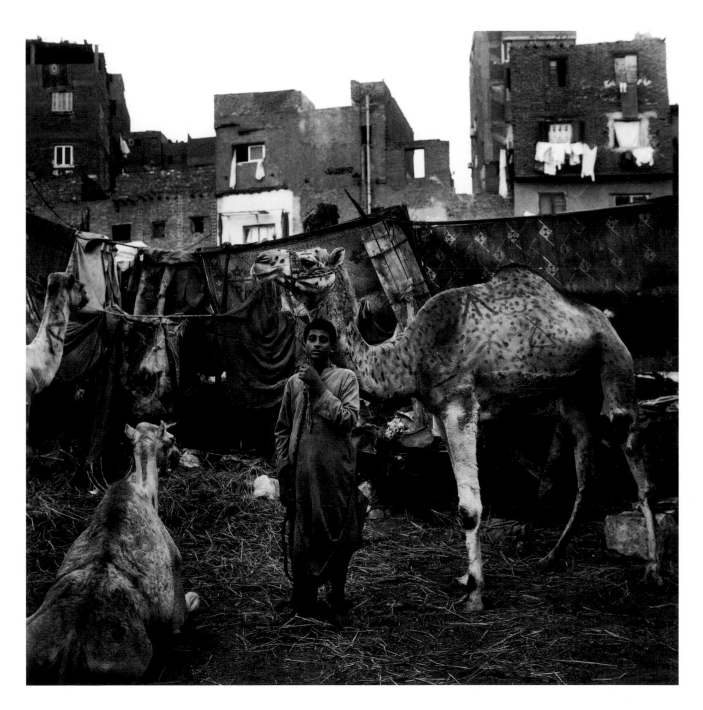

· Denis Dailleux
France, Agence Vu for DS Magazine

1ST **P**RIZE **S**TORIES

Every year more than two million people from all over Egypt gather in Cairo for a *mawlid* for Hussein, the grandson of the prophet Mohammed. For one week many camp out among sacrificial goats and camels. An Egyptian *mawlid* is a religious festival in honor of a saint. Celebrations mingle religious elements with ancient rituals and something of the atmosphere of a country fair. (story continues)

(story continued) A *mawlid* is very much a people's festival. Established scholarly religious practice is counterbalanced by popular mysticism, pre-Islamic traditions and trance states. Many of the practices are passed down through generations rather than enshrined in conventional belief.

· Philippe Gontier
France

2ND PRIZE STORIES

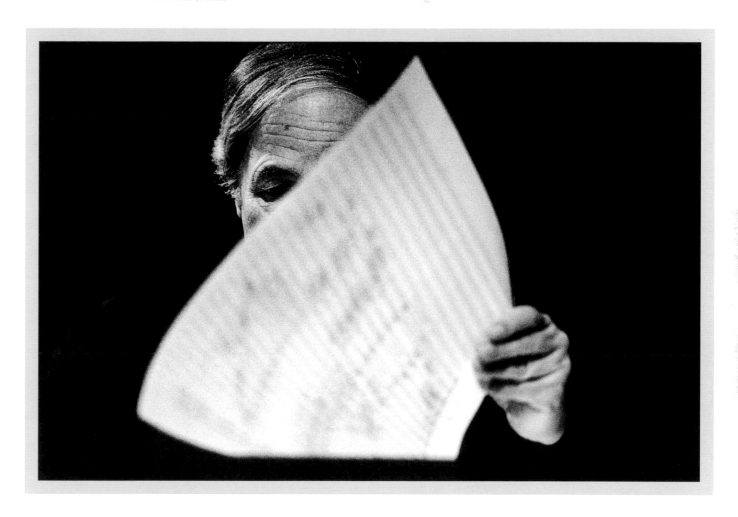

French composer and conductor Pierre Boulez focuses his activities on contemporary and modern music. He is considered one of the best interpreters of the Vienna School — Schönberg, Berg and Webern — and is deeply involved in such cornerstones of the contemporary music world as the Festival of New Music in Darmstadt, Germany, and the IRCAM institute in Paris. Boulez is also at the center of the involvement of electronics in new music. Here he works on the score of *Explosante Fixe*, a homage to Stravinsky. (story continues)

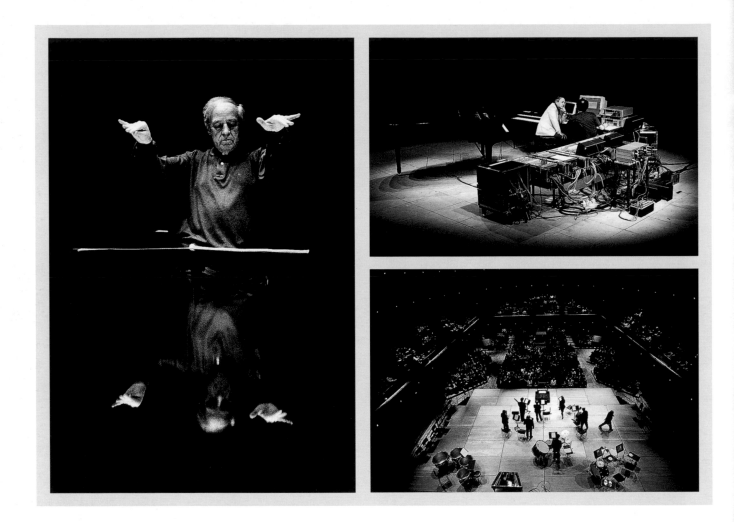

(story continued) A composer of note in his own right, Boulez is president of l'Ensemble Intercontemporain, a group of musicians whose aim is virtuoso interpretation of modern music. Above left: Boulez rehearses one of his most recent pieces, *Sur Incises*. Top right: The composer works with his collaborator Andrew Gerzsc on an electronic piece. Below: L'Ensemble Intercontemporain perform at the inaugural concert of the Cité de la Musique, of which Boulez is a founder. Facing page: A rehearsal at the Mozarteum during the 1999 Salzburg Festival.

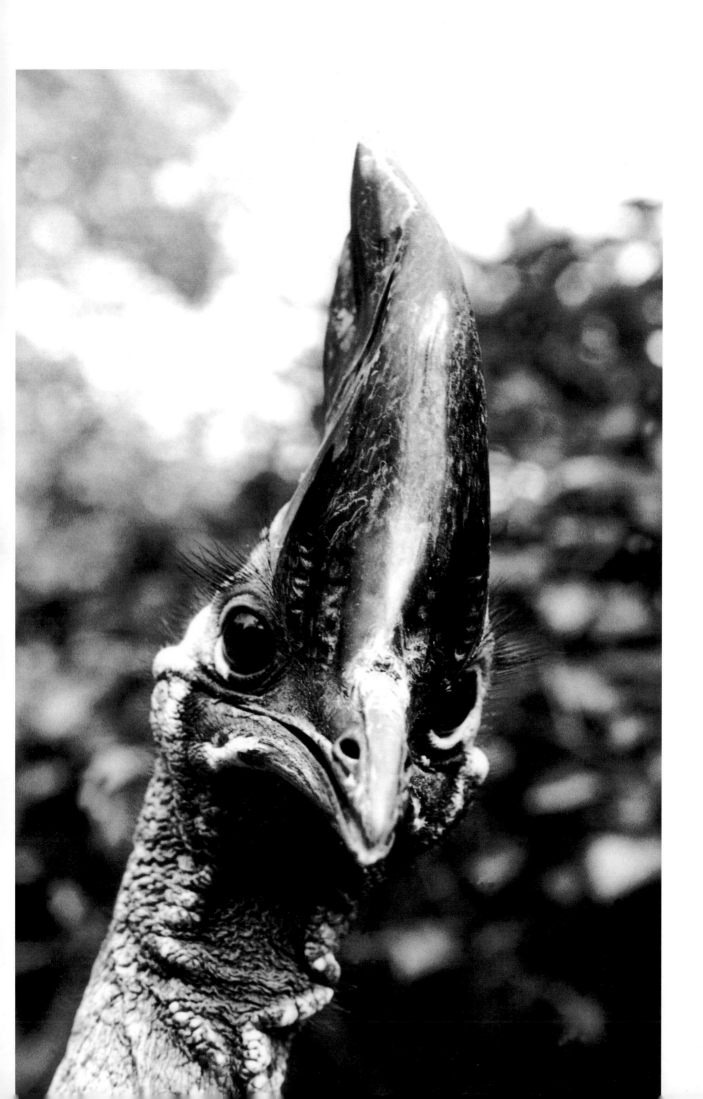

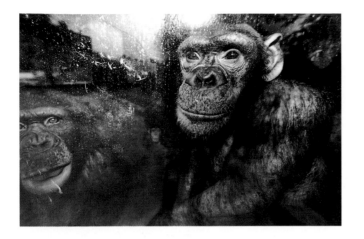

· Silva
Italy, Agenzia Contrasto

3RD PRIZE STORIES

A series of animal portraits taken in zoos. Clockwise from facing page: A flightless Australian cassowary, a chimpanzee, a tiger, and a leopard all photographed in Italian zoos; and a ray from a British aquarium.

Daily Life

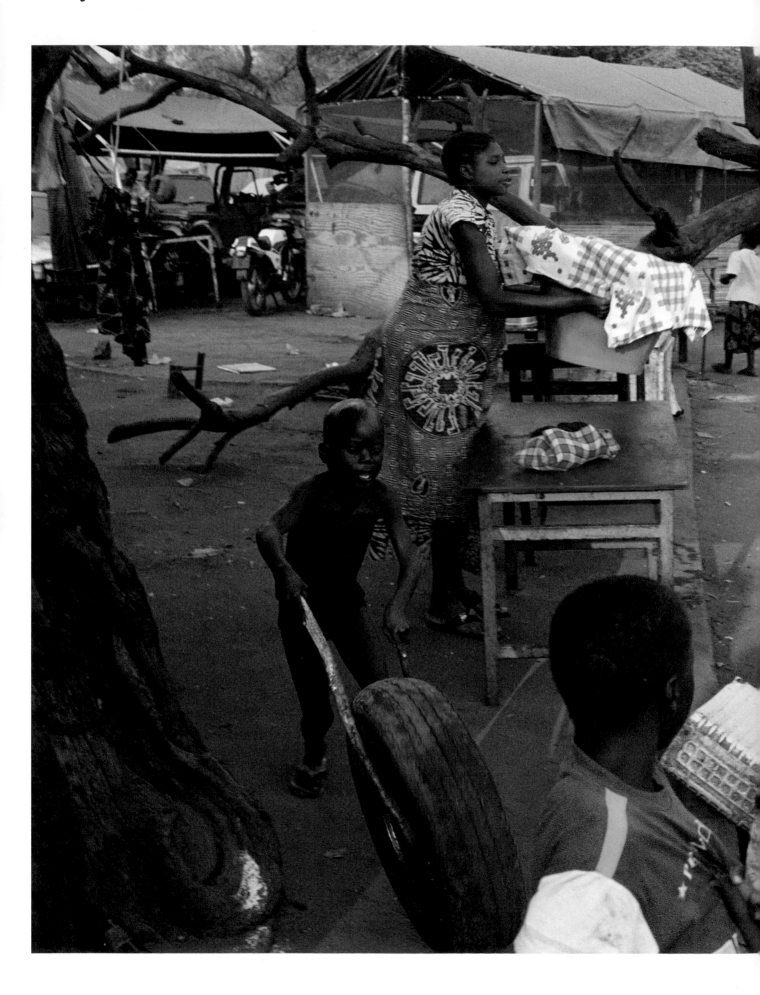

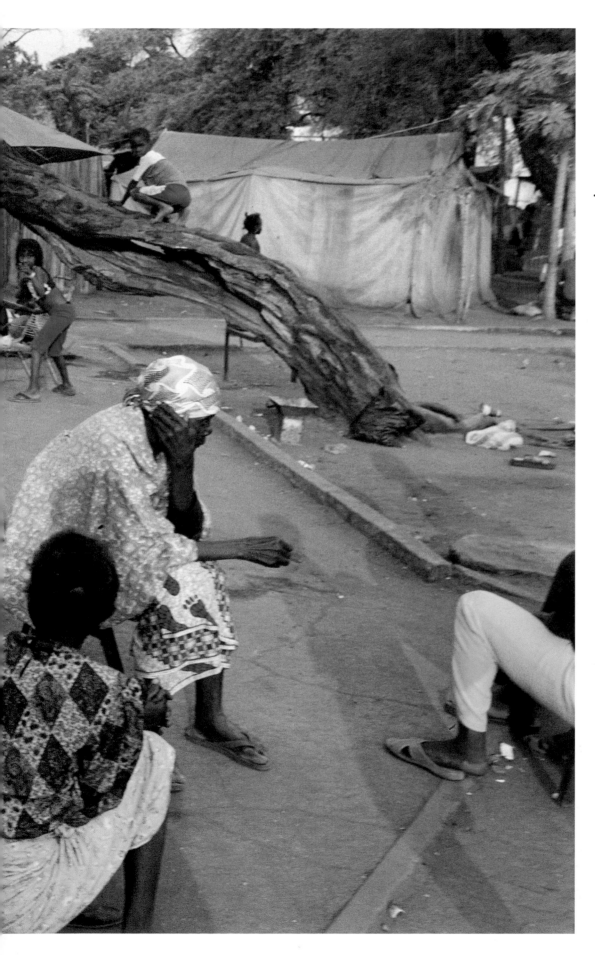

· Chris Steele-Perkins
UK, Magnum Photos
for Der Spiegel, Germany

1ST PRIZE SINGLES

People displaced by civil
war in Angola, living in a
camp in the capital Luanda.
The debilitating war
between the governing
MPLA and the Unita resis-
tance movement has gone
on for nearly three decades,
with just a short period of
peace in the mid 1990s.
Although Angola is poten-
tially extremely wealthy,
with top-quality diamond
deposits and massive oil
reserves, 80 percent of its
12 million inhabitants now
live below the poverty line.

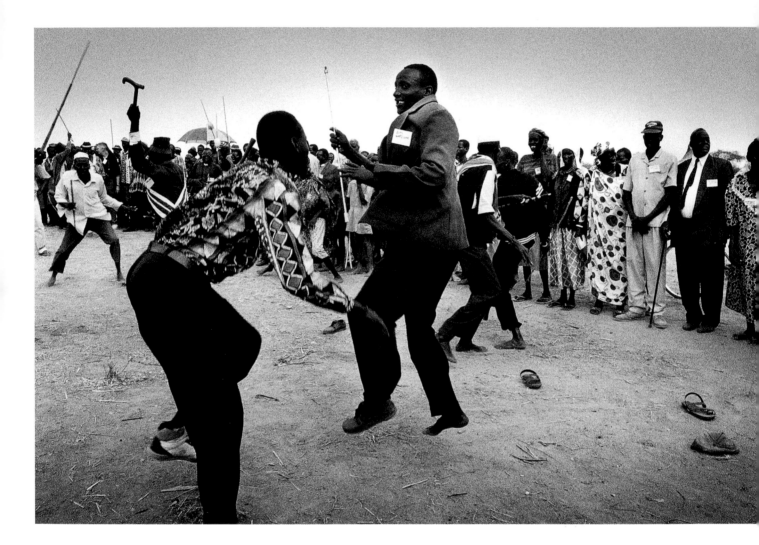

· Tom Pilston
UK, The Independent

2ND PRIZE SINGLES

Nuer and Dinka chiefs engage in mock hand-to-hand combat at the opening of a peace conference, in a purpose-built village in southwest Sudan. Decades of conflict between these two southern ethnic groups, further complicated by ongoing strife between north and south, has meant in the past that the population could not settle to grow its own food. Severe famine has followed. Many people walked for days to get to the peace talks, which were brokered by the New Sudanese Council of Churches.

· Thomas James Hurst
USA, The Seattle Times/Time

3RD PRIZE SINGLES

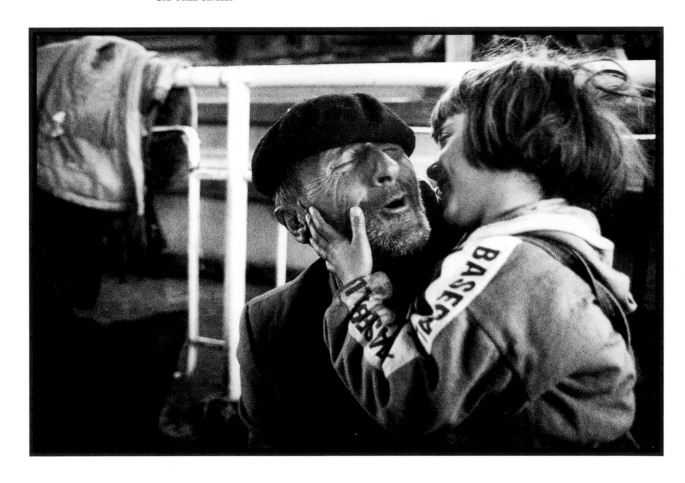

A Kosovar grandfather and child
share a loving moment in a refu-
gee camp in Korçë, near the
Albanian border. By far the largest
number of refugees went to
Albania, most arriving in camps
around the towns of Kukës and
Korçë. Aid organizations struggled
to keep up with providing even
basic requirements, such as the
supply of tents, drinking water
and latrines. Refugees had to
stand in line for hours for food,
typically a little bread, fruit and
juice each day.

· Zana Briski
USA

1ST PRIZE STORIES

Over 6,000 sex workers operate in the Rambagan/Sonagachi red-light district of Calcutta, many of them forced into prostitution by poverty. The women come from all castes and religious backgrounds, and entertain clients from all levels of Indian society. Above: Brothel customers await their turn. Top right: Hasina, a sex worker, bathes in a Rambagan brothel. Below right: Asha has been in the profession for seven years, earning money to support herself and her daughter. Some women have 'babus', or regular customers, on whom they rely for financial support. Next page: Sandhya prepares for a customer in her room in the brothel. (story continues)

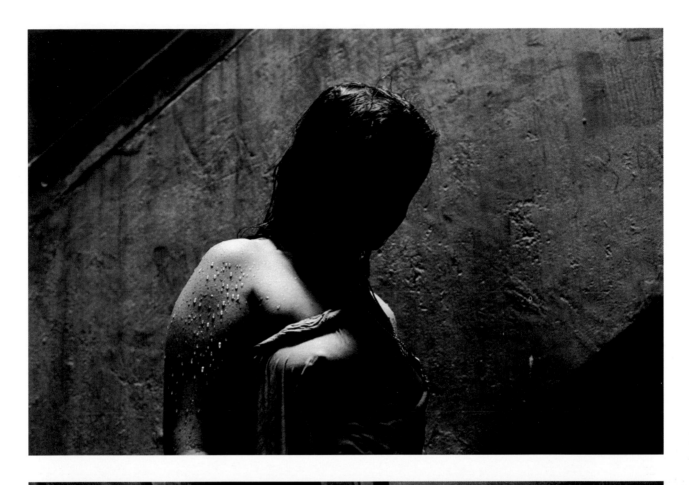

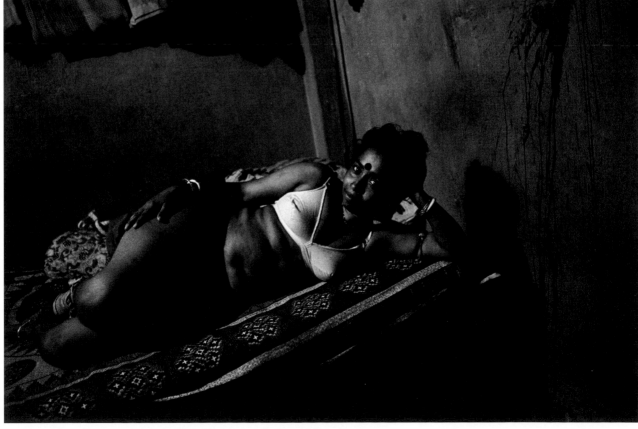

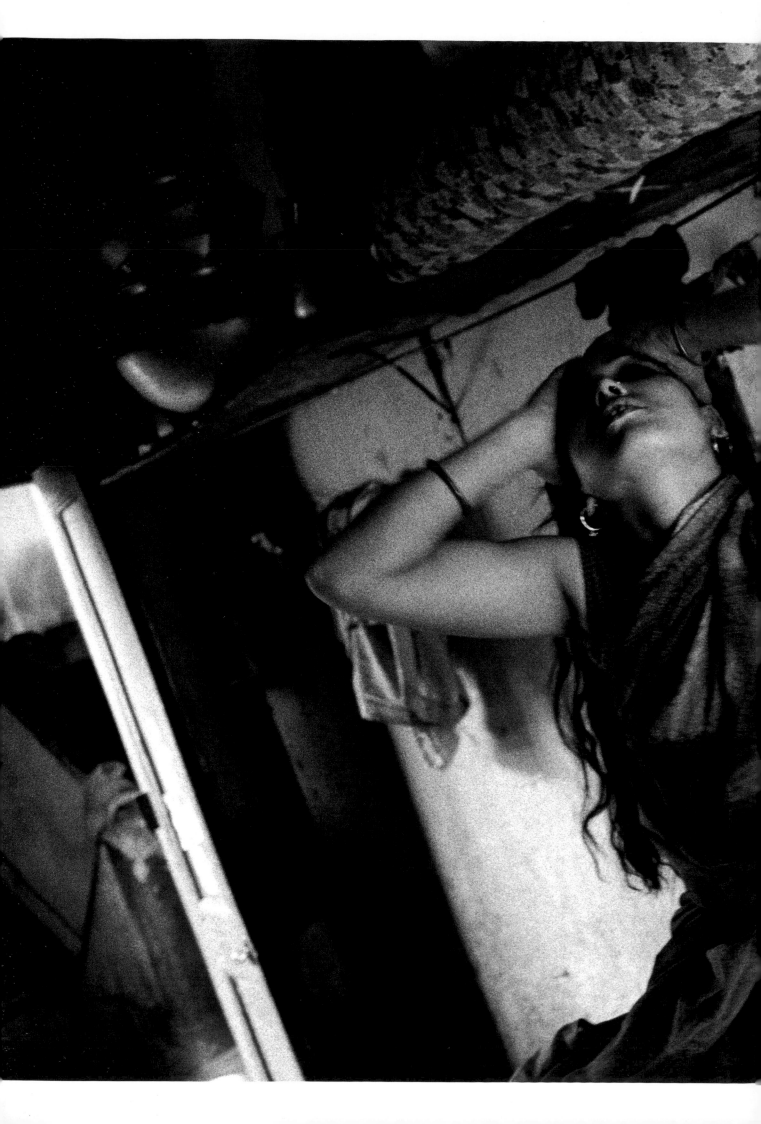

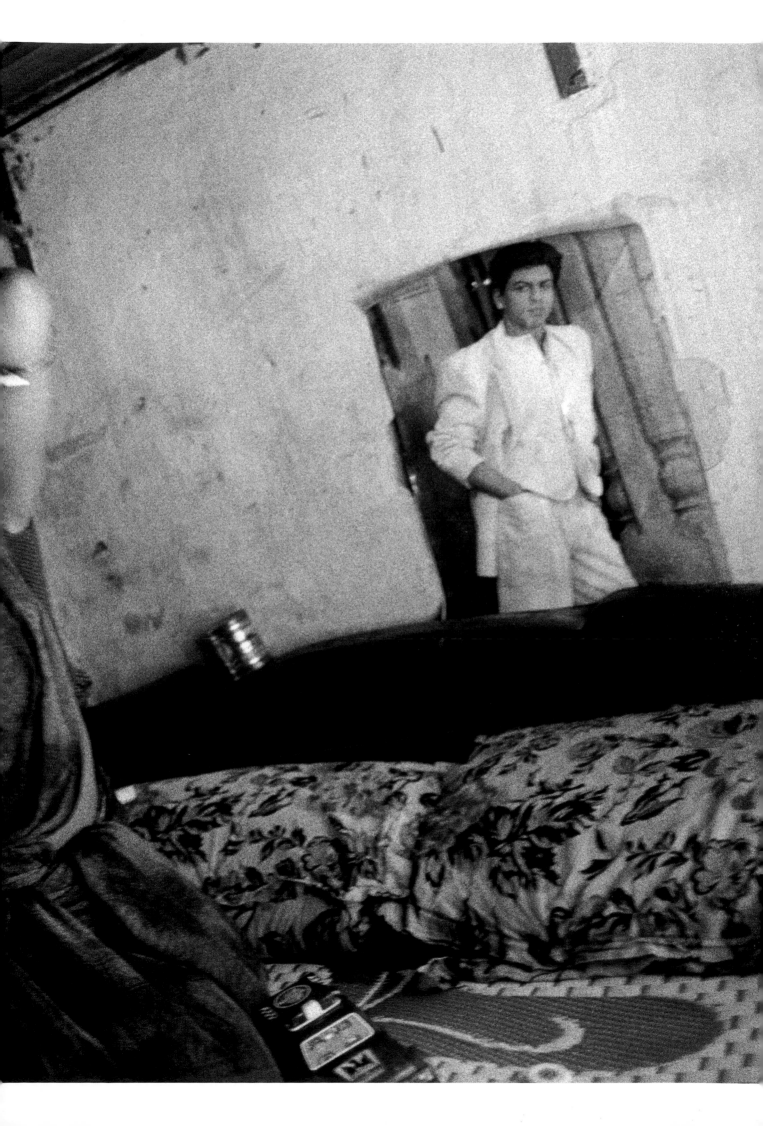

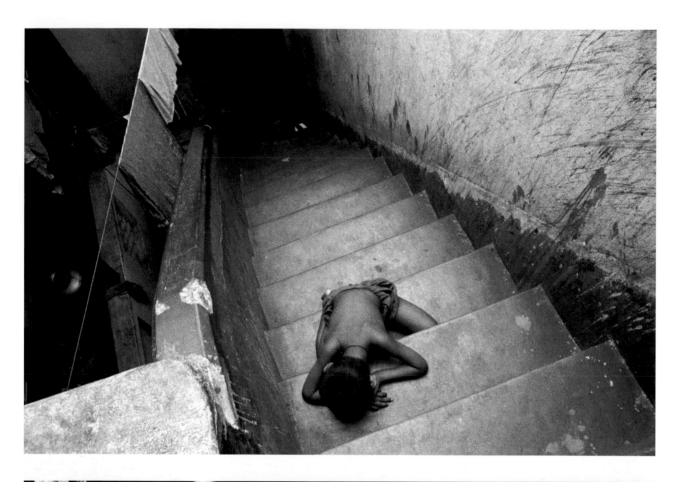

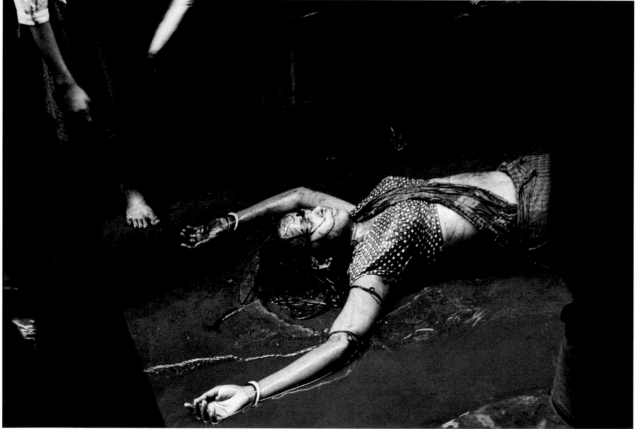

(continued) Top: Hasina's daughter Mukta plays on the brothel stairs. Hasina sends Mukta to school and wants another life for her. Below: A woman collapses during a ceremony of worship for the goddess Sheetla in the red-light district.

· Trent Parke
Australia, The Australian newspaper

2ND PRIZE STORIES

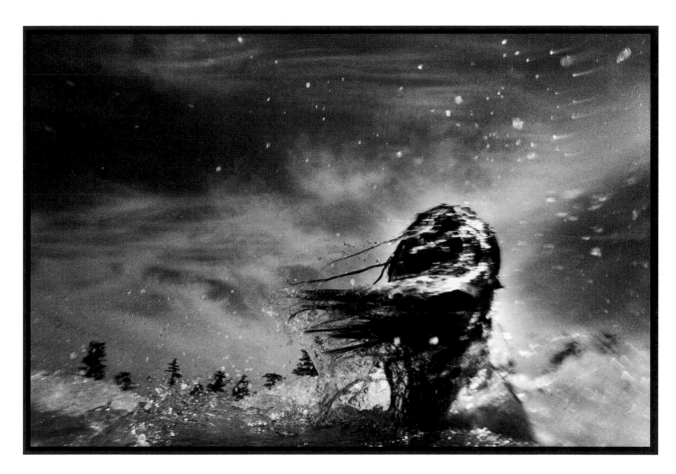

A woman comes up for air while swimming at Manly Beach in Sydney, Australia. A land surrounded by water, with much of its population living along the coastline, Australia has a lively beach culture. (story continues).

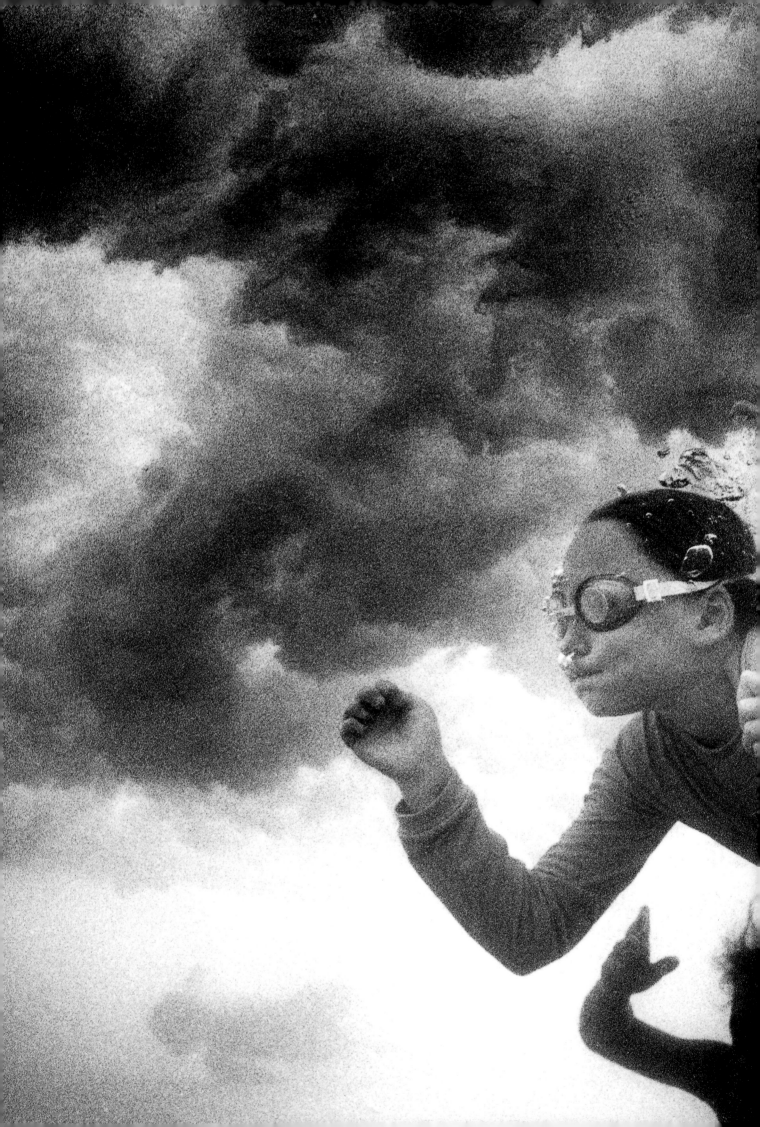

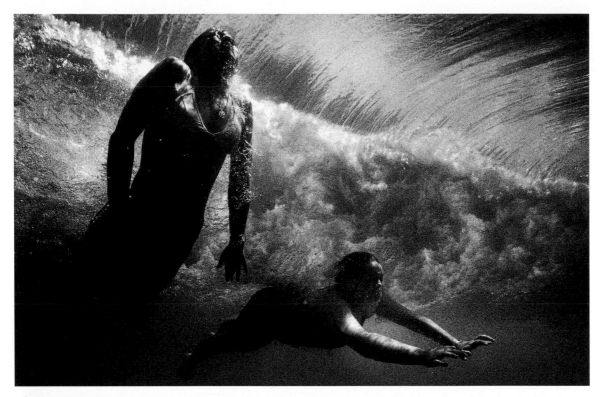

(continued) A sunny climate and good surf add to the attraction. Previous page: Swimmers duck below a large wave at Freshwater Beach, Sydney. Top: A fresh lung-full at Bondi Beach. Below: Waiting for waves at Freshwater Beach.

· Mike Abrahams
UK, Network Photographers

3RD **P**RIZE **S**TORIES

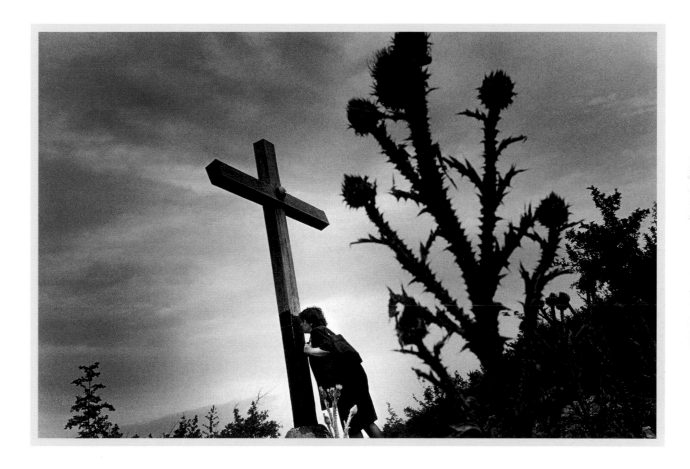

Personal expressions of
Christianity around the world
show an intensity often absent
from more institutionalized relig-
ious activity. Above: A woman
kisses a cross on a hill in
Medjugorje, in present-day Bosnia-
Herzegovina. In 1981, six children
claimed that the Madonna had
appeared to them on the hill, giv-
ing a message of peace and asking
people to return to the ways of
God. (story continues)

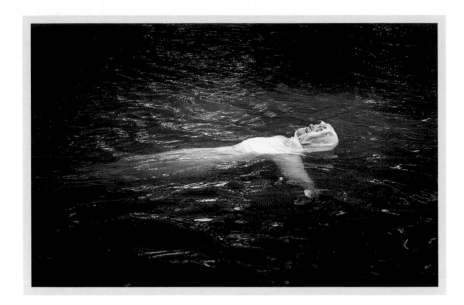

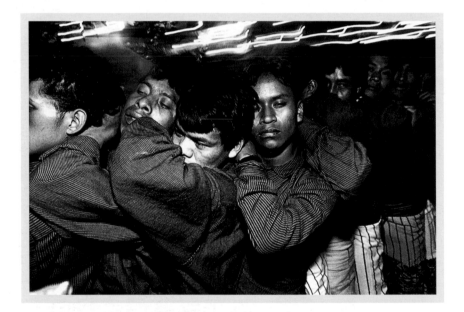

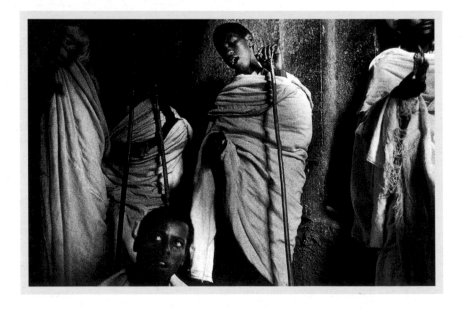

(continued) Conventional rituals can take passionate personal forms. Top: A nun from Kazakhstan undergoes baptism in the River Jordan. Middle: On Good Friday, 70 men carry Christ's coffin through the village of Santiago Atitlan in Guatemala, taking one step forward and two back throughout the day and night. Below: Monks chant their daily prayers at the Bete Meskel chapel in Lalibela, Ethiopia. Facing page: A hermit nun outside her cave home. The cave, just large enough to accommodate the body of its occupant, is carved into the wall of a passage leading to the Bete Giorgis church in Lalibela.

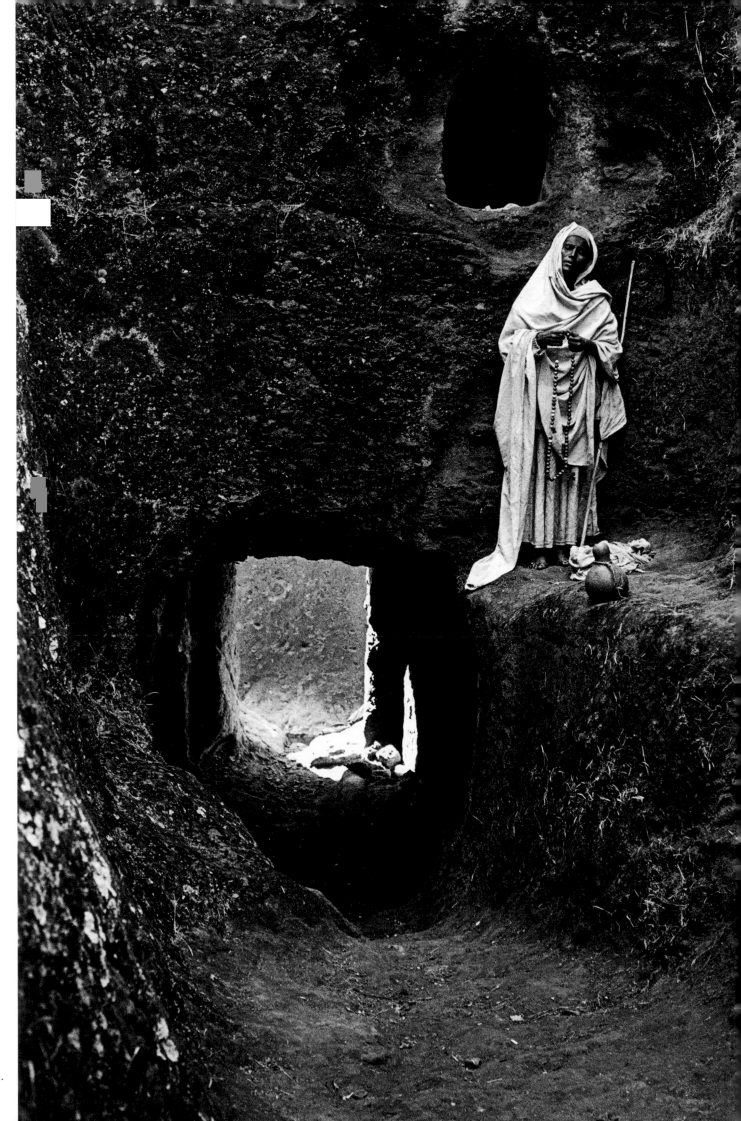

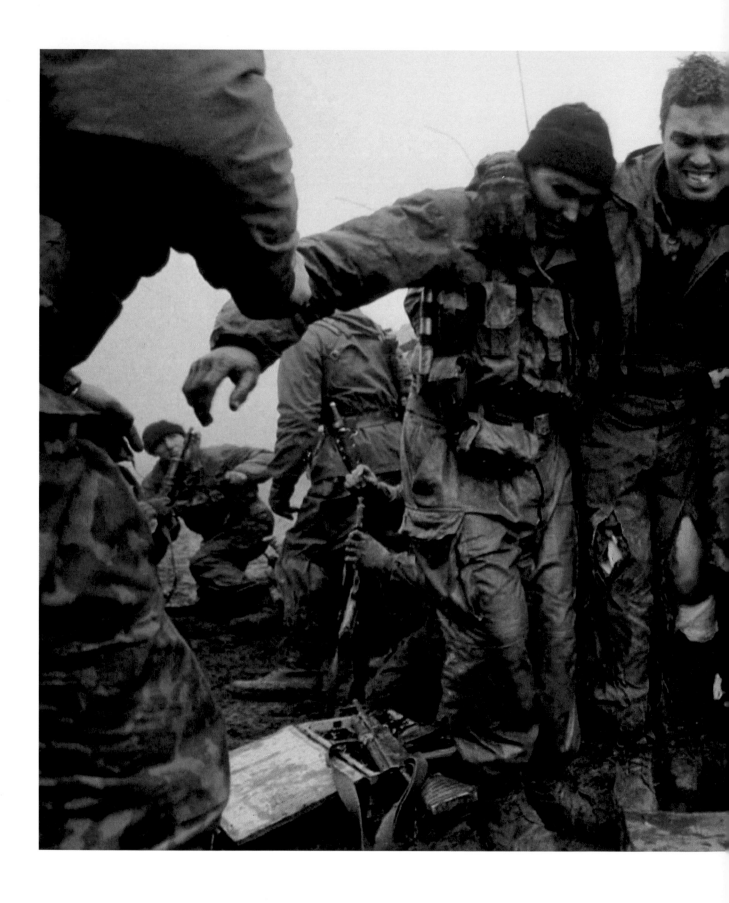

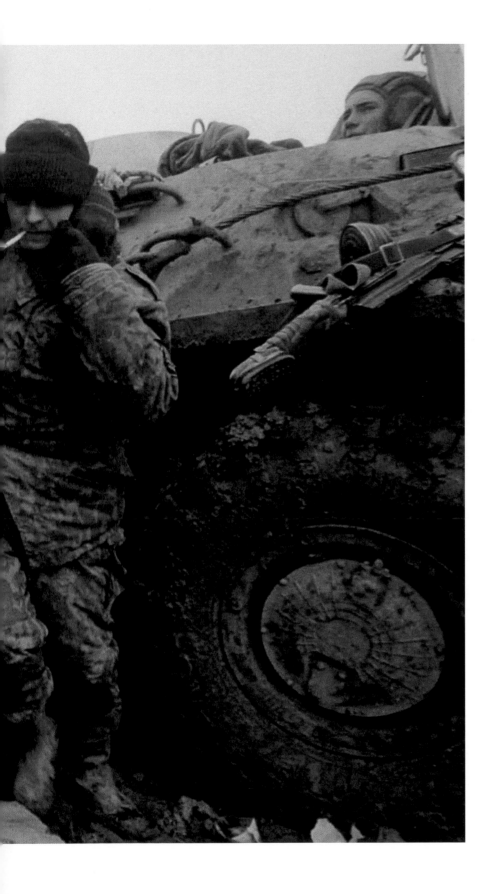

· Yuri Kozyrev
Russia, Associated Press

1ST PRIZE SINGLES

Russian marines help a wounded fellow soldier after being caught in an ambush near Tsentoroi southeast of Grozny in Chechnya on December 16. In September, Russian forces had begun military action against Chechen rebels. Initial operations were confined to air attacks, but on October 1 Russian troops entered Chechnya. By the beginning of December the Russians had surrounded the capital Grozny. The Russians held that their casualties during the conflict were minimal.

· David W. Smith
Canada, Taiwan News/Corbis Sygma
for US News & World Report

2ND PRIZE SINGLES

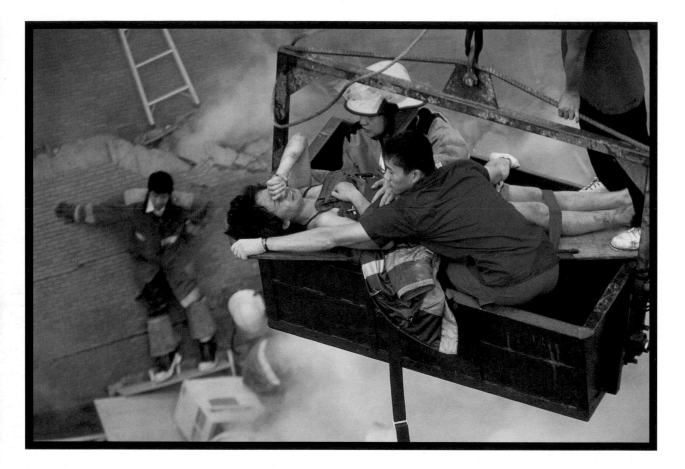

Rescue personnel, working with
equipment usually used for trans-
porting building material, free an
injured woman who had been
trapped for hours in the
Tunghsing Building in Taipei, after
an earthquake in Taiwan. The
quake, measuring 7.6 on the
Richter scale struck early on
Tuesday September 21, while
many people were still asleep.
Over 2,000 people died, tens of
thousands were left homeless,
and thousands of buildings were
toppled in what was the most
powerful earthquake to hit the
island in a century.

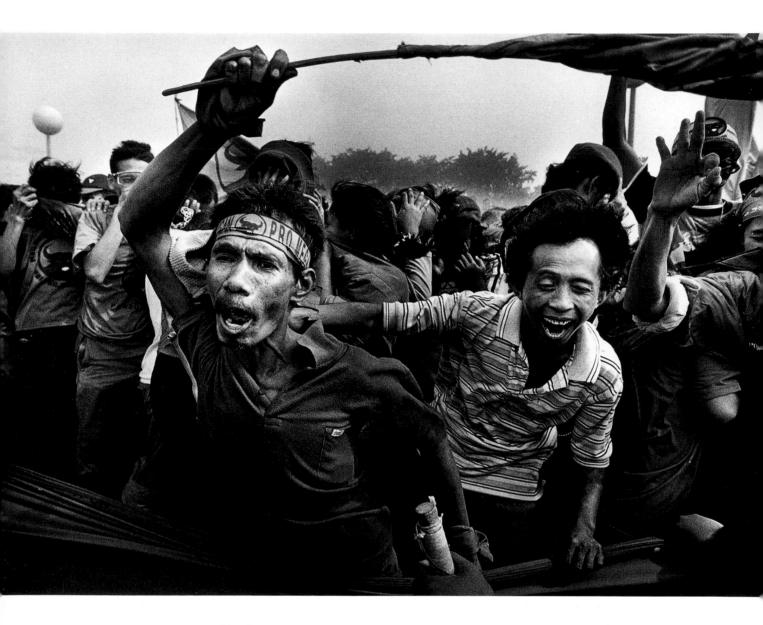

· Jan Dago
Denmark, Liaison Agency, USA

3RD PRIZE SINGLES

Supporters of the PDI (Partai Demokrasi Indonesia Perjuangan) cheer for their leader Megawati
Sukarnoputri in Jakarta early in June. The PDI went on to win the parliamentary elections on June 7,
in a contest that involved 48 parties. It gained 33 per cent of the votes and 153 seats in the 500-seat
parliament. The elections passed peacefully, but violence was to erupt later in the year when parlia-
ment failed to elect Megawati as president.

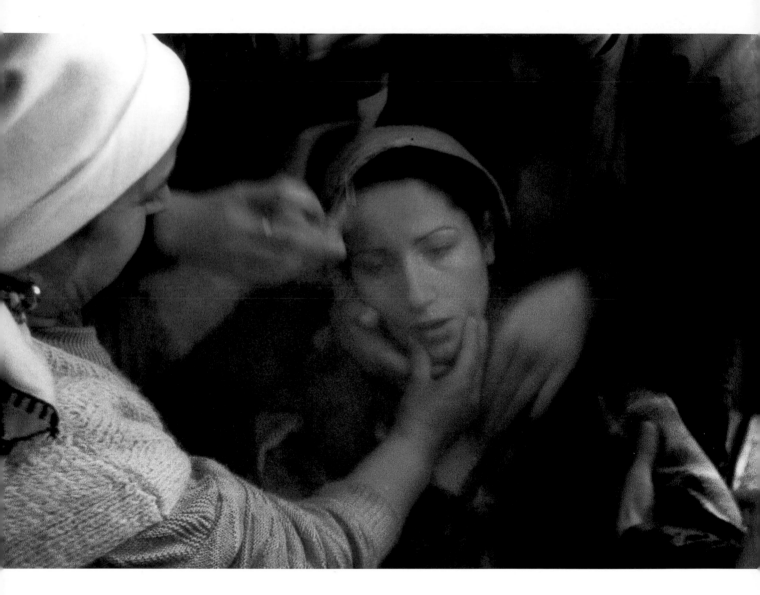

· Yannis Behrakis
Greece, Reuters

1ST PRIZE STORIES

Early in the year, conflict resumed in Kosovo after a fragile truce. In mid-January, 45 ethnic Albanians were killed during a Serb offensive on the village of Racak. Later in the month in Rogovo, west of Priština, 24 ethnic Albanians were ambushed and shot. Western allies demanded that the warring sides attend a peace conference. The first round of talks was held in early February in Rambouillet, France. Above: The wife of a Kosovo Liberation Army soldier faints during his funeral. Top right: A Serb paramilitary removes an AK-47 assault rifle from a victim of the ambush at Rogovo. Below right: Ethnic Albanians pay their respects to a family of five killed during the January outbreak of violence. (story continues)

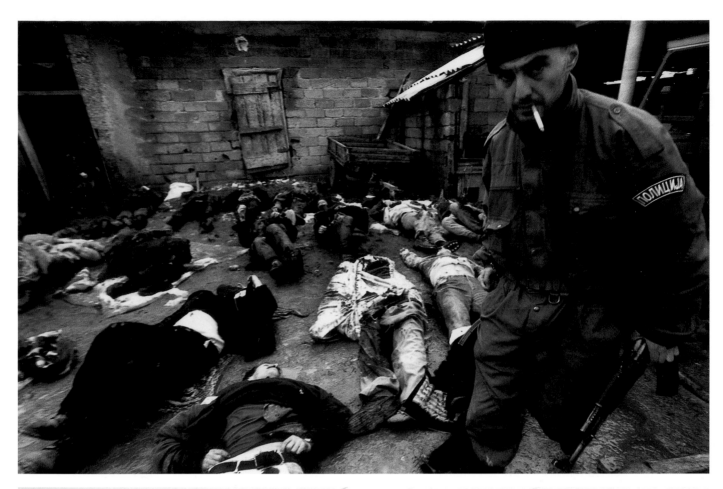

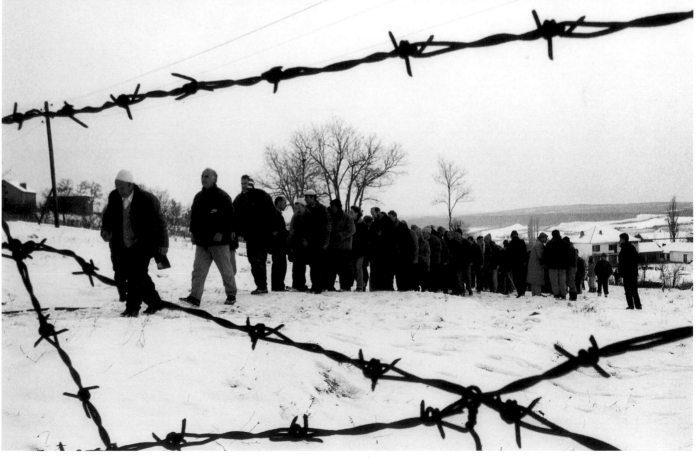

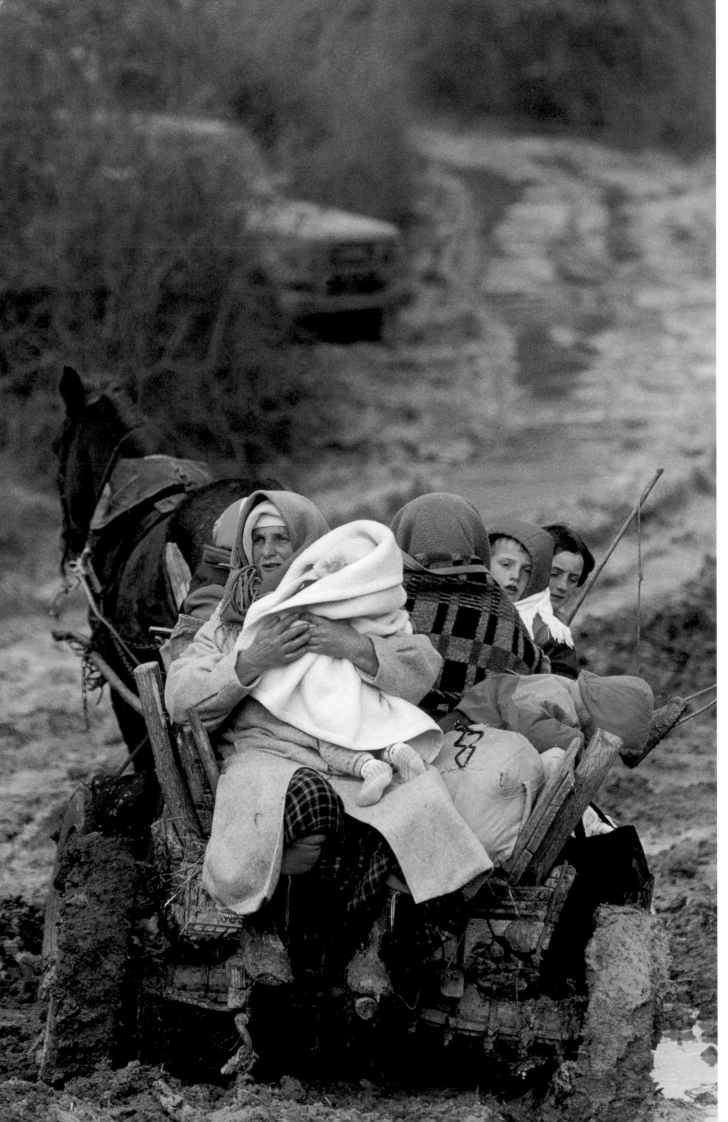

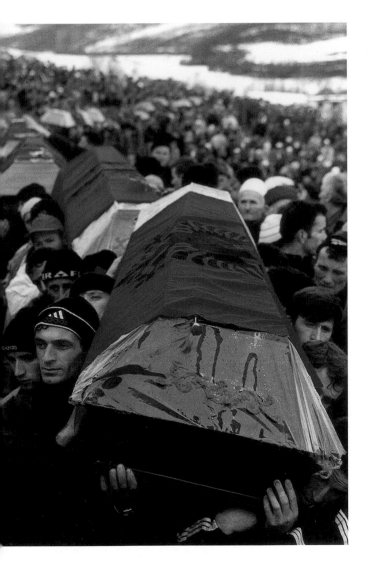

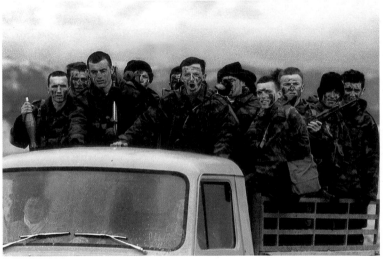

(continued) Clashes in northern Kosovo caused another wave of refugees. Above left: Victims of the killings in Racak are carried in coffins draped with the Albanian flag. Below right: KLA fighters are transported to new positions during clashes with Serb forces.

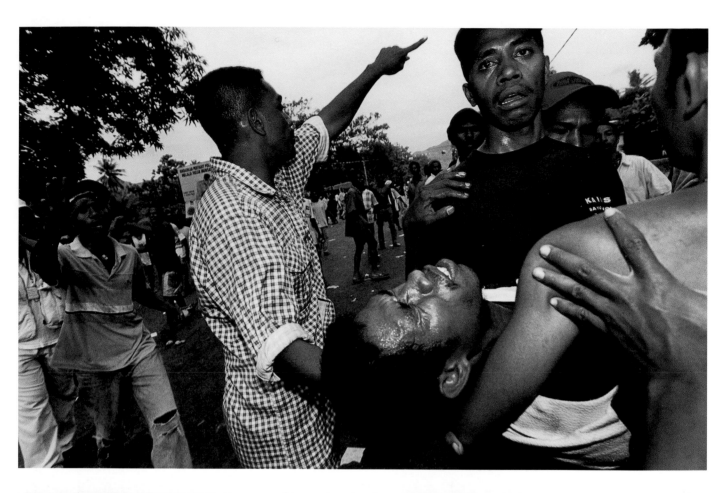

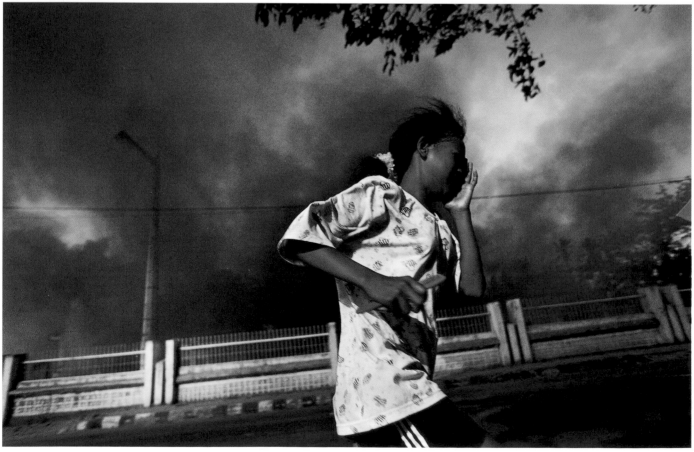

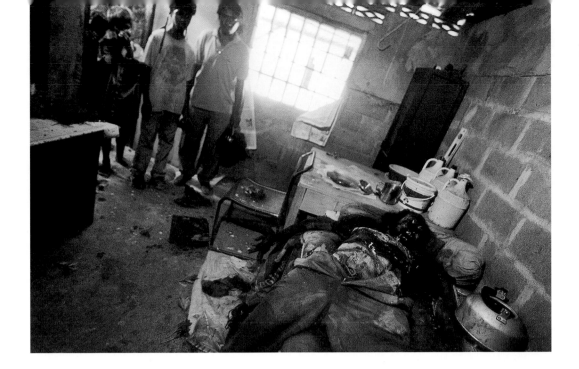

Ilkka Uimonen
Finland, Corbis Sygma for Newsweek

2ND PRIZE STORIES

At the end of August a referendum was held on East Timor, resulting in an 80 percent vote for independence from Indonesia. Tension escalated and violence intensified after results were announced, as pro-Indonesian militia went on a rampage, killing independence supporters and setting fire to buildings. Eventually the UN intervened, sending in an Australian peace-keeping force on September 20. Top right: People returning to their home in the capital Dili find mutilated and burned corpses. Middle: British UNAMET troops arrest a suspected militia member. Below: Australian soldiers direct East Timorese children at a checkpoint in Dili. Next page: Women in the village of Memo grieve after a militia attack has left 20 houses burned and six people dead.

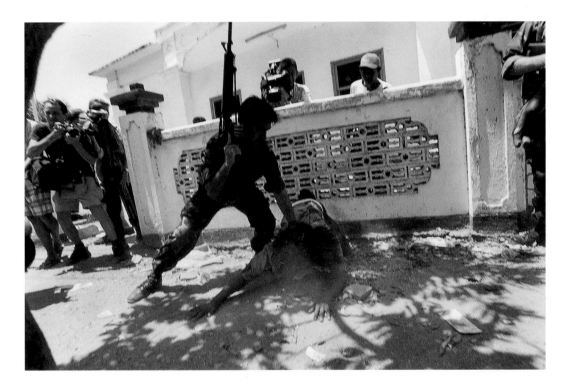

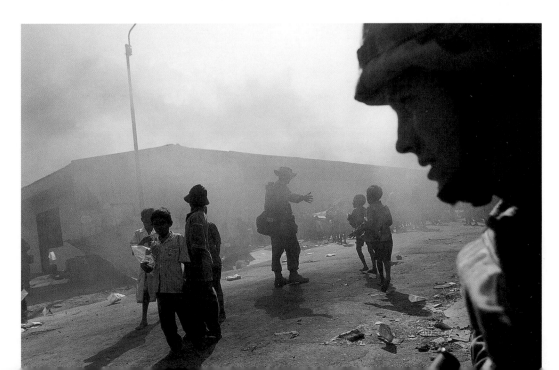

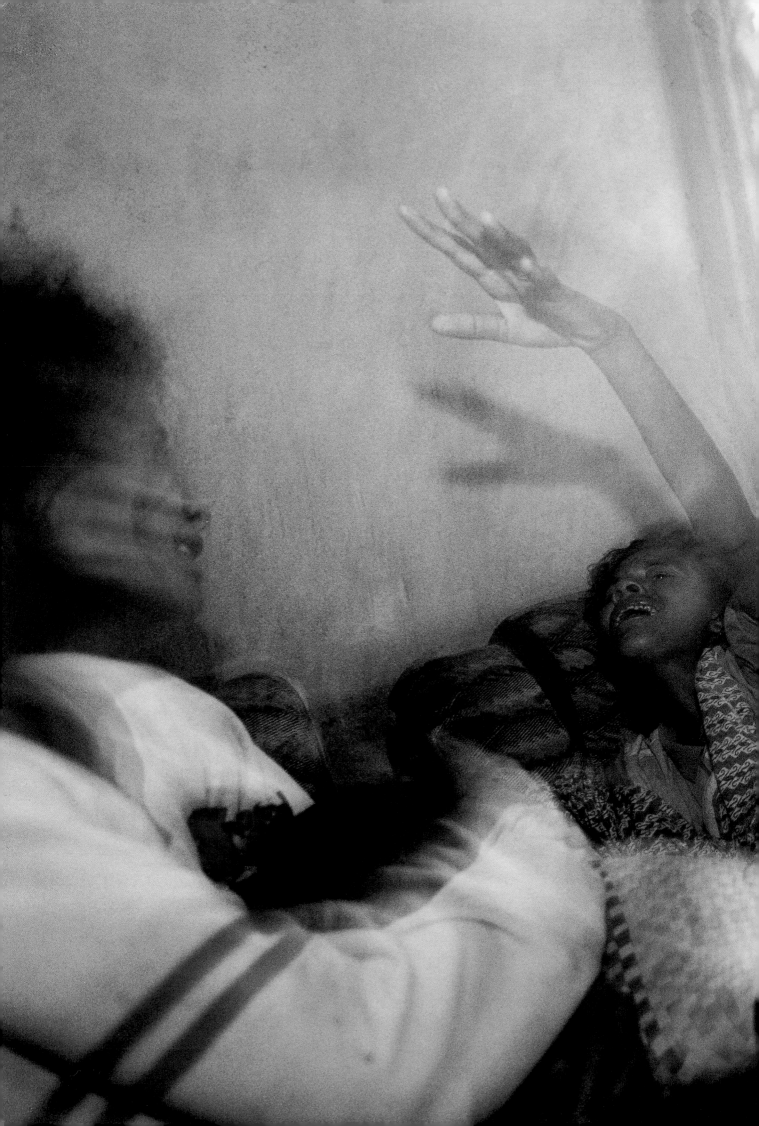

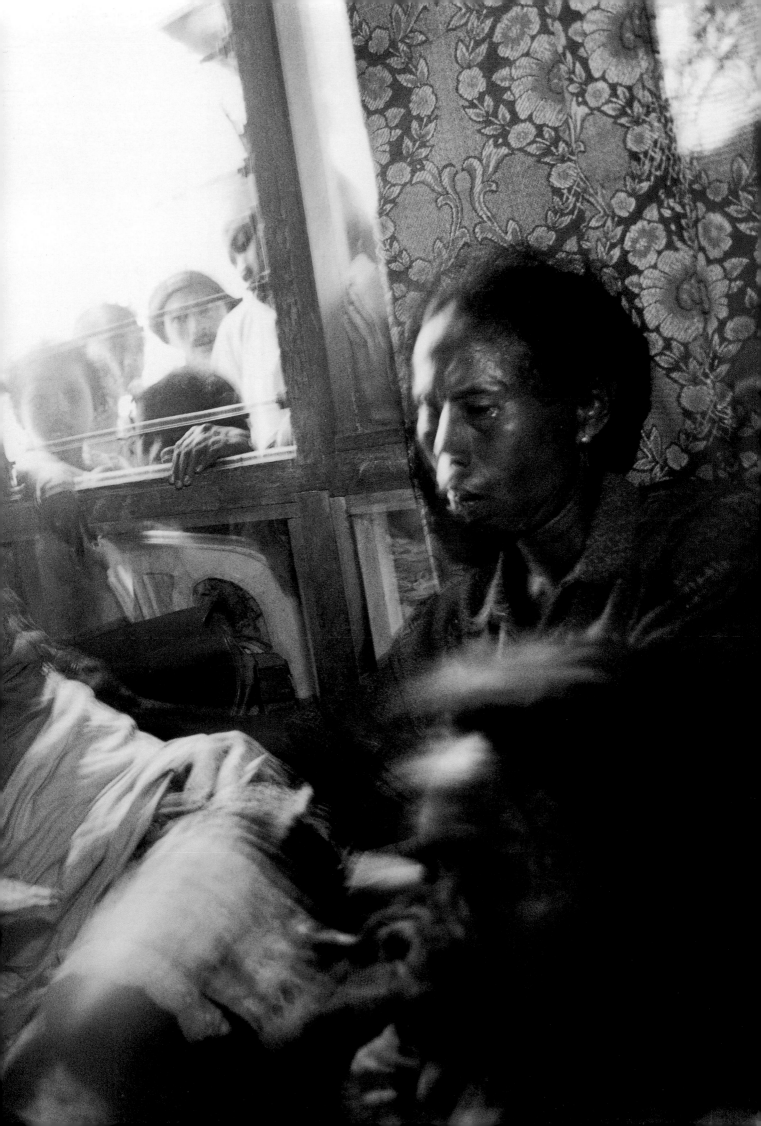

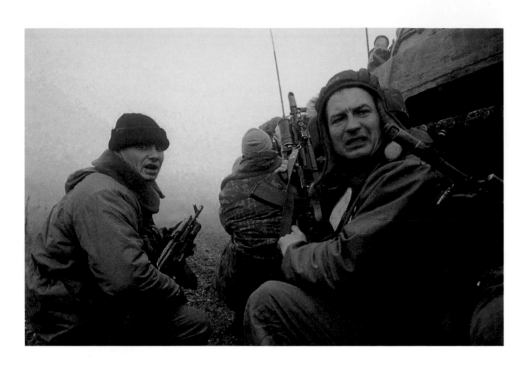

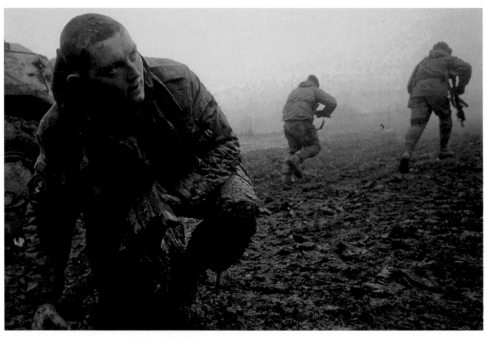

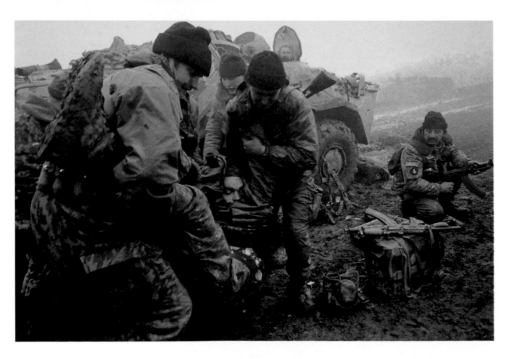

· Yuri Kozyrev
Russia, Associated Press

3RD PRIZE STORIES

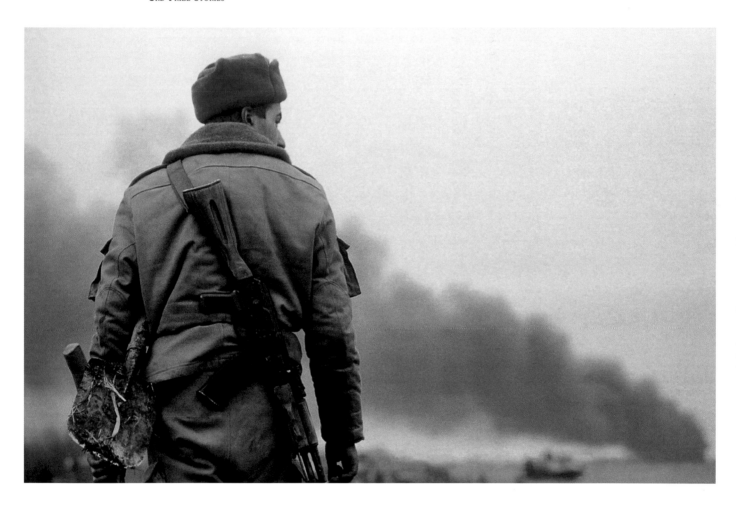

A Russian soldier watches a plume of smoke rising from the town of Urus-Martan in Chechnya. After entering Chechnya in October, Russian forces slowly closed in around the capital Grozny. By December they had encircled the city, which they stormed on the 25th. Urus-Martan, 20 kilometers southwest of Grozny, was a strategic point in the conflict. Facing page: Russian marines repel an attack by Chechen rebels after they were caught in an ambush near Tsentoroi, 45 kilometers southeast of Grozny.

Prizewinners

World Press Photo of the Year 1999

Claus Bjørn Larsen, Denmark, Berlingske Tidende
Wounded Kosovo Albanian Man, Kukës, Albania, 5 April

Page 4

The World Press Photo of the Year Award honors the photographer whose photograph, selected from all entries, can rightfully be regarded as the photojournalistic encapsulation of the year: a photograph that represents an issue, situation or event of great journalistic importance and which clearly demonstrates an outstanding level of visual perception and creativity.

World Press Photo Children's Award

Harald Henden, Norway, Verdens Gang/Black Star, USA
Kosovo Albanians Trapped in a No Man's Land Between Kosovo and Macedonia, April

Page 10

An international children's jury selects the winner of the Children's Award from the entries for the contest. The jury of schoolchildren in the age of 11 and 12 is composed of winners of national educational contests, organized by leading media in nine countries.

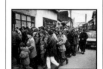

Spot News Singles

1 Cho Sung-Su, Republic of Korea, Corbis Sygma
Explosion During Pro-Megawati Sukarnoputri Demonstration, Jakarta, 20 October

Page 11

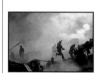

2 Afrim Hajrullahu, Contact Press Images for US News & World Report
Serbian Police Round up Albanians, Priština, 31 March

Page 12

3 Aijaz Rahi, India, Associated Press
Indian Artillery Guns in Battle Zone, Kashmir, 10 July

Page 13

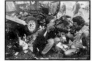

Spot News Stories

1 John Stanmeyer, USA, Saba Press Photos for Time
Riots in Jakarta, November

Page 14

 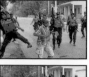 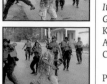

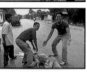

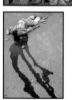

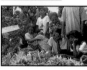

2 Neil Libbert, UK, Network Photographers
Soho Nail Bombing, London, 30 April

Page 18

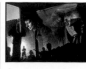

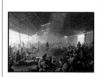

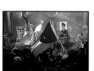

3 John Stanmeyer, USA, Saba Press Photos for Time
Indonesian Riot Police Shoot East Timor Independence Supporter, Dili, 26 August

Page 20

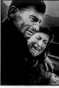

People in the News Singles

1 Paolo Pellegrin, Italy, Agenzia Grazia Neri
Kosovo Albanians Arrive at Refugee Camp

Page 22

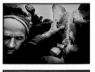

2 Robert Knoth, The Netherlands, Hollandse Hoogte for Metro
Refugee Camp, Caála, Angola

Page 24

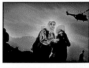

3 Tim Zielenbach, USA, Contact Press Images for Stern, Germany
Jordanians Mourn for King Hussein, Amman, 7 February

Page 25

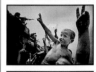

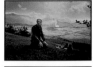

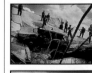

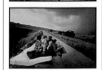

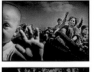

People in the News Stories

1 Jan Grarup, Denmark, Ekstra-Bladet
Kosovo Albanians, March-July

Page 26

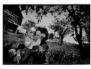

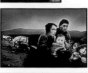 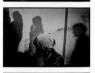 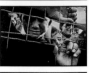

2 Dean Sewell, Australia, The Bulletin
East Timor, Ju

Page 32

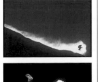

Science and Technology Singles

1 *John Gay, USA, US Navy/Sports Illustrated*
F/A-18 "Hornet" Creates a Water Vapor Cloud During Flight at Speed of Sound

Page 38

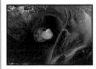

2 *Oliver Meckes & Nicole Ottawa, Germany, Eye of Science for Capital*
Micro-Submarine Inside Artery

Page 40

3 *Michael Adaskaveg, USA, Boston Herald*
Eye Tissue Transplant

Page 41

Science and Technology Stories

1 *Peter J. Menzel, USA, for Stern, Germany*
Latest Robotics

Page 42

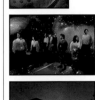

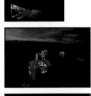
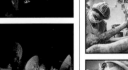
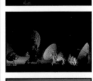
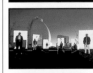
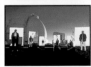

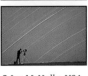

2 *Joe McNally, USA, for National Geographic Magazine*
Observatories

Page 46

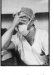

3 *Raphaël Gaillarde, France, Gamma*
Emergency Burns Unit

Page 48

Sports Singles

1 *Eric Larson, USA, Fort Lauderdale Sun-Sentinel*
Surfer, Costa Rica

Page 51

2 *Bruno Fablet, France, L'Equipe*
Paris-Dakar Rally

Page 52

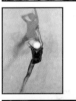

3 *Scott Barbour, New Zealand, Allsport*
Cricket at Sunset, Sydney

Page 54

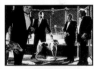

Honorable Mention
Harald Schmitt, Germany, Stern
Getting into Starting Positions, America's Cup

Page 55

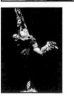

Sports Stories

1 *Adam Pretty, Australia, Allsport*
Portfolio: Australian Sports

Page 56

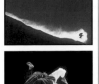
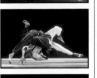

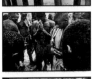
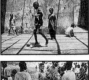
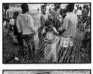
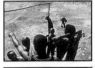
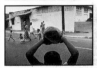

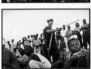

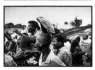

2 *Tim Hetherington, UK, Panos Pictures*
Healing Football, Liberia

Page 59

Prizewinners

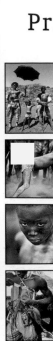

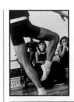

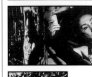

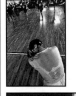

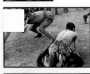
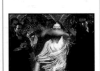
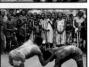
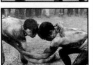
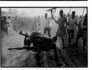
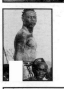
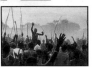

The Arts Singles

1 *Kalpesh Lathigra, UK, for The Independent*
Kathakali Actors, London

Page 64

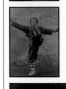

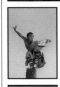

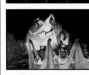
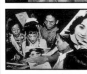

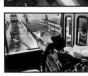

2 *John Peter Hogg, South Africa, The Sunday Independent*
Dance Umbrella Festival, Johannesburg

Page 65

3 *Cecilia Larrabure Simpson, Peru, El Comercio*
Flamenco Group, Barcelona

Page 66

3 *David Stewart-Smith, UK, Katz Pictures*
Nuba Wrestlers, Sudan

Page 62

The Arts Stories

1 *Wang Yao, People's Republic of China, China News Service*
Dancer's Comeback

Page 67

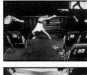

2 *Isabel Muñoz, Spain, Agence Vu, France*

Page 70

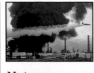

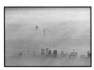

3 *Karl Lang, Germany*
Bridges

Page 72

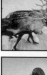

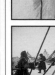

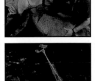
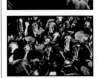
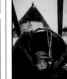

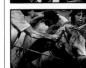
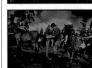

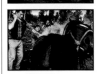

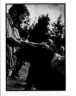

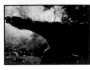

Nature and the Environment Singles

1 *Enric Marti, Spain, Associated Press*
Oil Refinery Burns Following Earthquake, Izmit, Turkey, 18 August

Page 75

2 *Tomasz Gudzowaty, Poland, Wprost magazine*
Wildebeest Cross Mara River, Kenya

Page 76

3 *Olivier Boëls, France, Contrast Photo Agency, Canada*
Pollution Over Paris

Page 77

Nature and the Environment Stories

1 *Tine Harden, Denmark, Politiken*
Wild Horses of Galicia

Page 78

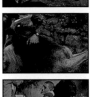

2 *Claudine D[...] France, Agen[...]*
Siberian Nom[...]

Page 82

Prizewinners

General News Singles
1 Yuri Kozyrev, Russia, Associated Press
Wounded Russian Soldier, Chechnya, 16 December

Page 120

2 David W. Smith, Canada, Taiwan News/Corbis Sygma for US News & World Report
Earthquake Victim Rescue, Taipei, 22 September

Page 122

3 Jan Dago, Denmark, Liaison Agency, USA
Supporters Cheer for Megawati Sukarnoputri, Jakarta, 3 June

Page 123

2 Trent Parke, Australia, The Australian newspaper
Beaches

Page 113

3 Mike Abrahams, UK, Network Photographers
Christian Worship Around the World

Page 117

General News Stories
1 Yannis Behrakis, Greece, Reuters
Kosovo, January-February

Page 124

3 Yuri Kozyrev, Russia, Associated Press
Russian Troops in Chechnya, December

Page 132

2 Ilkka Uimonen, Finland, Corbis Sygma for Newsweek
East Timor

Page 128

Participants 2000 Contest

In 2000, 3,981 photographers from 122 countries submitted 42,215 entries. The participants are listed according to nationality as stated on the contest entry form. In unclear cases the names are listed under the country of mail address.

ALBANIA
Feliks Bilani
Bevis Fusha
Visar Kryeziu
Thanas Pani
Marketin Pici
Sulo Pleurat
Llesh Prendi
Namik Selmani

ALGERIA
Saïd Imatovkene
Hamid Seghilani
Hocine Zaourar

ARGENTINA
Marcelo Aballay
Jose del Valle Nuno
Martin C.E. Acosta
Osvaldo Ancarola
Bernardino A. Avila
Alejandro Balaguer
Ruben Adrian Cabot
Pablo Enrique Cerolini
Alejandro Chaskielberg
Boris Cohen
Herman Javier Corba
Daniel Dapari
Santiago Echaniz
Benito Espindola
Enrico Fantoni
Sixto Farina
Julio Giustozzi
Oriana Gonzales
Ramón González
Sergio Gabriel Goya
Anibal Greco
Claudio Herdener
Leonardo La Valle
Pablo Alfredo Luca
Juan Pablo Maldovan
Claudio Mamin
Juan Carlos Marchak
Sebastian Marjanov
Luis Martin
Miguel Angel Mendez
Luis Alberto Micou
Maria Luisa Musso
Rodrigo Néspolo
Christopher Pillitz
Pablo Aurelio Puente
Sergio Omar Quinteros
Sergio Ruiz
Juan Jesús Sandoval
Rosana Schojett
Jose Maria Seoane
Carlos Andres Settepani
Nestor Roberto Sieira
David Sisso
Osvaldo Stigliano
Gustavo Marcelo Suarez
Sebastian Szyd
Luciano Thieberger
Marcelo Alejandro Ullua
Antonio Valdez
Juan Domingo Vera
Verónica Vichi
Diego Vinitzca
Enrique Wartenberg

ARMENIA
Stefan Alekyan

AUSTRALIA
Gillian Allen
Dave Anderson
Julian Andrews
Narelle Autio
Steve Baccon

Paul Blackmore
Philip Blenkinsop
Patrick Brown
Philip Brown
David Caird
David Callow
Gabriele Charotte
Steve Christo
Warren Clarke
Tim Clayton
Kevin Clogstoun
Simon Cocksedge
William Crabb
Nick Cubbin
Ian Charles Cugley
Stephen Dupont
Rob Elliott
Peter Enright
Brendan Esposito
George Fetting
Tim Georgeson
Craig Golding
Steve Gosch
Philip Gostelow
David Gray
Robert Griffith
Patrick Hannagan
Sahlan Hayes
Phillip Hearne
Mathias Heng
Phil Hillyard
Jessica Hromas
Martin Jacka
Quentin Cameron Jones
David L. Kelly
Grainger Laffan
Peter Daniel Lik
Bruce Long
Dean Martin
Jean-Dominique Martin
Regis Martin
Samuel McQuillan
Mike McWilliam
Andrew Meares
Peter Merkesteyn
Andrew Merry
Paul Miller
Palani Mohan
Nicholas Moir
Matthew Munro
Renee Nowytarger
Barry O'Brien
Trent Parke
David Dare Parker
Jeremy Piper
Gregg Porteous
Adam Pretty
Peter Rae
Matthew Reed
Ilana Rose
Sean Kennedy Santos
Dean Sewell
Russell Shakespeare
Steven Siewert
Troy Snook
Ross Swanborough
Tasso Taraboulsi
Andrew C. Taylor
Grant Turner
Nick Vasic
Angelo Velardo
Andy Zakeli

AUSTRIA
Heimo Aga
Toni Anzenberger
Heinz-Peter Bader
Contessina-Diana Bauer
Robert Fleischanderl
Arno Gasteiger
Christine Grancy
Peter Granser
Christoph Grill
Alexander Kaiser
Heimo Kernmayer
Robert Klein
Lois Lammerhuber
Christian Lapp
Christoph Lingg
Wolfgang W. Luif
Evy Mages
Walter Mayer
Dieter Nagl
Franz Neumayr

Rita Newman
Helmut Ploberger
Josef Polleross
Reiner Riedler
Chris Sattlberger
Roland Schönbauer
Arabella Schwarzkopf
Werner Thiele
Josef Timar
Ludwig Vysocan
Steve Wagner

AZERBAIJAN
Elnur Babayev
Rafig Gambarov
Ilgar Jafarov
Hasan Oglu Mirnaib

BANGLADESH
Abir Abdullah
Babu Ahmed
Suvash Kumer Barman
Firoz Chowdhury
Mohidul Haque
Sanaul Haque
Proshanta Karmakar
Abu Taher Khokon
Abdul Hamid Kotwal
Md. Seraj Miah
Shehzad Noorani
Khaled Sattar
Md Shafayet Hossain
Hashi Talukder
Md Wahiduzzaman

BARBADOS
Jefferson Jackman

BELARUS
Vladimir Bazan
Alyaxsandar Halkevich
Anatoli Kljashtchuk
Artur Prupas

BELGIUM
Valerie Berteau
Hilde Bock
Joost Bock
Patrick Bollen
Robert Brugge
Vicky Ceelen
Marc de Clercq
Johan van Cutsem
Mine Dalemans
Serge De Toledo
Tim De Waele
Sophie Deneumostier
Marc Deville
Tim Dirven
Caroline Ducobu
Stefan Geukens
Serge Goloubenko
Peter Hoof
Roger Job
Eddy Kellens
Jan Locus
Firmin Maitre
Frederic Materne
Jean-Pierre Monhonval
Philip Reynaers
Dominique Simon
Lieve Snellings
Bruno Stevens
Dieter Telemans
Gaël Turine
Wim Van Cappellen
Stephan Vanfleteren
Alex Vanhee
J.-M. Vantournhoudt
Jan Vel
Eva Vermandel
Peter Voecht

BOLIVIA
Patricio Crooker
Jorge Gutierrez Avila
E. Calderon de la Barca
Martha Vázquaz

BOSNIA-HERZEGOVINA
Darko Babic
Fehim Demir
Zijah Gafic

Senad Gubelic
Haris Memija
Damir Sagolj
Samir Saletovic
Didier Torche
Drago Vejnovic
Almin Zrno

BRAZIL
R. Almeida de Oliveira
Antonio Almeida Varela
W. Alvares de Carvalho
M. Alves de Almeida
Joaquim Alves Filho
Euler Alves Peixoto
Sergio Amaral
Paulo Amorim
J. Anchieta X. de Sousa
Eliaria Maria Andrade
Ricardo De Aratanha
Alberto Cesar Araujo
Leonardo Aversa
Nário Barbosa da Silva
Alexandre Belém
Mônica Bento
José Geraldo Borges
Mario Borges Junior
Luiz Braga
Otavio Brazil
Manoel de Brito
Leonardo Caldas
W. Carvalho Franco
Ivaldo Cavalcante Alves
Antonio Cazzali
F. Celso Cannalonga
A. Chaves de Oliveira
André Coelho Cardoso
Julio Cordeiro
André Correa
N. Hamilton Costa Jr
Fernando Costa Netto
Antonio Coutinho
Antonio José Cury
Leonardo Dias Corrêa
Ulysses F. de Freitas
G.B. Fernandes Dias
J.F. Fernandez da Silva
Denis Ferreira Netto
Victor Lucio Figueiredo
V. Freitas Ferreira Lima
Luiz Antonio Giope
Adriana Girodo
Ivo Gonzalez Marinho
Caio Garcia Guatelli
Yone Guedes da Costa
F. Guedes de Lima
Genaro Antionio Joner
Ana Emilia Jung
Andréa König Graiz
Marco André Lima
Levis Litz
Gustavo C. Lourencão
Benito Maddalena
G.C. Marques
Guimaraes
Enrique J. Matute
L.C. de Melo Nuñes
Roberto Mendes de Oliveira Castro
Antonio Menezes
M. Toshiyuki Michida
Mathilde Molla
Itamar Morais Nobre
S. Moreira e Silva Filho
Andrea Motta
Carlos Alves Moura
Glauco Moura Rossini
A. Claro Oliveira
Ronaldo Oliveira
Sergio Ricardo Oliveira
Antonio Carlos Paz
Emilio Sales Pedroso
F. Pereira de Souza
Eraldo Pres da Silva
José Emilio Perillo
Marcos André Pinto
Marcelo Prates
Eduardo Queiroga
Heudes Regis
Suzana Barreto Ribeiro
E. Ribeiro de Queiroz
Monica Richter
João Rodrigues
G. Tadday Rodrigues

E. Rodrigues de Freitas
A.P. Rodrigues Filho
Teotônio José Roque
E. P.F.T. dos Santos
Anderson Santos
P.R. Santos Araújo
P.C. Santos Araújo
F. Santos Dantas
A. Severino da Silva
José Patricio Silva
Alberto Leandro Silva
Marcelo Ferreira Silva
Joel Soares da Silva
Luís Carlos Tajes
Marco Flores Teixeira
André Telles
João Testa de Giusti
João Urban
Mauricio Val de Souza
Cláudio Versiani
G. Vicente de Brito Maia
Renata Victor de Araujo
Mauro Vieira
Marcelo Vigneron
Marcello Vitorino
Silva Wanderlan
Mônica Zarattini

BULGARIA
Nick Chaldakov
Roumen Georgiev
Mishael Gueron
Ilian Iliev
Lyubomir Jelyaskov
Nina Nikolova
Detelin Nikov
Oleg Popov
Svilen Stanoev
Todor Todorov
Ivan Sabev Tzonev
Ivaylo Velev
Vesel Vesselinov
Boyan Yurukov

BURKINA
Aristide Ouedraogo

CAMBODIA
Chan Vitharin
Chhoy Pisei
Keo Sothy
Khem Sovannra
Remissa Mak
Tang Chhin Sothy

CAMEROON
Dieudonne Abianda
E.D. Djitouo Ngouagna
Paphaël Mbiele Happi

CANADA
Carlo Allegri
Berge Arabian
Tim Atherton
Stan Behal
Bernard Beisinger
Normand Blouin
Tony Bock
Ruth Bonneville
Susan Bradnam
Bernard Brault
Dale Brazao
Phil Carpenter
Peter Casolino
Andrew Clark
Gary Crallé
Barbara Davidson
Hans Deryk
Gino Donato
Pam Doyle
Bruce Edwards
Richard Emblin
Alison Emde
Ken Faught
Benoît Gariépy
Brian James Gavriloff
Nicolas Girard
Wayne Glowacki
Mike Grandmaison
Roxanne Gregory
Jacques Grenier
Caroline Hayeur
Jonathan Hayward
Philip Hossack

Emiliano Joanes
Rene Johnston
Ken Kerr
Todd Korol
Judith Kostilek
Marie-Susanne Langille
Julie Langpeter
Richard Lautens
Roger Lemoyne
John Lucas
Doug MacLellan
Rick Madonik
John Mahoney
Orlando Marques
Sylvain Mayer
Bryan McBurney
Allen McInnis
Jeff McIntosh
Boris Minkevich
Martin Mraz
Marcus Oleniuk
Louise Oligny
George Omerean
Panagiotis Pantazidis
André Pichette
Vincenzo Pietropaolo
Peter Power
Duane Prentice
Joshua Radu
Jim Rankin
Craig Robertson
Marc Rochette
Chuck Russell
Steve Russell
Derek Ruttan
Rick Rycroft
Bill Sandford
Chris Schwarz
Dave Sidaway
Steve Simon
David W. Smith
Gregory Southam
Boris Spremo, C.M.
Lyle Stafford
Andrew Stawicki
Fabrice Strippoli
Homer W. Sykes
Vincent Talotta
Peter J. Thompson
Robert Tinker
David Trattles
Sandra Traversy
Stephen Uhraney
Ron Ward
George Webber
Bernard Weil
Darren Whiteside
Larry Wong
Jim Young
Iva Zimová

CHILE
Eduardo Beyer
Marcela Castillo
Hector Flores Scrofet
Marcos Guiñez Castro
Jaime Hernandez
Alvaro Larco Gajardo
Tomas Munita Philippi
Jaime Puebla
Victor Toledo Aguilar

COLOMBIA
Fabiola Acevedo
Aymer Alvarez
Fredy Amariles Garcia
Felipe Caicedo Chacon
Abel Cardenas Ortegon
Dario Augusto Cardona
Gerardo Chaves Alonso
Rodrigo Cicery Beltran
Jesus Colorado Lopez
Milton Diaz Guillermo
Jose Gomez Mogollon
Diego González Torres
Jose Luis Guzman
Julian Lineros Castro
Eduardo Maldonado
William Martinez
Hector Moreno Valdes
Jorge Paez Fonseca
Bernardo Peña Olaya
Jaime Perez Munevar
Luis Ramirez Ordonez

Pedro Reina Leon
Henry Romero
M.Saldarriaga Quintero
Juan Sanchez Ocampo
Jorge Sanchez Zapata
Roberto Schmidt
Donaldo Zuluaga Velilla

COSTA RICA
Gloria Calderon
Mario Castillo Navarro
Mario Fernández Silva
Eduardo López Lizano
Marco Monge Rodriguez

CROATIA
Darko Bandic
Antonio Bat
Vladimir Dugandzic
Filip Horvat
Sasa Kralj
Duric Kresimir
Mario Kucera
Lidija Maricic
Srecko Niketic
Zlatko Ramnicer
Kristina Stedul
Denis Stosic
Nikola Tacevski
Kos Vlado
Srdjan Vrancic

CUBA
Roque Adalberto
Alejandro Azcuy
Niurka Barroso
José Berenguer Garcia
Luis Bruzón Fuentes
Hector Fernandez Ferrer
Jorge López Viera
Ahmed Velazquez

CYPRUS
Andreas Vassiliou

CZECH REPUBLIC
Günter Bartos
Josef Bradna
Ivo Dokoupil
Dragan Dragin
Radek Grosman
Antonin Kratochvil
Tomas Krist
Blanka Lamrová
David Neff
Michal Novotny
Jiri Pekarek
Milan Petrik
David Port
Michal Prokop
Josef Ptáček
Roman Sejkot
Jan Sibik
Josef Sloup
Evzen Sobek
Tomas Svoboda
Jaroslav Tatek
Boris Trickovic

DENMARK
Adam Amsinck
Tomas Bertelsen
Lars Bertelsen
Claus Boesen
Thomas Borberg
Asger Carlsen
Jakob Carlsen
Jan Dago
Casper Dalhoff
Jacob Ehrbahn
Jorgen Flemming
Finn Frandsen
Jan Anders Grarup
Tine Harden
Mads Ifversen
Michael Jensen
Christian T. Joergensen
Thomas V. Jorgensen
Lars Krabbe
Joachim Ladefoged
Claus Bjørn Larsen
Søren Lauridsen
Søren Lorenzen
Claus Lunde

Sif Meicke
Nils Meilvang
Ricky John Molloy
Peter Overgaard
Thomas Roenn
Thomas Sjorup
Preben B. Soborg
Jan Sommer
Detlef Stoller
Michael Svenningsen
Ernst Tobisch
Martin Toft
Anders Vendelbo
Robert Wengler

ECUADOR
Stalin Diaz Suarez
Cesar Guaña Cando
Jorge Guzman Coello
Victor Ipanaque Proano
Alfredo Lagla Lagla
Galo Paguay Becerra
Jorge Penafiel Fajardo
Leen Prado Viteri
Cesar Rosa Araúz
ManuelSosa Boada
Eduardo Teran Urresta
Jorge Vinueza Garcia

EGYPT
Albert Antoune
Gamal El Arabe
Khaled El Figi
Wd Zenhom El Shamy
Hassan Aly Hassan
Mustapha Ibrahim
W. Amin Mahanna
D. Ebrahem Md Mostafa
Marwan Naamani
Wael Kamal El-Din Taha

EL SALVADOR
Francisco Campos
Yuri Cortez Avalos
Milton Flores
Fernando Golscher
Carlos Gonzálezl
Vladimir Lara
Salvador Melendez
Alberto Morales
Jose Moreno
Ulises Rodríguez

ERITREA
Russom Fesahaye

ESTONIA
Tiit Räis

ETHIOPIA
Dagne Abera
Fasika Ermias Mammo
Chirubel G. Yohanis
H. Kenfemichel
Werke Tegegn Berhe
Th. Teshome Kebede
Tewodros Tilahun

FINLAND
Matti Ihatsu
Petteri Kokkonen
Lauri Mannermaa
Jorma Mylly
Jussi Nukari
Hans Paul
Erkki Raskinen
Eetu Sillanpää
Veikko Tabell
Ilkka Uimonen

FRANCE
Ammar Abd Rabbo
Lahcène Abib
Pierre Adenis
Catherine Alonso Krulik
Johannes Armineh
Yann Arthus-Bertrand
Patrick Artinian
Maher Attar
Olivier Aubert
Alain Auboiroux
Aurélie Audureau
Patrick Aventurier
Georges Bartoli

Frederic Bassemayousse
Gilles Bassignac
Francois Baudin
Eric Bauer Dantzer
Patrick Baz
Jean Becker
Arnaud Beinat
Sam Bellet
Remi Benali
Halim Berbar
Gilles Bertrand
Thierry Besançon
Alain Bétry
Bernard Bisson
Romain Blanquart
Olivier Boëls
Chr. Boisseaux-Chical
Samuel Bollendorff
Guillaume Bonn
Lionel Boscher
Jean-Marc Bouju
Denis Boulanger
Alexandra Boulat
Jean-Christian Bourcart
Philippe Bourseiller
Eric Bouvet
Gabriel Bouys
Philippe Brault
Jean-Pierre Brunet
Alain Buu
Eric Cabanis
Serge Cantó
Sarah Caron
Jean-François Castell
Julien Chatelin
Benyoucef Cherif
Sophie Chivet
Olivier Chouchana
Pierre Ciot
Serge Moreno Cohen
Stephane Compoint
Jerome Conquy
Alexis Cordesse
Carl Cordonnier
Christophe Coste
Christophe Courteau
Jean-Louis Courtinat
Jean-Pierre Cousin
Gilles Crampes
Denis Dailleux
Georges Dayan
H. De Wurstemberger
Gautier Deblonde
Regis Delacote
Luc Delahaye
Jerome Delay
Michel Denis-Huot
Lionel Derimais
Xavier Desmier
T. Doan de Champassak
Claudine Doury
Christophe Dubois
Alexis Duclos
Emmanuel Dunand
Philippe Dupre
Philippe Dupuich
Andre Durand
Patrick Durand
Georges Dussaud
Philippe Eranian
Isabelle Eshraghi
Patricio Estay
Wilfrid Esteve
Bruno Fablet
Albert Facelly
Gilles Favier
Eric Feferberg
Didier Fèvre
Franck Fife
Jehan Pierre Filatriau
Laurence Fleury
François Fontaine
Hugues Fontaine
Eric Franceschi
Raphaël Gaillarde
Cedric Galbe
Beatrice Gea
Norbert Genetiaux
Jean-Marc Giboux
Frédéric Girou
Georges Gobet
Philippe Gontier
Didier Goupy
José Grain

Diane Grimonet
Olivier Grunewald
Laurent Guerin
Claude Guillard
Daniël Gullian
Michel Gunther
Antoine Gyori
Valéry Hache
Eric Hadj
Philippe Henry
Guillaume Herbaut
Jean-Marie Hervio
Patrick James
Olivier Jobard
Thomas Jouanneau
Gérard Julien
Debra Kellner
Pascale Kobeh
A. Kremer-Khomassouridze
Jean Philippe Ksiazek
Brigitte Lacombe
Vincent Laforet
Stephane Lagoutte
Patrick Landmann
Jacques Langevin
Francis Latreille
Frederic Le Floc´h
Didier Lefevre
Vincent Leloup
Eddy Lemaistre
Michel Lipchitz
Philippe Lopparelli
Laurence Louis
Olivier Luc
Jean-Luc Manaud
Manoocher
Olivier Marguerat
Olivier Martel
Clement Martin
Georges Merillon
Pierre Mérimée
Michel Moine
Luc Moleux
Laurent Monlaü
Bruno Morandi
David Morel
Jean Francios Muguet
Hop Nguyen
Jose Nicolas
Alain Noguès
Emmanuel Ortiz
Serge Pagano
Arnelle Paranthoen
Cédric Pasquini
Pascal Pavani
Micheline Pelletier
Gilles Peress
Laurent Pinsard
Michel Pissotte
Jean-Luc Piteux
Philippe Plailly
Gerard Planchenault
Jean-Pierre Porcher
Yud Pourdieu le Coz
Frederic Presles
Eric Prinvault
Dominique Quet
Noël Quidu
Benoît Rajau
Romuald Rat
Stephane Remael
Mila Reynaud
Reza
Patrick Robert
Joël Robine
Alexis Rosenfeld
Jean-Philippe Rousseille
Denis Rouvre
Lizzie Sadin
Victor Saez
Joël Saget
Eric Sampers
Frédéric Sautereau
David Sauveur
Sylvain Savolainen
Benoit Schaeffer
Pascal Segretain
Ahmet Sel
Antoine Serra
Michel Setboun
Vlastimir Shone
Jean-Manuel Simoes
Christophe Simon

Jean-Noël de Soye
Françoise Spiekermeier
Laurent Starzynska
Laurent Stockt
Dominique Szczepanski
Philippe Taris
Robert Taurines
Amboise Tezenas
Nathalie Tirot
Jacques Torregano
Olivier Touron
Jean-Michel Turpin
Gérard Uferas
Patrick Valasseris
Laurent Vautrin
Pierre Verdy
Maya Vidon
Lorenzo Virgili
Vo Trung Dung
Patrick Wallet
Hervé Williencourt
Bernard Wis
Alfred Yaghobzadeh

GEORGIA
Tamaz Bibiluri
Irakliy Chokhonelidze

GERMANY
Adalbert Adaszynski
Melanie Ahlemeier
Alexander Alfes
Carola Alge
Albert Alten
Ingo Arndt
Bernd Arnold
David Ausserhofer
Dirk Bauer
Alexander Baum
Michael Bause
Siegfried Becker
Fabrizio Bensch
Wonge Bergmann
Klaus Beth
Birgit Betzelt
Daniel Biskup
Christoph Boeckheler
Sebastian Bolesch
Stefan Boness
Wolfgang Borm
Katharina Bosse
Michael Braun
Frank Bredel
Matthias Breiter
Ulrich Brinkhoff
Hans Jürgen Britsch
Martin Brockhoff
Ina-Maria Brämswig
Mark Bullik
Hans-Jürgen Burkard
Achim Buttkewitz
Jörg Böthling
Wolf Böwig
Peter Christmann
Matthias Creutziger
Sven Creutzmann
Michael Dalder
Peter Dammann
Tomas Dashuber
Uli Deck
Christian Ditsch
Thomas Duffé
Thomas Dworzak
Erwin Döring
Sven Döring
Winfried Eberhardt
Hans Richard Edinger
Ralf Ehrlich
Frauke Eigen
Wolfgang Eilmes
Stephan Elleringmann
Stephan Engler
Blasius Erlinger
Volker Essler
Nicolas Felder
H. Fernandes da Silva
Rüdiger Fessel
Jockel Finck
Ute Fischer
Gerald Forster
Klaus Franke
Arve Frase
Helmut Fricke
Horst A. Friedrichs

Sascha Fromm
Ronald Frommann
Mike Fröhling
Jürgen Gebhardt
Boris Geilert
Uwe George
Franz Gerg
Fidel Gerlachas
Peter Ginter
José Giribás Marambio
Wilfrid Glatten
Bodo Goeke
Igor Gorovenko
Gosbert Gottmann
Eberhard Grames
Jan Greune
Benno Grieshaber
Kirsten Haarmann
Esther Haase
Gabriel Habermann
Michael Hagedorn
Oliver Hamann
Alexander Hassenstein
Gerhard Heidorn
Alexander Heimann
Wim Helm
Arnd Hemmersbach
Andreas Herzau
Catharina Hess
Stefan Hesse
Katharina Hesse
Kerstin Heyde
Markus C. Hildebrand
Karl-Josef Hildenbrand
Erik Hinz
Joachim Hirschfeld
Udo Horn
Wolfgang Huppertz
Bernd Jonkmanns
Henning Kaiser
Enno Kapitza
Karl-Bernd Karwasz
Thomas Kienzle
Wolfgang Kiesel
Robert Kliem
Gunter Klötzer
Hermann Knippertz
Herbert Knosowski
Hans-Jürgen Koch
Heidi Koch
Vincent Kohlbecher
Michael Kottmeier
Ulrich Kox
Michael Krämer
Reinhard Krause
Stephan Krudewig
Guido Krzikowski
Bernhard Kunze
Andrea Künzig
Georg Kürzinger
Peter Lammerer
Karl Lang
Martin Langer
Elke Maria Latinovic
Gudrun Laufer-Vetter
Robert Lebeck
Jens Liebchen
Dorothea Loftus
Gerd Ludwig
André Lützen
Birgit-Cathrin Maier
Martin Maier
Thomas Mangold
Hans Manteuffel
Ralf Maro
Nicole Maskus
Markus Matzel
Fabian Matzerath
Oliver Meckes
Rudi Meisel
Guenther Menn
Dieter Menne
Veit Mette
Heiko Meyer
Thorsten Mischke
Achim Multhaupt
Bernd Müller
Bodo Müller
Peter Müller
Ralf Nachtmann
Horst Nebe
Anna Neumann
Anja Niedringhaus
Reinhard G. Niessing

Axel Nordmeier
Nick Nostitz
Roland Obst
Nicole Ottawa
Jens Palme
Michael Penner
Laci Perenyi
Thomas Pflaum
Martin Pudenz
Frank Pusch
Andreas Püfke
Roland Rasemann
Andreas Reeg
Jiri Rezac
Herbert Richenzhagen
Astrid Riecken
Christian Riefling
Michael Riehle
Lutz Roessler
Daniel Roland
Tina Ruisinger
Norbert Rzepka
Gerard Saitner
Ottfried Sannemann
Martin Sasse
Rüdiger Schall
Ingo Scheffler
Michael Schindel
Gregor Schläger
Bernhard Schmitt
Harald Schmitt
Walter Schmitz
Harry Schnitger
Martin Schoeller
Edgar Schoepal
Markus Schreiber
Bernd Schuller
Frank Schultze
Helmut R. Schulze
Stephan Schütze
Horst Schäfer
Oliver Sehorsch
Uwe Seibt
Siegfried Seibt
Stephan Siedler
Barbara Siewer
Falko Siewert
Renado Spalthoff
Martin Specht
Thomas Starost
Berthold Steinhilber
Marc Steinmetz
Wolfgang Steinruck
Björn Steinz
Thomas Stephan
Ralf Stockhoff
Angelika Stocki
Patrik Stollarz
Anna E. Stärk
Camay Sunqu
Olaf Tamm
Andreas Teichmann
Andreas W. Thelen
Peter Thomann
Ralf Tooten
Murat Türemis
Waltraut Tänzler
Alexander Unger
Marco Urban
Mehmet Ünal
Friedemann Vetter
Stefan Warter
Erich Weiss
Markus Weiss
Gordon Welters
Petra Welzel
Margit Werbinek
Kai Wiedenhöfer
Arnd Wiegmann
Mathias Wild
Jens Wilkening
Jorg Wischmann
Michael Wolf
Olaf Wunder
Markus Wächter
Reto Zimpel
Monika Zucht

GHANA
Godfred Blay Gibbah

GREECE
Yannis Behrakis
Alexandre Beltes

Fragkiskos Bizas
Michalis Boliakis
Efstratios Chavalezis
Greg Chrisohoidis
Nikos Economopoulos
Theodosis Giannakidis
Louisa Gouliamaki
Yannis Kabouris
Vasilis Karafillides
Petros Kipouros
Yiannis Kolesidis
Giorgos Konstandinidis
Yannis Kontos
Kosmas Lazaridis
John Lefakis
Nicholas Louridis
Andonis Mamillos
Dimitri Messinis
Stefania Mizara
Yiorgos Nikiteas
Lefteris Pitarakis
Christos Siarris
Margarite Sophie
Alexandros Stamatiou
Thanasis Stavrakis
Stelios Tsagris
John Vellis

GUATEMALA
Moisés Castillo Aragón
Ricardo Ramirez Arriola

HAITI
Marc Yves Regis

HUNGARY
Eva Arnold
Gardi Balazs
Attila Balázs
Róbert Balázs
Andras Bankuti
Sandor Barna
Imre Benkö
Noemi Bruzak
Miklós Csák
Gyula Czimbal
Zsolt Demecs
Bela Doka
Szabolcs Dudas
Imre Földi
Danka Istuán
Sandor Katalin
Gabor Koczan
Szilard Koszticsak
Attila Kovács
Gabor Monos
Zsolt Pataky
Zsuzsanna Petö
Zoltán Pólya
Peter Rakosi
Tamás Révész
Andrea Schmidt
Laszlo Sebestyén
Lajos Sods
Gyula Sporonyi
Barnabas Szabó
Péter Szalmás
Béla Szandelszky
Robert Szebo
Albert Gábor Szerényi
Zsolt Szigetváry
Miklos Teknos
Illyés Tibor
András Vas
Margit Wagner
Péter Zádor

ICELAND
Larus Pall Birgisson
Th. Örn Kristmundsson

INDIA
Abdul Rahman
Pradip Adak
Piyal Adhikary
Amit Arora
Atul
Gautam Kumar Bakshi
Asish Bal
Mohan Dattaram Bane
Tarapada Banerjee
Utpal Baruah
Shyamal Basu

Samir Basu
Gautam Basu
Jayanta Battacharyya
Sandesh Bhandare
Rajesh Kumar Bhasin
Kamana Bhaskar Rao
V. Ch.VS. Bhaskar Rao
Kedar Vilas Bhat
Gopal Bhattacharjee
Sudip Bhattacharya
Dharmesh S. Bhavsar
G. Binu Lal
Hersh W. Chadha
Abdulla Chaithottam
Kalyan Chakravorty
Shyamal Chakrovorty
Suvendu Chatterjee
Johnson V. Chirayath
Chou Chiang
A.R. Chowdhury
Bikas Das
Saurabh Das
Sipra Das
Pradip Das
Suman Datta
Rajib De
Pallikunnel R. Devadas
Gajanan Dudhalkar
J. Durai Raj
Santosh Dutta
Gautam Sen
Victor George
Vasanth Kumar
Ghantasala
Suman Gharai
Nimai Chandra Ghosh
Sanjoy Ghosh
Gauri Gill
Alok Bandhu Guha
Akhil Hardia
K. Harikrishna
Vyas Himanshu
Fawzan Husain
Sunil Inframe
R.S. Iyer
Hoshi Jal
Roy Jayanta
John Jeejo
Samar S. Jodha
Rana Kamal
James Keivom
Anita Khemka
Achal Kumar
Bhupesh Chandra Little
Atul Loke
T. Madhuraj
Skumar Mahajan
Shyamal Maitra
Nirmalendu Majumdar
Ashok Majumder
Sailendra Mal
Natasha M. Martis
Amit Mehra
Dilip Mehta
Jewella C. Miranda
Aloke Mitra
Dakoo Mitra
S.K. Mohan
Tapan Mondal
Moni Sankar Das
Bhaskar Mukherjee
Dines Mukherjee
Indranil Mukherjee
Joy Mukhopadhyay
Peediekal Mustafa
K.K. Najeeb
Suresh Narayanan
Ashok Nath Dey
Swapan Nayak
Dev Nayak
Kedar Nene
Nanu Neware
Dutta Nilayan
Dave Nirav
Sudharak Olwe
Das Pabitra
Prashant Panjiar
Ganesh Parida
Rajan.T Poduval
C.B. Pradeep
Bhagya Prakash
Renuka Puri
Shakeel Qureshy
A.P. Radhakrishna

Aijaz Rahi
Rajneesh Parihan
Akash Rajpal
Saggere Ramaswamy
K. Ramesh Babu
K.S. Ranganath
Shailesh Raval
Raman Raveendran
Ravi Batra
Kushal Ray
Avijit Roy
Jayanta Saha
Rakesh Sahai
Suman Sarkar
Sarvesh
Dominic Sebastian
Bijoy Sengupta
Hemendra A. Shah
Pankaj Sharma
Sanjay Sharma
Shirish Shete
Shihab
Prabhakar Shirodkar
Uday M. Shirodkar
Paresh J. Shukla
Ajoy Sil
Bandeep Singh
Dayanita Singh
Rajib Singha
Arun Sreedhar
P.V. Sujith
Adesara Sunil
P.K. Suresh
Naresh Suri
Manish Swarup
Leen Thobias
Bino Thomas
M.M. Thomas
Rajan M. Thomas
G. Vazhisojan
Robert Vinod
Keshav Vitla
Ali Zakir

INDONESIA
Ade Dani Setiawan
M. Agung Wisnu Pati
Mirza M. Asrian
Bambang A Fadjar
Tantyo Bangun
Oka Barta Daud
Beawiharta
Sinar Goro Belawan
Adek Berry
Bonifacius Purl W.
Ali Budiman
Achmad Yessa Dimyati
Fadjar Roosdianto
Uning Heri Gagarin
Elano Gantiano
A. Hamzah Subekti
Hariyanto
Eddy Hasby
R. Hendroko Setyobudi
Veronica R. Hidajat
Iim Ibrahim
Mohamad Iqbal
Hubert Januar
Kemal Jufri
Edwin Karim
Ralph Kholid
N. Krisnadi-Wahyudi
Andi Kurniawan Lubis
Aris Liem
Mak Pak Kim
Nogo Agusto Alimin
Yusuf Nurrachman
Pandji Vasco Da Gama
Pang Hway Sheng
I. Nardi Patmadiwiria
Paulus Patmawitana
Erik Prasetya
Hermanus Prihatna
Budi Purwanto
Arbain Rambey
Suhendra Ramli
Sutrisna Ramli, E. Fiap
Muhammad Reza
Roy Rubianto
A. Rusdiansyah
Zakir Salmun
Sandhi Irawan
Yamtono Sardi
Julian Sihombing

Ferdy Siregar
Sugede S. Sudarto
Tarko Sudiarno
Taka Sugiyanta
A.Suhardiman Sutardjo
Daniel Supriyono
Agus Susanto
Sandra Tanrawali
Tatan Agus Rustandi
Wibudiwan Tirta Brata
Nuraini Tjitra Widya
Dadang Trimulyanto
Weda
R.A.B. Widjanarko
Tjitra Winarno
Bagong Zelphi

IRAQ
Z. Kadham Al Soudani
Mohammed Aziz
Ibrahim Dagher
Amad J. Kareman
O.M.Khalil Kamal-Addin
S. Muhsin Al-Samawi
Ibrahim S. Nadir
Noor Al-Deen H. Md
Ali Talib

IRELAND
Laurence Boland
Deirdre Brennan
Cyril Byrne
Mhic Chambers
Tadhg Devlin
Kieran Doherty
Colman Doyle
Michael Dunlea
Steve Humphreys
Eric Luke
Philip Magee
Paul McCambridge
Eoin McCarthy
Denis Minihane
Gerry Mooney
Seamus Murphy
Peter Nash
Jeremy Nicholl
Jack P. Nutan
Bryan O'Brien
Kyran O'Brien
Kenneth O'Halloran
Jim O'Kelly
Colin O'Riordan
Joe O'Shaughnessy
Eamon Ward
Neil Wilder

ISLAMIC REPUBLIC OF IRAN
Nima Abdolahi
Arash Akhtari Rad
Md. Reza Alimadady
M.Amdjadi-Moghaddam
A.A. Arfa Kaboodvand
Raffi Avanessian
Sarlak Azar
Mahmood Badfar
Modarssi Banafsheh
Mandana Bekheirnia
Afsaneh Chehrehgosha
Majid Dozdabi Movahed
. Erfanian Aalimanesh
Sadredin Farahmand
Gh. Reza Fereidooni
Maryam Ghoreishi
Farad Goltarash
Somayeh Hadji
M. Hajmohammadi
Yousef Lavi Hamid
Persila Hamidi
Ali Heidari Klash
Nemat Hezar Jaribi
Ahad Issavi
Hashem Javadzadeh
Ali Reza Karimi Saremi
Kaveh Kazemi
Ziba Kazemi
Atta Kenare
M. Keshavarz Keyvani
Mehdi Keshvari
Farzaneh Khademyan
Majid Khamseh Nia
Siami Khan Ali
Md. Khodadadash

Mohamad Kochakpour
Ali Mazarei
Hadi Mehdizadeh
Reza Moattarian
Morteza Md. Beiglou
Hamid Md. Nazar
Farideh Mohseni
M. Mola Abassi Amoli
Javad Montazeri
Mansore Motamadi
Mahour Mousaeian
Hamid Mozafari
G. Reza Nasr Esfahani
Ahmad Nateghi
M. Nikoobazl Motlagh
Nazi Nivandy
Morteza Pournejat
H. Razdasht Tazkand
Farzad Refahi
Payam Rouhani
Alireza Rouhnavaz
Rahelek Sadr
M. Aznaveh Saeed
Khamesipour Saeid
Karim Sahib
Ali Salahsour
Wahid Salemi
Mohsen Sanei Yarndi
Hassan Sarbakhshian
Hamid Reza Seddighy
Ali Seraj
Shahin Shahablou
Homeira Soleymani
Md. Parham Tagkioff
Baharnaz Vahidi
Mohammadi Valiollah
H. Vasheghani Farahani
S. Vasheghani Farahani

ISRAEL
Sharon Abbady
Esteban Alterman
D. Java Balanovsky
Jonathan Bloom
Rina Castelnuovo
Yori Costa
Hanoch Grizitzki
Jaime R. Halegua
Nir Kafri
Menahem Kahana
Ronen Kedem
Ziv Koren
Yoav Lemmer
Chen Mika
Daoud Mizrahi
Avichai Nitzan
Barak Oserovitz
Jacob Saltiel
Roni Schützer
Shaul Schwarz
Ahikam Seri
Moshe Shai
David Silverman
Eyal Warshavsky
Shi Yehezke'el
Yossi Zamir
Ronen Zvulun

ITALY
Francesco Acerbis
Alessandro Albert
Marco Albonico
Michele Alquati
Marco Anelli
Manna Annunziata
Roberto Arcari
Fabio Artusi
Alfio Aurora
Luigi Baldelli
Alberto Bevilacqua
Rino Bianchi
Giuseppe Bizzarri
Tommaso Bonaventura
Enrico Bossan
Luca Bracali
Giovanni Broccio
Davide Caforio
Maristella
Campolunghi
Luca Cappellaro
Alessandro Carpentieri
Remo Casilli
Luciano del Castillo
Raffaele Celentano

Carlo Cerchioli
Ascanio Raffaele Ciriello
Lauria Ciro
Francesco Cito
Pier Paolo Cito
Francesco Cocco
Claudio Colombo
Gianni Congiu
Alessandro Cosmelli
Lidia Costantini
Massimo Cutrupi
Daniele Dainelli
Marco Delogu
Enrico Fantoni
Marci Fausto
Manuela Federella
Giuliano Ferrari
Sergio Ferraris
Fabio Fiorani
Giorgia Fiorio
Massimiliano Fornari
Franco Fracassi
Adolfo Franzo
Gianni Giansanti
Helen Giovanello
Nicola Giuliato
Giovanni Gregorio
Giuliano Grittini
Guido Harari
Nicola Lamberti
Saba Laudanna
Marco Lauro
Riccardo de Luca
Stefano Luigi
Valentina Macchi
Daniela Maestrelli
Arnaldo Magnani
Paolo Magni
Alessandro Majoli
Ettore Malanca
Alberto Malucchi
Claudio Marcozzi
Ilvo Marelli
Luca Marinelli
Enrico Mascheroni
Massimo Mastrorillo
Daniele Mattioli
Giovanni Mereghetti
Giovanni Minozzi
Giovanni Miserocchi
Mimi Mollica
Bruno Monaco
Silvia Morara
Alberto Moretti
Cira Moro
Gianfranco Mura
Gianni Muratore
Antonello Nusca
Mauro Oggioni
Claudio Olivato
Olivieri Oliviero
Maurizio Orlanduccio
Agostino Pacciani
Antonio Pagano
Franco Pagetti
Andrea Pagliarulo
Ugo Panella
Giuseppe Panniello
Bruno Pantaloni
Eligio Paoni
Pino Pasquini
Bruno Pavan
Stefano Pavesi
Paolo Pellegrin
Maurizio Petrignani
Carlo Pezzini
Sandro Pintus
Maria-Luisa Pirrottina
Carlo Pisa
Antonio Pisacreta
Roberto Ponti
Franco Pontiggia
Sergio Pozzi
Dario Puglia
Alfio Elio Quattrocchi
Sergio Efrem Raimondi
Alberto Ramella
Giancarlo Reggiani
Stefano Rellandini
Mario Renzis
Andrea Sabbadini
Andrea Samaritani
Patricia Savavese
Antonio Scattolon

Stefano Schirato
Massimo Sciacca
Livio Senigalliesi
Shobha
Silva
Giuliani Silvio
Attilio Solzi
Mario Spada
Stefano Torrione
Alessandro Tosatto
Angelo Turetta
Marco Vacca
Riccardo Venturi
Stefano Veratti
Paolo Verzone
Claudio Vitale
Francesco Zizola
Aldo Zizzo
Vittorio Zunino Celotto

IVORY COAST
Babehi Rachele Crasso

JAMAICA
Junior Dowie
Norman Grindley
Headly G. Samuels

JAPAN
Takao Fujita
White Harada
Tsutomu Hasegawa
Hirohito Nomoto
Inouye Itsu
Takaaki Iwabu
Chiaki Kawajiri
Tomoko Kikuchi
Masanori Kobayashi
Taro Konishi
Toshio Kosaka
Toyokazu Kosugi
Ryoko Kubo
Masato Kudou
Toshi Matsumoto
Toru Morimoto
Ichiroh Morita
Shinichi Murata
Takuma Nakamura
Akihiro Ogomori
Sayuri Ohkawa
Akira Ono
Nobuko Oyabu
Q. Sakamaki
Chitose Suzuki
Ryuzo Suzuki
Kuni Takahashi
Tadao Takako
Yuzo Uda
Masakazu Watanabe
Kazuhito Yamada
Munesuke Yamamoto
Yutaka Yonezawa

JORDAN
Hassan Abu-Gallyoun
Iyad Ahmad
Amira Al-Homsi
Osama Al-Natour
Salman All Al-Masri
Jamal A. Issa Nasrallah
Md. A.A.R. Salameh

KAZAKHSTAN
Viktor Gorbunov
Olga Korenchuk
Valery Korenchuk

KENYA
Winnie Ogana
Steve Okoko
C. Omondi Onyango
Malachi Mula Owino

KUWAIT
Ali Nasser Al-Roumi
Bahaadeen M. Muhsun

KYRGYZSTAN
Sagyn Ailchiev
Victor Berdigan
Vladimir Dotsenko
Jenishbek Nazaraliev

LATVIA
Leon Bessar
Aivars Draznieks
Aigars Eglite
Andris Kozlovskis
Aivars Liepins
Ritvars Skuja
Zigismunds Zalmanis
Maris Zemgalietis

LEBANON
Mahmoud Al-Zayat
Oussama Ayoub
Joseph Barrak
Sivak Davidian
Ramzi Haidar
Rabih Moghrabi
Saleh Rifai
Suhaila Sahmarani

LESOTHO
Ntebaleng Tiny Sefuthi

LIBERIA
Drseyeh B. Acqui Sr

LITHUANIA
Romualdas Augusnas
Janis Aukstins
Giedrius Baranauskas
Ramunas Danisevicius
Jonas Daniunas
Laima Geleziute
Irena Giedraitiene
Romas Juskelis
Petras Katauskas
Kazimieras Linkevicius
A. Macijauskas
S. Michelkeviciute
R. Parafinavicius
Ramune Pigagaite
Romualdas Pozerskis
Jonas Strazdauskas
Rimaldas Viksraitis

LUXEMBOURG
Jean-Claude Ernst
Luc Kohnen

MACEDONIA
Zoran Jovanovic
Predrag Krstic
Georgi Licovski

MALAWI
Amos Gumulira
M. Jeka Chipofya
Govati Nyirenda

MALAYSIA
Jaafar Abdullah
Chong Voon Chung
Goh Chai Hin
Ricky Heng Fook Wing
Ho Puue Yun
Mohamad Ali Ismail
Koh Kok Hwa
Lee Lay Kin
Leong Kok Wah
Lim Beng Hui
Jeffery Lim Chee Yong
Lin Kian On
Peter Liow Chien Ying
David Loh Swee Tatt
Bazuki Muhammad
Noor Azman Zainudin
Peter Wee
Sang Tan
Shim Hooi Wooi
Shum Fook Weng
Sin Peng Yeow
T.B. Muhd. Yaacob
Tan Seng Huat
Teh Eng Koon
Alan Teh Pek Ling
Thian Yoon Keong
Wong Sung Jeng
Aswad Yahya
Yau Choon Hiam
Yong Chu Mung
Mazlan Zulkifly

MALTA
Matthew Mirabelli

Darrin Zammit Lupi

MAURITIUS ISLAND
George Michel
Sarvottam Rajkoomar

MEXICO
Daniel Aguilar
Hector Amezcua
Lizeth Arauz Velasco
Armando Arorizo
Xoloh Salazar Bonilla
Ulises Castellanos
Guillermo Castrejón
Carlos Cazalis Ramirez
Ray Chavez
Carlos Chavez
Marcos Corona
Alejandro Cossio Borboa
Elizabeth Dalziel
Cesar Delgado Pauli
Jose Fuentes Franco
F. Garcia Martinez
Ulises Garcia Vela
Maya Goded
Susana Gonzalez Torres
Luis González Silva
Jose Hernandez Claire
E. Hernandez Garciá
Gerardo Magallon
E. Martinez Escamilla
Victor Mendiola
Octavio Omar F. Nava
Marco Nava Hernandez
L. Navarro Gutierrez
Ana Ochoa Schöndube
Jose Ordaz Gonzales
Tomas Ovalle
Carlos Puma
Miguel Ramirez Reyes
Rafael Rio Chavez
Oscar Salas Gómez
Pablo Salazar Socis
Oscar Sánchez Crómis
Juan Antonio Sosa Ríos
Marco Vargas Lopez
F. Villa del Angel
Enrique Villaseñor
Jose Luis Villegas

MOÇAMBIQUE
Inácio Pereira
Ana Maria Rodrigues

MOLDAVIA
Vitalya Yakovlev

MONGOLIA
Buyandelguer Menguet

MOROCCO
Hamid Ben Thami
Mustapha Ennaimi
Abdelhak Senna

NEPAL
Mukunda Kumar Bogati
Nishchal Chapagain
Sanchit Lamichhane
Kiran Panday
Kishor Rajbhandari
Sudhira Shah
Sagar Shrestha

NETHERLANDS
Rogier Alleblas
Jan Banning
Shirley Barenholz
Maurice Bastings
Rob Becker
Paul Beekhuis
Yvonne Bijl
Peter Blok
Remco Bohle
Jeroen Bouman
Maurice Boyer
Eric Brinkhorst
Arnd Bronkhorst
Surya Caglan
John G. Clous
Rachel Corner
Roger Cremers
Kees Dongen
Rob Doolaard

Leo Erken
Marco Eschler
Annie Gemert
Robert Goddijn
Martijn van de Griendt
Marco Groote
Christine Hartogh
Bastiaan Heus
Hans Heus
Harry Heuts
Wim Hofland
Paul Huf
Evelyne Jacq
Jasper Juinen
Geert Kesteren
Chris Keulen
Arie Kievit
Robert Knoth
Cor de Kock
Marc Kort
John Lambrichts
Jerry Lampen
Frans Marten Lanting
Gé Jan Leeuwen
Floris Leeuwenberg
Louis Lemaire
Fred Libochant
Jaco Lith
Emile Luider
Menno Meijer
Willem Middelkoop
Reinout Mulder
Benno Neeleman
Lenny Oosterwijk
Ed Oudenaarden
Brand Overeem
Henk Pluijm
Frans Poptie
Antonio Quintero
Ton van Rijn
Martin Roemers
Gerhard van Roon
Raymond Rutting
Friso Spoelstra
Monique Stap
Frans Stoppelman
Jan Teeffelen
Frits Terpoorten
Anne Marie Trovato
Catrinus van der Veen
Sander Veeneman
Arnold Vente
Koen Verheyden
Peter Verhoog
Henk Versteeg
Rolf Versteegh
Teun Voeten
Klaas-Jan Weij
Eddy Wessel
Emily Wiessner
Pieter Willemse
Herman Wouters
Rop Zoutberg

NEW ZEALAND
Greg Baker
Scott Barbour
Liz Brooker
Marion Dijk
Janet Durrans
Mark Dwyer
Peter Elbeshausen
Wade Goddard
Michael Hall
David Hancock
Jimmy Joe
John Kirk-Anderson
Robert Marriott
Marty John Melville
Dean Purcell
Peter James Quinn
Phil Reid
Martin Ruyter
Jason Paul South
Terence White
Staton Winter

NICARAGUA
Evelin Flores Mairena
Alejandro Sanchez

NIGERIA
Sunday Olufemi Adedeji
Ozouama Benard

George Esiri
Isa Bayoor Ewuoso
Kehinde O. M.
Gbadamosi
Peace Udugba

NORTH KOREA
Gye-Hyeon Jeong

NORWAY
Odd R. Andersen
Oddleiv Apneseth
Lise Aserud
Paal Audestad
Jonas Bendiksen
Stein Jarle Bjorge
Tomm W. Christiansen
Robert Eik
Oyvind Ellingsen
Kai Flatekval
Christian Fougner
Jan Tore Glenjen
Jan Greve
Espen Egil Hansen
Harald Henden
Pal Hermansen
Jan Johannessen
Morten Krogh
Bjorn Langsem
Henning Lillegård
Bo Mathisen
Mimsy Moller
Otto Münchow
Fredrik Naumann
Aleksander Nordahl
Rune Saevig
Knut Snare
Knut Egil Wang

OMAN
Hamid Al-Qasmi

PAKISTAN
Javed Ahmed Khan
M. Hussain Pasha
Ayesha Vellani

PALESTINA AUTONO-MOUS TERRITORIES
Jamal Aruri
Rula Halawani

PANAMA
Bernardino Freire
Essdras M. Suarez

PARAGUAY
Hugo Fernández Enciso

PEOPLE'S REPUBLIC OF CHINA
Ba Shan
Bao Wei Dong
Chai Jijun
Chen Binghong
Chen Da Yao
Chen Liang
Chen Wen Wei
Chen Xi Shan
Chen Zungang
Cheng Xun
Chenglie Wish
Chenke Jingye
Cui Bo Qian
Cui Zhi Shuang
Cui Zi Yin
Cun Yun Zhou
Da Hai Yang
Dajia-Liu
Dalang Shao
Deng Bo
Deng Chaoxing
Deng Gang
Ding Wen Peng
Duan Jimin
Fan Haibo
Fan Jinying
Fan Ying
Fan Zong Lu
Fu Sheng Yang
Gao Hongxun
Gao Min
Goahua Zheng
Guo Chengchiang

Guo Li Hua
Guo Qiang Zou
Guo Zhigui
Guoyue Zhang
Han Yong Gao
He DeLiang
He Jing Chen
He Yanguang
He Liang Hou
Hong Qun Liu
Hou Jian Hua
Hu Baowen
Hu Qingming
Hu Wei Min
Huang Xiaojian
Huang Jingda
Huang Yaogao
Huang Yiming
Huang Ze Min
Jia Tian E
Jiang Ding Zhong
Jiang Yun Long
Jianshe Guo
Jiao Bo
Jie Lu
Ju Guangcai
Jun Duan
Junqi Zhao
Lai Tu Qiang
Lan Feng
Lan Hong Guang
Leng Bai
Leung Ka Ming
Li Fang Gui
Li Gang
Li Hui
Li Jie Jun
Li Kaijie
Li Ming
Li Nan
Li Xinfeng
Li Xiaoning
Li Xueyu
Lian Xiang Yu
Liang Daming
Liang Shan
Liang Yao Jun
Lin Ting-Hung
Lin Xi
Lin Yong Hui
Liu Aimin
Liu Chun Feng
Liu Jie Min
Liu Liqun
Liu Wei
Liu Xiao-Kuang
Liu Zhen Qing
Liuji Liu Weijun
Lu Guang
Lu Huainan
Lu Hui Bin
Lu Ling Long
Lu Quanguo
Lu Su Yang
Lu Zhong Bin
Ma Hong Jie
Ma Jianhe
Mao Shuo
Mei Zhiqiang
Miao Fengwu
Ming Zhong
Meng Mingguo
Pan Haiqi
Pang Zhengzheng
Pen Cheng Sha
Qi Xiao Long
Qi-Hou-Liu
Qian Yijun
Qiu Yan
Ren Qing
Ren Shao Hua
Ren Wei
Ren Xihai
Shao He Lu
Shen Biao Tong
Shen Zhuqing
Shi Jianxue
Shi Liguo
Shuang Qijie
Song Bujun
Song Gang Ming
Song Jianchun
Song Wei Dong
Su Wei Min

Sun Hetian
Sun Yunhe
Sun Zhijun
Tang Jian
Tao Yuanming
Teng Ke
Tian Fei
Tong Jiang
Wan Wenxian
Wang Bin
Wang Decheng
Wang Dongwei
Wang Fuchun
Wang Huan Miao
Wang Hongji
Wang Jicheng
Wang Jing Chun
Wang Keju
Wang Ruilin
Wang Shi Jun
Wang Tao
Wang Tieheng
Wang Tong
Wang Xinyi
Wang Yao
Wang Yuming
Wang Yun-Lu
Wang Zhi Yun
Wei Feng Zheng
Wen Huang
Wong Chi-kin David
Wu Haibo
Wu Jian Xin
Wu Jiuling
Wu Mao Jia
Wu Niao
Wu Si Hua
Wu Wang Sheng
Wu Yaolin
Xia Jing Hua
Xian Xin Xu
Xiaoyun Luo
Xie Minggang
Xie Qi
Xin Ting Li
Xin Yue Yang
Xinke Wang
Xiu Yang Li
Xu Cheng Ai
Xu Jia Shan
Xu Jian Hua
Xu Pu
Xu Wei
Xu Wu
Xu Zhan
Yan Bailiang
Yan Chang Jiang
Yang Bing Xiao
Yang Ming
Yang Mingui
Yang Tao
Yang Xinyu
Yang Yanhai
Yang Zhenhua
Yao Fan
Ye Wei Hua
Yie Gian Qiang
You HongYuan
Yuan Xiao Zhen
Zeng Nian
Zeng Wenbin
Zeng Yi-Cheng
Zhang Heyong
Zhang Jingyun
Zhang Meng
Zhang Nan Xiu
Zhang Qiao Shi
Zhang Run Jia
Zhang Xi Zhen
Zhang Yanhui
Zhang Yi
Zhang Ying
Zhang Yong
Zhang Zhuo
Zhao Li Jun
Zhao Liyi
Zhao Wen Sheng
Zhao Ya-Shen
Zhe Guo Qiang
Zhi Jian
Zhi Xinping
Zhou Chong You
Zhou Qing Xian
Zhou Rui Sheng

Zhou Xing Hua
Zhou Yun
Zhou Zi Dong
Zhou Zong Ming
Zhu Jian Xing
Zhu Ling
Zhu Minghui
Zhu Yue

PERU
Miguel Almeyda Bellido
Mariana Bazo Zavala
Martin Bernetti Vera
Max Cabello Orcasitas
Peruska Chambi
Nancy Chappell Voysest
Jose Chuquiure Alva
Enrique Cuneo
Hector Emanuel
Guillermo F. Figueroa
Luis Flores Machuca
Mayu Mahanna Garcia
Silvia Izquierdo
Alexander Kornhuber
C. Larrabure Simpson
Gary Manrique Robles
Hector Mata
Maria Menacho Ortega
Karel Navarro Pando
Pilar Olivares Novoa
Deborah Paredes
Rolly Reyna Yupanqui
Jaime Rodriguez
Luis Silva Yoshisato
Renzo Uccelli Masias
Jorge Verastique

PHILIPPINES
M. "Bong" Cabagbag
Jose V. Galvez Jr.
Oliver Y. Garcia
George Gascon
Andy Hernandez
Hadrian Hernandez
Alfonso L. Mundo
M. Flordeliza Odulio

POLAND
Cebula Arkadiusz
Piotr Blawicki
Grzegorz Bury
Grzegorz Celejewski
Antoni Chrzastowski
Zbigniew Cierpisz
Peter Ciesla
Robert Cieslinski
Ania Czop
Jacenty Dedek
Ryszard Dziedzic
Janusz Filipczak
Piotr Gajek
Agnieszka Gaszynska
Jan Glowacki
Lukasz Glowala
Arkadiusz Gola
Adam Golec
Waldemar Gorlewski
Tomasz Griessgraber
Andrzej Piotr Grygiel
Piotr Grzybowsul
Tomasz Gudzowaty
Jerzy Gumowski
Jacek Herok
Aleksander Holubowicz
Wojciech Jakubwski
Marcin Jamkowski
Maciej Jawornicki
Piotr Jaxa-Kwaitkowski
Tomasz Jodlowski
Mieczystaw Jurga
Jaroslaw Jurkiewicz
Slawomir Kaminski
Aleksander Keplicz
Grzegorz Klatka
Rafal Klimkiewicz
Maciej Kosycarz
Pawel Kot
Piotr Kowalczyk
Robert Kowalewski
Hilary Kowalski
Andrzej Kramarz
Damian Kramski
Witold Krassowski
Przemek Krzakiewicz

Robert Krzanowski
Robert Kwiatek
Adam Lach
Arek Lawrywianiec
Marcin Lobaczewski
Gabor Gabriel Lorinczy
Andrzej Luc
Andrzej Miaskiewicz
Mieczystaw Michalak
Filip Miller
Chris Niedenthal
Wojciech Olkusnik
Daniel Pach
Cezary Pecold
Radek Pietruszka
Leszek Pilichowski
Guz Rafat
Przemyslaw Reichel
Ryszard Rogalski
Olgierd M. Rudak
Michal Sadowski
Maciej Skawinski
Grzegorz Skowronek
Jacek Smarz
Marek Socha
Czarek Sokolowski
Maciej Sosnowski
Waldemar Sosnowski
Piotr Sumara
Wojtek Szabelski
Robert Szykowski
Filip Tepkowicz
Lukasz Trzcinski
Jacek Turczyk
Pawel Ulatowski
Marek Wachowicz
Maria Zbaska
Jerzy Zegarlinski
Lech Zielaskowski
Leszek Zych

PORTUGAL
J. Almeida de Carvalho
Ana Baiao
José Barradas
Ricardo Bento
Rita Carmo
Antonio Carrapato
Leonel Castro
Luis Catro Catarino
Antonio José Cunha
Ignacio Dole Villemar
Paulo Duarte
Antonio Fazendeiro
Antonio Pedro Ferreira
Carlos Guarita
Miguel Madeira
João Mariano
Tiago Ferreira Petinga
Luiz Moreira Carvalho
Rui Hernani Ochoa
Putu Carlos Palma
P. Pinto Figueiredo
Bruno Rascao
Jose Martins Ribeiro
Daniel Marques Rocha
Maria Luiza Rolim
Gonçalo Rosa da Silva
P. Rosa Teodosio Ferreira
Vitor M. Oliveira Santos
Bernardo Saraiva Lobo
Jorge Simão
Pedro Sottomayor
Joao Francisco Vilhena

QATAR
Salim Mohd. Al Marri

REPUBLIC OF KOREA
Chae Seung-Woo
Cho Sung-Su
Soo Young Chun
Chung Sung-Jun
Kim Ki Sung
Koh Young-Kwon
Kyung Keun Kwak
Nam Deog Kim
Seokyong Lee
Soo Hyun Park

ROMANIA
Adrian Ovidiu Armanca
Remus Nicolae Badea
Paul Stefan Buciuta

Lucian Crisan
Halip Doru-Mirel
Andriana Dragos
Zsolt Fekete
Vadim Ghirda
Radu Ghitulescu
Marin Giurgiu
M.Horvath Bugnariu
Angela Kallo
Dragos Lumpan
Adrian Luput
Emil Moritz
Marius Nemes
Mircea Opris
Iulian Pascaluta
Tudor Predescu
Radu Sigheti
Septimiu Slicaru

RUSSIA
Andrey Arkhipov
Dmitri Astakhov
Dmitry Azarov
Vitaliy Balmatkov
Victor Bazhenov
Dmitry Beliakov
Ilya Belyaev
Alexei Belyantchev
Alexei Boitsov
Viacheslav Buharev
Oleg Buldakov
Viktor Chernov
Sergei Chirikov
Roman Denisov
Boris Dolmatovsky
Alexander Dorogan
Vadim Dorohin
Valery Dorohov
Sergey Dubanin
Mikhail Evstafiev
Rasim Farvazitdinov
Vladimir Fedorenko
Yuri Feygin
Vladimir Filimonov
Igor Gavrilov
Stanislav Gnedin
Natalia Goguinova
Alexei Goloubtov
Pavel Gorshkov
Alexander Grek
Alexander Gronsky
Ludmila Hapiy
Alik Hasanov
Victor Ilyin
Vyachelov Ivanov
Victoria Ivleva
Misha Japaridze
Yuri Kadobnov
Vladimir Kakovkin
Sergey Kaptilkin
Eugeniy Karmayev
Boris Kavashkin
Yori Kaver
Nickolay Kireyev
Sergey Kiselev
Mikhail W. Klimentiev
Yuri Kochetkov
Natan Koifman
Roman Koksharov
S.A. Kompaniychenko
Alexei Kompaniychenko
Dmitry Korotayev
Sergei Kovalev
Yuri Kozyrev
Igor Kravchenko
Eduard Kudriavitsky
Dimitry Lapanik
Oleg Lastochken
Teodon Lebedev
Dmitry Leonov
German Levin
Sergei Lidov
Dmitryi Loshagin
Anatoly Maltsev
Nikolai Malyshev
Olga Mamedova
Pavel Markelov
Nikolai Marochkin
Vita Masliv
Semjon Meisterman
Sergei Metelitsa
Wilhelm Mikhailovsky
Vladimir Moisejev
B. Mukhamedzyanov

Alexander Nemenov
Oleg Nikishin
ALexander Orlov
Svetlana Osmachkina
Konstantin Panshev
Maxim Polouboiarinov
Alexander Polyakov
Natalia Razina
Vladimir Rodionov
Andrei Rudakov
Yevgeniy Rysikov
André Samoilov
Ravil Schafikow
Sergey Scherbakov
Oleg Schukin
Sergey Shekotov
Yuri Shtukiv
Nikolay Sidorov
Sergey Sidorov
Nicolas Simakove
Andrei Sladkov
Oleg Smirnov
Alexei Smirnov
Evgenij Spektorov
Alexander Stepanenko
Vladimir Stolyarov
Jouri Strelets
Vitaly Sutulov
Igor Tabakov
Nikolai Tikhomirov
Elena Tikhonova
Yuri Tutov
Vladimir Tykaev
Alexander Usanov
Sergei Vasiliev
Vladimir Velengurin
Viktor Velikzhanin
Ilya Volkov
Vladimir Vyatkin
Roman Yarovitcin
Marina V. Yurchenko
Alexandr Zaboev
Juri Zaritovsky
Konstantin Zavrazhin
A. Zemlianichenko
Igor Zotin
Tatyana Zubkova

SAUDI ARABIA
Zaki Al-Sinan

SENEGAL
Doudou Diop Sall
Matourou Sow
Mamadou Sy

SINGAPORE
Ishak Samon Mohamad
Sim Chi Yin

SLOVAKIA
Marek Velcek

SLOVENIA
Roman Bezjak
Bojan Brecelj
Jure Erzen
Dusan Jez
Tomi Lombar
Darije Petkovic
Mitja Pipan

SOUTH AFRICA
Jenny Altschuler
Piet Beer-Strydom
Jodi Bieber
Dawn Bruchez
Thys Dullaart
Jillian Elaine Edelstein
Brenton Geach
Louise Gubb
George Hallett
John Peter Hogg
Rian Horn
Andrew Ingram
Rajesh Jantilal
Fanie Jason
Jeremy Jowell
Carolyn Koopmann
Sue Kramer
Alf Kumalo
Anne Laing
Barry Lamprecht
Steve Lawrence

Leon Edward Lestrade
Charlé Lombard
Kim Ludbrook
David Lurie
Motlhalefi Mahlabe
Gideon Mendel
Eric Miller
Khaya Ngwenya
Mykel Nicolaou
Obie Oberholzer
Doug Pithey
Hein Plessis
Raymond Preston
David Sandison
Justin Sholk
Brent Stirton
Caroline Suzman
Guy Tillim
Johann van Tonder
Johannes Vogel
Louis Vosloo
Roy Wigley
Graeme Williams
Debbie Yazbek
Anna Zieminski
Siyabulela Obed Zilwa

SPAIN
Tomás Abella
Luis Alcala Del Olmo
Diego Alquerache
Carlos Andrés
Javier Arcenillas
Cristian Baitg
Pablo Balbontin Arenas
Sandra Balsells
Erika Barahona Ede
Rosa Bardt Casany
Yann Bautista Wiberg
Eduardo Bayona
Pablo Bellido Paricio
Daniel Beltra
EnriqueBeltran Terol
Antonio Benitez Barrios
Javier Bergasa Mendive
Manuel Berral Pérez
Jaume Blassi Alemany
Xavier Calabuig Lluch
Nacho Calonge Minguez
José Camacho
Jordi Cami Caldes
Julio Carbó Ferrer
Vicente Cardona Orloff
Francisco Casante
Cristobal Castro
Agustín Catalán
Ignacio Cerezo Otega
Santiago Cogolludo
Mireia Comas Franch
Matias Costa
Jose Luis Cuesta Solera
Daniel Culla
Michel Curel
Marcelo Del Pozo Perez
Juan Diaz Castromil
Jon Dimmis
Tatiana Donoso
Carlos Luján Estellés
Andres Fernandez
Pere Ferré Caballero
Cristina Garcia Rodero
Amparo Gil Grinan
Pedro Pablo Gonzalez
Pasqual Gorriz
M. Hernandez de Leon
Victoria Iglesias
Antonduras Ibawez
Frank Kalero
Julen Alonso Laborde
Santiago Lyon
Kim Manresa Mirabet
Francisco Márquez
Sánchez
Enric F. Marti
Xavier Marti Alavedra
Cèsar Mateu i Beltran
Fernando Moleres
Isabel Muñoz
Mónica Nogueiras Perez
Cipriano Pastrano
Yolanda Pelaez
Antonio Jesús Pérez Gil
Eudaldo Picas Vinas
Andreu Puig Marti

Joan Pujol Creus
Miguel Riopa Alende
Higsel Roca Vila
Quim Roser
Manuel Ruiz Toribio
Antonio Sabater Artús
Luis Sanchez Davilla
Gervasio Sanchez
Alonso Serrano Suarez
Jorge Sierra Antinolo
Tino Soriano
Nelson Souto Oviedo
Carlos Spottorno
Javier Tentiente Lago
Francis Tsang
Pedro Vallespi Porres
Moryana Vargas Llosa
Luis Vega
Roser Vilallonga Tena
Xulio Villarino Aguiar
Gustavo Vizoso

SRI LANKA
T. Kumara Ratnayake
G.D. Vijayadasa

SUDAN
I. Ahmed Abdelhafiez
Al Fateh Al Dekhery
Freabi Md. Ahmed
Hassan Hamed Md.
Md.Nur El-Din Abdallah

SWEDEN
Christopher Anderson
Torbjörn Andersson
Jens Assur
Sophie Brandström
Magdalena Caris
Peter Claesson
Joakim Eneroth
Ake Ericson
Jan Fleischmann
Jacob Forsell
Helené Furness
Johan Gunséus
Torbjörn F. Gustafsson
Johnny Gustavsson
Tommy Holl
Stefan Hyttfors
Leif Jacobsson
Nicke Johansson
Gerhard Joren
Kent Klich
Jan-Peter Lahall
Jonas Lindkvist
Joachim Lundgren
Chris Maluszynski
Tommy Mardell
Jack Mikrut
Brita Nordholm
Cici Olsson
Björn Olsson
Per-Anders Pettersson
Karl Rabe
Per-Anders Rosenkvist
Peter Schedwin
Hakan Sjöström
Per-Olof Stoltz
Mats Strand
Michael Svensson
Britt Marie Trensmar
Roger A. Turesson
Anne-Lise Vullioud
Joachim Wall
Curt Waras
Jan Wiridén
N. Zahedi Fougstedt

SWITZERLAND
Francesca Agosta
Karl E. Ammann
Iris Andermatt
Patrick Armbruster
Manuel Bauer
Karine Bauzin
Monica Beurer
Andreas Blatter
Mathias Braschler
Fritz-Markus Brügger
Markus Bühler
Vicente Burgal
Christoph Bürki
André Bärtschi

Marcel Chassot
Fabrice Coffrini
Thomas Cugini
Daniel Fuchs
Mariella Furrer
Andrea Helbling
Roger Huber
Tobias Hitsch
Didier Ischi
Jean-Marie Jolidon
Alexander Keppler
Thomas Kern
Reza Khatir
Yves Leresche
Michele Limina
Brigitte Lustenberger
Marcel Malherbe
Ursula Markus
Samuel Mizrahi
Antoinette Moos
Balz M. Murer
Tomas Muscionico
Dominik Plüss
Daniel Reinhard
Josef Ritler
Werner Rolli
Didier Ruef
Roland Schmid
Daniel Schwartz
Peter Schweizer
Andreas Seibert
Stefan Süess
Hansüli Trachsel
Michael Trost
Valdemar Verissimo
Olivier Vogelsang
Andreas Zimmermann

SYRIA
Basema Al Asaad
Ziad Al-Set
Jihad Alaiedi
Mouhamad Alcawy
Saer Aldhak
Kaldoun Alheen
Sharefe Alhosen
Rahaf Aljalled
Zoukaa Alkahhal
Khalid Almasri
Munzer Bachour
Mussa Bchara
Suheir Bchara
Mohamad Gyas Habbob
N.-Annur Hammami
Yousef Hosein
Samerhaj Housen
Jak Jadour
Nour Jalambou
Akef Kammouh
Ryad Ksaibeh
Fadi Masri Zada
Antoun Mezawi
Mehealdicn Omran
Mahmoud Salem
Manar Shaal
Raghda Solayman
Faragalla Ssamas
Isaac Tamer
Imad Wardeh
Gassan Yagee
Hana Yousif
Aous Zeina

TAIWAN ROC
Chan Cheung-On
Chien-Chi Chang
Chein-Chung Su
Chen Kung-Ku
Chen Yao-Ho
Cheng-Hui Hsu
Chi Chih Hsiang
Chia-Chang Hsieh
Chia-Jung Chang
Chiang Ying-Ying
Chiang Yung-Nien
Ching-Ching Wang
Ching-Chou Hu
Chiung-Huei Huang
Dah-Perng Hang
Han Tong-Ching
Hsiu-Ming Kao
Jen-Yi Tsai
Jung-Fong Chien
Lin Daw-Ming

Lin Shyi-Ming
Peng-Chieh Huang
San-Tai Hsieh
Shen Chao-Liang
Sheng-Fei Hung
Tsung-Sung Lin
Wang Ying-Hao
Wen-Cheng Wong
Wen-Tsai Yang
Yeh Jen-Hao
Yi Chieh Chung
Yi-Pin Wu
Yi-Shu Huang
Yu Chih-Sheng

THAILAND
P. Kittiwongsakul
S. Meksophawannakul
Jetjaras Na Ranong
Sombat Raksakul

**TRINIDAD AND
TOBAGO**
Tobias Francis

TUNISIA
Karim Ben Khelifa

TURKEY
Cahit Akyol
Sinan Akyüz
Necdet Altinok
Abdurrahman
Antakyali
Suleyman Arat
Yavuz Arslan
Coskun Asar
Özden Atik
Ihsan Kani Atmaca
Fikret Ay
Ardig Aytalar
Ali Borovali
Bahri Büke
Ömer Çaglak
Oktay Cilesiz
Kenan Cimen
Eyup Coskun
Ali Daglar
Hakan Denker
Bikem Ekberzade
Ersin Ercan
Hasan Ersan
Murat Getin
Mehmet Gülbiz
Ali Kabas
Hayrettin Karateke
Engin Karderin
Bahar Kaymakci
Ali Kilic
Recai Kömûr
Cemal Köyük
Ilyas Namoglu
Kerim Ökten
Fahrettin Gütkan Örenli
Burhan Özbilici
Sefa Özkaya
Mehmet Hikmet Saatci
Hamza Sahin
Kerem Saltuk
Fatih Saribas
Serkan Akkog
Erhan Sevenver
Sulyman Arat
Ömer Tekdal
Ahmet Tarik Tinazay
Hasan Turkan
Kozan Ümit
Aziz Uzun
Alper Yurtsever

UGANDA
Henry Bongyereirwe
P. Ongom Komakech
John W.K. Oryema

UKRAINE
Igor Bulgarin
Sergei Datsenko
Gleb Garanich
Alexander Gordievich
Alexander Kanischew
Andrey Kanishchev
Ivan Melnik
Leonid Naidiouk

Vladimir Osmushko
Oleg Poddubniy
Sergei Supinsky
Sergey Svetlitsky
Alexander Svetlovsky
Victor Vasilevski

UNITED KINGDOM
Mike Abrahams
John Angerson
David W. Ashdown
Marc Aspland
Dan Atkin
Stewart Attwood
Richard Baker
Roger Bamber
Frank Baron
Jonathan Bartholomew
Gareth Beard
Eleanor Bentall
Vince Bevan
Steve Bould
Nigel Bowles
Kelvin Boyes
Chas Breton
Clive Brunskill
Richard Byerley
Gary Calton
Richard Cannon
Brian Cassey
Angela Catlin
David Cheskin
Wattie Cheung
Felix Clay
Paul Clements
Nick Cobbing
Chris Coekin
Phil Coomes
Paul Cooper
Steve Cox
Tom Craig
Neil Cross
Simon Dack
Nick Danziger
Prodeepta Das
Howard J. Davies
Karen Davies
Haydn Denman
Adrian Dennis
Nigel Dickinson
Ann Doherty
John Downing
Frazer Dryden
Mark Earthy
Colin Edwards
Neville Elder
Jonathan Elderfield
Stuart Emmerson
Steve Etherington
Mark Evans
Sophia Evans
Sam Faulkner
Malcolm Fearon
Steve J. Forrest
Adam Fradgley
Stuart Freedman
Melanie Friend
Christopher Furlong
Drew Gardner
Davies Gareth
George Georgiou
Paula Glassman
Michael Goldwater
Mark R. Graham
Trevor Graham
Michael Graig
Alistair Grant
David Graves
Ben Graville
Charlie Gray
Matt Griggs
Julia Guest
John Gunion
Nick Gurney
Gary Hampton
Neil Hanna
T. Harley-Easthope
Brian Harris
Sam Harris
Andrew Hendry
Tim Hetherington
Tim Hetherington
Tommy Hindley
Adam Hinton

Dave Hogan
Jim Holden
David Hollins
Mike Hollist
Kate Holt
Rip Hopkins
Suzanne Hubbard
Derek Hudson
Mel Hulme
Richard Humphries
Rehan Jamil
Lee Jenkins
Tom Jenkins
Victor Jesus
Justin Jin
Andy Johnstone
Davy Jones
Terry Kane
Christian Keenan
Findlay Kember
Daniel Kennedy
Mike King
Ross Kinnaird
David Kinsella
Glyn Kirk
Gary Knight
Tony Kyriacou
Colin Lane
Kalpesh Lathigra
Stephen Lawrence
T.J. Lemon
Nicky Lewin
Barry Lewis
Richard Lewis
Neil Libbert
Graham Lindley
Malcolm Linton
Paul Lowe
Sinead Lynch
Andrew MacColl
Peter MacDiarmid
Stuart MacFarlane
Mike Maloney
Peter Marlow
Paul Marriott
Bob Martin
Dylan Martinez
Leo Mason
Jenny Matthews
Tim Matthews
Ed Maynard
Gerry McCann
Eric McCowat
Mark McEvoy
William A. McLeod
Colin Mearns
Keith Meatheringham
Philip Meech
Toby Melville
Sacha William Miller
Allan Milligan
Rizwan Mirza
David Modell
David Moir
Mike Moore
Rod Morris
Douglas Morrison
Nevil Mountford
Eddie Mulholland
Pauline Neild
Zed Nelson
Guy Newman
Peter Nicholls
Phil Noble
Jonathan Olley
Charles M. Ommanney
Kevin Oules
Jeff Overs
Dan Oxtoby
Mark Pain
Nigel Parry
David Pearson
Alan Peebles
Caroline Penn
Rob Penn
Marcus Perkins
Michael Franjo Persson
Michael John Pett
Paul Pickard
Tom Pilston
Olivier Pin-Fat
Gary Prior
Steve Race
Michael S. Radley

Rankin
John Reardon
Steve Reid
Gary Roberts
Mike Roberts
Simon Roberts
Ian Robinson
Karen Robinson
Stuart Robinson
Paul Rogers
David Rose
Ian Rutherford
Howard Sayer
Andrew Scaysbrook
Mark Seager
Anup Shah
David Shopland
John Sibley
Annand Simon
Michael Steele
Chris Steele-Perkins
David Stewart-Smith
Tom Stoddart
Graham Stuart
Justin Sutcliffe
Sean Sutton
Ray Tang
Edmond Terakopian
Gordon Terris
Andrew Testa
Mark J. Thomas
Martin Thomas
Ian Torrance
Siôn Touhig
David Trainer
Neelakshi Vidyalankara
John Voos
Simon Walker
Michael Walter
Andy Walton-Vaines
Pam Warne
Chris Watt
Felicia Webb
Amiran White
Clifford White
David White
Andrew Wiard
Kirsty Wigglesworth
Geoff Wilkinson
Alan Williams
Greg Williams
John Williams
Andrew Winning
Vanessa Winship
Antony Wood
David Wootton
Nicholas Ysenburg

URUGUAY
Leo Barizzoni Martinez
Hugo Conzie Bermúdez
Gabriel Cusmir Cúneo
Julio Etchart
Ignacio Ferrari Giorello
Enrique Kierszenbaum

USA
Jeffrey Aaronson
Eddie Adams
Shelby Lee Adams
Steven W. Adams
Michael Adaskaveg
Lynsey Addario
Rich Addicks
Noah Addis
Michelle Agins
Max Aguilera-Hellweg
K.C. Alfred
Craig Ambrosio
Chris Anderson
Daniel Anderson
Ed Andrieski
Charlie Archambault
Juana Arias
Glenn Asakawa
Marc Asnin
Lacy Atkins
Bill Auth
Alexandra Avakian
Tony Avelar
Brian Baer
Karen Ballard
Alyssa Banta
Candace B. Barbot

Rebecca Barger
Don Bartletti
David Bathgate
John Bazemore
Jamison Bazinet
Grace Beahm
Robert Beck
Natalie Behring
Bill Belknap
Al Bello
Bruce Bennett
Benjamin Benschneider
Harry Benson
Randall Benton
Larry Benvenuti
David Berkwitz
Nina Berman
Alan Berner
Matt Bernhardt
Pam Berry
Susan Biddle
John Biever
Todd Bigelow
Chris Birks
Keith Birmingham
Gary Bogdan
David Bohrer
Anthony Bolante
Reece Booth
Kathy Borchers
Harry Borden
Peter Andrew Bosch
Mark Boster
Heidi Bradner
Brian Branch-Price
Alex Brandon
David Brauchli
William Bretzger
Zana Briski
Russel Bronson
Paula Bronstein
Dudley Brooks
Matt Brown
Milbert Orlando Brown
Paul Joseph Brown
Scott Brown
Brian van der Brug
Luca Bruno
Simon Bruty
Mark Bugnaski
Khue Bui
Gregory Bull
Joe Burbank
Jeff Burk
Lauren Victoria Burke
David Burnett
G. Paul Burnett
David Butow
Alexandra Buxbaum
Sherrie Buzby
Renée Byer
Julia Calfee
Loren Callahan
Mary Calvert
Nick Cardillicchio
J. Pat Carter
Kevin Casey
John Castillo
Bryan Chan
Chang W. Lee
Tim Chapman
Richard A. Chapman
Dominic Chavez
Stephen Chernin
Chien Min Chung
Alan Chin
Barry Chin
André F. Chung
Daniel F. Cima
Mary Circelli
Michael Clancy
Marshall Clarke
Timothy Clary
Thomas Clauson
Jay Clendenin
Bradley E. Clift
Rachel Cobb
Victor José Cobo
Gigi Cohen
Marice Cohn Band
Carolyn Cole
Charlie Cole
Jim O. Collins
Jay Colton

Fred Conrad
Rebecca Cooney
Allison Corbett
Josef Corso
Ronald Cortés
Peter Cosgrove
Carl D. Costas
John Costello
Bill Crandall
Christopher J. Crewell
Mark Crosse
Dave Cruz
Thomas Cruze
Michele Curel
Rob Curtis
Annie Cusack
Craig Cutler
Andrew Cutraro
Scott Dalton
Keith Dannemiller
Suzanne DeChillo
Dan Delong
Julie Denesha
Charles Dharapak
Peter Diana
J. Albert Diaz
Cheryl Diaz Meyer
Melchior Digiacomo
Anthony V. DiGiannurio
Nuccio DiNuzzo
Sean Dougherty
Larry Downing
Eric Draper
Richard Drew
Michel DuCille
David Duprey
Steve Dykes
Greg Ebersole
Aristide Economopoulos
J.M. Eddins Jr.
Richard Ellis
Douglas Engle
Bill Eppridge
Barbara Errickson
James Estrin
Gary Fabiano
Timothy Fadek
Bob Falcetti
Steven Falk
Patrick Farrell
Safia Fatimi
Najlah Feanny
Paul Feiner
Gina Ferazzi
Gloria Ferniz
Donna Ferrato
Jonathan Ferrey
Stephen Ferry
Brian Finke
Gail L. Fisher
Deanne Fitzmaurice
Viorel Florescu
Lake Fong
Peter Fowkes
Rick Fowler
Charles Fox
William Frakes
Angel Franco
Wilcox Danny Frazier
Luke Frazza
Jonathan Fredin
Carol Freeman
John Freidah
Ruth Fremson
Lee Friedlander
Gary Friedman
Rich Frishman
Christian Fuchs
Paul Fusco
Patricia Gallinek
Sean Gallup
Eugene Garcia
Mark Garfinkel
Robert Gauthier
John Gay
Karl Gehring
Sharon Gekoski-Kimmel
Phillip Geller
Catrina Genovese
Jim Gensheimer
Nikolaos Giakoumidis
Bruce Gilbert
Sarah Glover
Scott Goldsmith

Carlos Gonzales
Rodolfo Gonzalez
Jay Gorodetzer
Arlene Gottfried
Tom Gralish
Jason Green
John Green
Bill Greene
Stanley Greene
Lauren Greenfield
Susye Greenwood
Peter Gregoire
Norbert Groeben
Daniel Groshong
Deborah A. Grove
Lori Ann Grzelak
Paul Grzelak
Justin Guariglia
Jim Gund
David Guralnick
Erol Gurian
John Gurzinski
David Guttenfelder
Carol Guzy
Tina Hager
David Hahn
Gail Albert Halaban
Donald Halasy
Kari René Hall
Robert Hallinen
Marscha Halper
Scott Hamrick
David Handschul
Chris Hardy
Chick Harrity
Rick Hartford
Richard Hartog
Elizabeth Hartzenbusch
David Alan Harvey
Ron Haviv
Jeff Haynes
Elizabeth Hefelfinger
Gregory Heisler
Dan Helms
Mark Henle
Gerald Herbert
Tom Herde
Alvaro Hernandez
Jake Herrle
Tyler Hicks
Kevin Higley
Edward J. Hille
John Hios
Charles Hires
Mark E. Hirsch
Evelyn Hockstein
Fritz Hoffmann
Jeremy Hogan
Jim Hollander
Dan Honda
Chris Hondros
Kevin Horan
Eugene Hoshiko
Stewart F. House
Rose Howerter
Daniel Hulshizer
Thomas James Hurst
Eric Hylden
John Iacono
Justin Ide
Andrew Innerarity
Walter Iooss
Stuart H. Isett
Stephen Jaffe
Kenneth Jarecke
Janet Jarman
Christopher Johns
Kim Johnson
Frank Johnston
Marvin Joseph
Nancy Jung
Oówlan Jah Kamoze
Doug Kanter
Sylwia Kapuscinski
Doug Kapustin
Ed Kashi
Karen Kasmauski
Jeff Katz
Edward Keating
John Keating
Reseph Keiderling
Casey Keil
Chuck Kennedy
David Hume Kennerly

143 ·

John J. Kim
Robert King
Yunghi Kim
Jed Kirschbaum
Torsten Kjellstrand
Steve Klaver
Laura Kleinhenz
Heinz Kluetmeier
David E. Klutho
Janet Knott
George Kochaniec jr.
C. Koci Hernandez
Richard H. Koehler
Glenn Koenig
Craig Kohlruss
Jeff Kowalsky
Benjamin Krain
Kevin Kreck
Suzanne Kreiter
Charles Krupa
Amelia Kunhardt
Jack Kurtz
Nisha Kutty
Teru Kuwayama
David Lachapelle
Garo Lachinian
Jerry Laizure
André Lambertson
Rodney A. Lamkey, Jr.
Wendy Sue Lamm
Nick Lammers
Nancy Lane
Brian Lanker
Kate Lapides
Tyler Larkin
Bob Larson
Eric Larson
Olivier Laude
Cesar Laure
Neal C. Lauron
David Leeson
Mark Leffingwell
Andres Leighton
Mark Leong
Claude Alan Lessig
Catherine Leuthold
Douglas Levere
Mel Levine
Richard Levine
Michael S. Levy
Serge J-F. Levy
Janis Lewin
William W. Lewis III
Andrew Lichtenstein
Jennifer Lindberg
Brennan Linsley
Richard Lipski
Steve Liss
Pat Little
Mary Lommori Vignoles
David Longstreath
Rick Loomis
Delcia Lopez
Jim Loscalzo
V.J. Lovero
Robin Loznak
Raymond Lustig
Michael Lutzky
Winston Luzier
Preston Mack
Jeffrey MacMillan
Jim MacMillan
James Mahan
James F. Mahoney
Jim Mahoney
David Maialetti
John Makely
Tyler Mallory
Jeff Mankie
Mary Ellen Mark
Maxim Marmur
Fred Maroon
Joseph Marquette
Bullit Marquez
Dan Marschka
Pablo Martínez
Monsivais
Sven Martson
Tim Matsui
Steven F. Matteo
Robert Mayer
Ricardo Mazalan
Linda McConnell
Cyrus McCrimmon

Steve McCurry
John McDonnell
John McDonough
David G. McIntyre
Rick McKay
Scott McKiernan
Joseph McNally
Daniel J. Mears
Steve Mellon
Eric Mencher
Sheryl A. Mendez
Peter J. Menzel
Mikhail Metzel
Frank Micelotta
Peter Read Miller
George W. Miller III
Mark Milstein
Ming Hui Cheng
Ari Mintz
Donald Miralle
Mark W. Moffett
Genaro Molina
Thomas Monaster
Scott Moon
Jose M. More
Christopher Morris
Paul Morse
Ozier Muhammad
Michael Munden
James Nachtwey
Joyce Naltchayan
Mike Nelson
Scott Neville
Gregg Newton
Arleen Ng
Ray Ng
Nick Nichols
Steven Ralph Nickerson
John O' Boyle
Annie O´Neill
Michael O'Neill
Morgan Ong
Edward A. Ornelas III
Francine E. Orr
José M. Osorio
Darcy Padilla
Todd Panagopoulos
Aldo Panzieri
Helena Pasquarella
Judah Passow
Bryan Patrick
Robert Pavuchak
Paxton
Reginald Pearman
Douglas Pensinger
Hilda M. Perez
Lucian Perkins
Freddy Perojo
Mark Peterson
Alysia Peyton
Stephanie Pfriender
Keri Pickett
Marc. A Piscotty
Brian Plonka
Richard Pohle
Arthur Pollock
Smiley Pool
David Portnoy
Fred Prouser
Alex Quesada
Shana Raab
Barron Rachman
Joseph Raedle
Lois Raimondo
Anacleto Rapping
Laura A. Rauch
Patrick Raycraft
Steven L. Raymer
Tom Reese
Joan Regen
Tim Revell
James Rexroad
Paul Richards
Roger Richards
L. Jane Ringe
Kim Ritzenthaler
Christine Rivera
José A. Rivera
M. Robinson-Chávez
Manuel Rocca
Paul Rodriguez
Librado Romero
Vivian Ronay
Jose Rosario

Bob Rosato
Daniel Rosenbaum
Marissa Roth
Jeffrey B. Russell
David L. Ryan
Bob Sacha
Joseph McNally
Wally Santana
April Saul
Jonathan Saunders
Stephan Savoia
Allen Schaben
Erich Schlegel
Jake Schoellkopf
Thomas Schudel
Jamie Schwaberow
David Scull
Michael Seamans
Carl Seibert
Bob Self
William Serne
Daniel Shanken
Stephen Shaver
Brynne Shaw
Ezra Shaw
Steve Shelton
Shepard Sherbell
Nancy Siesel
Benny Sieu
Barton Silverman
Meri Simon
Luis Sinco
Wally Skalij
John Slavin
Tim Sloan
Christopher Smith
Dayna Smith
Gregory Smith
Brian Snyder
Lara Solt
Harley Soltes
Kenneth Somodevilla
Pete Souza
Alan Spearman
Fred Squillante
Jamie Squire
John Stanmeyer
Shannon Stapleton
Steve Starr
Susan Stava
Larry Steagall
Maggie Steber
George Steinmetz
Lezlie Sterling
Mike Stocker
Hal Stoelzle
Leslie Stone
Matt Stone
Wendy Stone
Scott Strazzante
Damian Strohmeyer
Bruce C. Strong
Cyndy Sullivan
Pat Sullivan
Sunny H. Sung
Akira Suwa
Lea Suzuki
David Robert Swanson
Laurie Swope
Clarence Tabb, Jr
Mario Tama
Allan Tannenbaum
Patrick Tehan
Joyce Tenneson
Donna Terek
Mark J. Terrill
Shmuel Thaler
Scott Thaley
Robert P. Thayer
Marianne Thomas
Al Tielemans
Lonnie Timmons III
Tom Tingle
Peter Tobia
Joe Traver
Robert Trippett
Linda Troeller
John Trotter
Lane Turner
Peter Turnley
Jane Tyska

Betty Udesen
Steven Ueckert
Gregory Urquiaga
Chris Usher
Steven Valenti
Victoria Ann Valerio
Nuri Vallbona
Jim Varhegyi
William Vasta
Sergei Venyavsky
Vanessa Vick
Ami Vitale
Sarah Voisin
Tamara Voninski
Dino Vournas
Anastasia T. Vrachnos
Bill Wade
Kat Wade
Diana Walker
Stephen Wallace
C. Wallace de Cornwall
Anastasia Walsh
Brian Walski
Ting-Li Wang
Paul Warner
Jill Waterman
Susan Watts
Apicart Weerawong
Spencer Weiner
Robin Weiner
Nathaniel Welch
David H. Wells
Annie Wells
Candace West
Matthew West
Theo Westenberger
Steve Wewerka
John H. White
Rodney White
Samuel Whitemore
Bryan Whitney
John Wilcox
Jonathan Wilcox
George Wilhelm
G. Wilkins-Kasing'A
Anne Williams
Clarence Williams
J. Conrad Williams
Michael Williamson
Damon Winter
Michael S. Wirtz
Patrick Dennis Witty
Barry Wong
Darrell Wong
Suné Woods
Ed Wray
Norbert Wu
Ron Wurzer
Michael S. Yamashita
Boris Yaro
Mark Zaleski
Barry L. Zecher
Tim Zielenbach

VENEZUELA
Venancio Alcazarez
Carlos Balza Casado
Alfredo Cedeno Salazar
Jose Cohen
Vicente Correale
Osver Diaz
Carlos Fuguet Giron
Felix Gerardi
Carlos Hernández
Enrique Hernández
Nelson Maya Matheus
Jacinto Oliveros Perez
Jorge Gregorio Pacheco
Enio Perdomo
Nicola Rocco
Fernando José Sanchez
Carlos Andrés Sanchez
Jorge Santos
Franklin Suarez
Luis Vallenilla

VIETNAM
Bai Nguyen Duc
Chi Trung Dang
Dac Phuong
Dang Cong Duc
Dang Ngoc Thai
Dao Hoa Nu
Dinh Duy Bê

Doan Anh Huy
Dohuu Duc
Dong Nguyen
Duc Huy
Dung Nguyen Van
Duong Van Nhan
Hai Ngoc Nguyen
Minh Ho Thanh
Thach Van Hoang
Hoang Quoc Tuan
Huynh Lam
Huynh Ngoc Dan
Khanh Lai
Lai Dien Dam
Le An
Le Chi Bac
Le Duy
Le My Phuong
Le Ngoc Tuan
Le Nguyen
Le Trinh
Le Vi
Lu Hoang Van
Luong Chinh Huu
Luong Van Tu
Ngo Quang Yen
Nguyen Anh Tuan
Nguyen Ba Dung
Nguyen Cong Van
Lac Nguyen Dinh
Nguyen Dinh Hai
Nguyen Dinh Vinh
Nguyen Duc Lan
Nguyen Hong Nga
Nguyen Khac Huong
Nguyen Kim Quan
Nguyen Long Hong
Nguyen Nhung
Phien Nguyen Thai
Nguyen Thanh Sum
Nguyen The Huyen
Nguyên Thê Trí
Nguyen Van Vuong
Tin Trung Nguyen
Pham Duc Thang
Pham Thi Lai
Phuong Dung
Quang Huy Vu
Que Nguyen Van
Quy Tran
Tan Thang Huynh
Thai Dang
Thinh Pham Ba
Trân Chinh
Trân Cu
Trân Dinh Huòng
Hong Tran Hinh
Tran Huu Cuong
Tran Huu Cuu
Tran Lam
Tran Nam Son
Tran Ngoc Thanh
Tran Quoc Dung
Tran Thi Tuyet Mai
Tran Van Chau
Tran Van Luu
Trungh-Thu Nguyen
Truong Hung Cang
Tuong Nguyen Duc
Van Bao
Vo Huy Cat
Vu Anh Tuan
Vu Anh Tuan
Vu Ngoc Hoang

YUGOSLAVIA
Zoran Anastasijevic
Ilic Andrija
Petrov Bogdan
Vuk Brankovic
Aleksandar Djorovic
Ivan Dobricic
Nikola Fific
Afrim Hajrullahu
Srdjan Ilic
Aleksandar Kelic
Matija Kokovic
Igor Marinkovic
Dragan Milovanovic
Zoran Milovanovic
Zoran Mircetic
Mihály Moldvay
Milan Obradovich
Slobodan Pikula

Radivoje Raskovic
Hazir Reka
Aleksander Stankovic
Boris Subasic
Srdjan Suleymanovic
Goran Tomasevic
Emil Vas
Vanja Vukovic

ZAMBIA
Emmah Nakapizye
Patrick Ngoma
John Ngoma

ZIMBABWE
Costa Manzini
Wallace Mawire
James M. Mayuni
Dennis Mudzamiri
David Mukandiwona
Mark B. Peters
Mukwazhi Tsvangirayi

The visionary EOS-1V

Can you afford to look the other way?

If you're earning your living on photography's front line, you're probably already using an EOS. If you aren't, perhaps you should be. Because it takes more than technological expertise to create the world's finest photographic system, it takes vision. The kind of vision that has driven Canon to push relentlessly at the boundaries of photography, introducing innovation after innovation; providing photographers with the tools to give them the edge. And now comes the latest addition to the EOS System, the EOS-1V. Descended from the legendary EOS-1N and the astonishingly advanced EOS-3, the EOS-1V is the ultimate professional SLR. Visit your professional dealer or check out our website www.cps.canon-europa.com to find out when the EOS-1V pro roadshow is at a location near you.

• Super fast shooting speed 10fps • World's fastest AF (45 point area AF) • Ultra-rigid magnesium alloy body • Fully water-resistant & dust-proof structure • Durable rotary-magnet shutter tested to 150,000 cycles • 21 zone evaluative metering

http://www.canon.com

Future & speed

Kodak Professional DCS 520

DCS 620
DCS 520

Only with Kodak Professional DCS Digital Cameras are you prepared for the future. Benefit from firmware and software upgrades from the web and add new features to your Kodak Professional DCS Digital Camera. Remain up-to-date and guarantee your future with Kodak Digital SLRs.

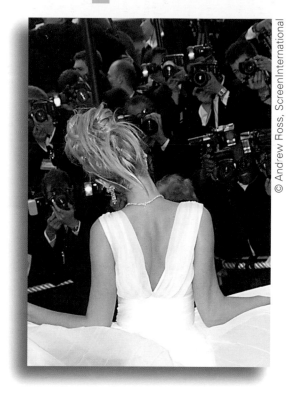

© Andrew Ross, ScreenInternational

O The new firmware allows users to produce raw finished, TIFF or JPEG files on board the camera.

O The IPTC window allows the photographer to input data that describes the image according to the IPTC standard.

O Exposure compensation allows the photographer to fine tune exposure after the image is captured.

O Dual slot can already be used for additional image storage. In the very near future, further firmware upgrades, avalaible to all Kodak Professional DCS Digital Camera owners, will permit the use of other PCMCIA cards to support applications such as global positioning system and mobile telephone transmission direct out of the DCS Digital Camera.

Kodak Professional DCS 620

Kodak Digital Technology

WHAT THE BEST DIGITAL SLRs ARE BUILT AROUND

For further information on the Kodak Professional range of digital cameras call:
UK 0870 6006 1423 **France** 01 55 1740 72 **Germany** 069 5007 0020
Italy 02 696 334 36 **Spain** 91 406 90 52 **Netherlands** 020 346 9129

www.kodak.com/go/professional

 Kodak TAKE PICTURES. FURTHER.™

Kodak Professional

The world's finest books on
photography and photographers from

Thames & Hudson

Bailey **Blumenfeld** Bischof

Bill Brandt Brassaï **Cartier-Bresson**

Walker Evans **Lois Greenfield**

Horst **Hoyningen-Huene**

Jacques-Henri Lartigue **Duane Michals**

Lee Miller **Tim Page** Man Ray

Riboud Daniel Schwartz

Cindy Sherman W. Eugene Smith

For details of our new and forthcoming titles, please write to:

(UK) Thames & Hudson Ltd 181A High Holborn London WC1V 7QX **(USA)** Thames & Hudson Inc. 500 Fifth Avenue New York NY 10110

Art director
Teun van der Heijden
Design
Heijdens Karwei
Picture coordinators
Nina Steinke
Marieke Wiegel
Interview and captions
Rodney Bolt
Editorial coordinators
Femke Rotteveel
Bart Schoonus
Supervising editor
Kari Lundelin

Lithography
Sdu Grafisch Bedrijf bv, The Hague
Paper
Hello Silk 135 g, quality Sappi
machine coated, groundwood-free paper
Cover
Hello Silk 300 g
Proost en Brandt, Diemen
Printing and binding
Sdu Grafisch Bedrijf bv, The Hague
Production supervisor
Rob van Zweden
Sdu Publishers, The Hague

Jury 2000
Mark Grosset, France (chair)
director Agence de Presse Rapho
Pablo Bartholomew, India
photographer
Robin Comley, South Africa
picture editor The Star
Peter Dejong, The Netherlands
photographer Associated Press
Roger Hutchings, United Kingdom
photographer Network Photographers
Margot Klingsporn, Germany
director Focus Photo und Presse Agentur
Kadir van Lohuizen, The Netherlands
photographer Agence Vu
Michele McNally, USA
picture editor Fortune
Krzysztof Miller, Poland
photographer Gazeta Wyborcza
Grazia Neri, Italy
president Agenzia Grazia Neri
Don Rypka, USA
picture editor La Nación, Argentina
Sally Stapleton, USA
senior international photo editor Associated
Press
Xia Daoling, People's Republic of China
vice chairman Shanghai Photographers
Association

Children's Jury 2000
Elizabeth Alvarado, Peru
Centro de la Fotografia / El Comercio /
UNICEF
Dan Collin, Finland
Helsingin Sanomat
Anna Csonka, Hungary
Népszabadság
Adrita Hossain, Bangladesh
Drik Picture Library
Thirii Myint, USA
San Francisco Chronicle
Antoine Nadal, France
Images DOC
Jesper Sørensen, Denmark
Politiken
Mila de Wit, The Netherlands
de Volkskrant / Stichting Krant in de Klas /
UNICEF
Tafadzwa Zharare, Zimbabwe
ZATCYP

Office
World Press Photo
Jacob Obrechtstraat 26
1071 KM Amsterdam
The Netherlands

Telephone: +31 (20) 6766 096
Fax: +31 (20) 6764 471
E-mail: office@worldpressphoto.nl
URL: http://www.worldpressphoto.nl

Managing director: Árpád Gerecsey
Deputy managing director:
Michiel Munneke

Cover picture (detail)
World Press Photo of the Year 1999
Claus Bjørn Larsen, Denmark, Berlingske
Tidende
Wounded Kosovo Albanian Man, Kukës,
Albania, 5 April

World Press Photo Foundation